W9-CFB-331

Barcelona
Open-Air Sculpture Gallery

Barcelona
Open-Air Sculpture Gallery

Text

Lluís Permanyer

Photographs

Melba Levick

Rizzoli
NEW YORK

First published in the United States of America in 1992 by
RIZZOLI INTERNATIONAL PUBLICATIONS, INC.
300 Park Avenue South, New York, NY 10010

© 1991 Ediciones Polígrafa, S.A.

© Photographs: Melba Levick
Design: Toni Miserachs
Translated by Joanna Martínez

Library of Congress Cataloging-in-Publication Data

Permanyer, L.
 [Barcelona, un museo de esculturas al aire libre. English]
 Barcelona, open air sculpture gallery / photographs by Melba Levick ;
 text by Lluís Permanyer.
 p. cm.
 Translation of: Barcelona, un museo de esculturas al aire libre.
 Includes index.
 ISBN 0-8478-1554-4
 1. Sculpture, Modern—20th century—Spain—Barcelona.
 2. Outdoor sculpture—Spain—Barcelona.
I. Levick, Melba. II. Title.
NB811.B6P47 1992 91-51005
735'.23'0744672—dc20 CIP

Color separation: Reprocolor Llovet, S.A. - Barcelona
Printed and bound in Spain by La Polígrafa, S.A.
Parets del Vallès (Barcelona) - Dep. Leg.: B. 1.467 - 1992

Contents

From a city without squares to an open-air sculpture gallery

Barcelona has been described by accredited commentators from all over the world as not only the most dynamic city in Europe but also the one with the most avant-garde town planning and urban design. In order to assess accurately the importance to the city itself of this municipal policy, set in motion by the City Councils that followed the establishment of democracy in Spain, it is essential to recap the history of the place.

Since the beginning of the last century, Barcelona has seen a spectacular increase in its population. In 1818 there were 83,000 inhabitants, in 1841 the number had increased to 140,000, and by 1850 it had reached 187,000. Despite this growth, the inhabited area remained unchanged at only 2,048,172 square meters. But another essential factor should be taken into account, which is that no less than 40% of that urban area was occupied by Church property, hospitals and public buildings. The actual space available to the residents was so small that the density of population reached inhuman levels: 11.44 square meters per person, when experts consider a reasonable minimum figure to be 40. Given all this, not to mention the poor sanitation of that period, it can be understood how the death rate was far above that of Paris and even London. In the middle of the century it was estimated that the average age of a member of the wealthy classes of Barcelona was 36, while that of the working classes was no more than 23.

In that Barcelona strangled by its walls, with a constantly increasing population, the inhabitants did their utmost to gain space in which to survive. They slung arches over the streets in order to build on top of them; hence the origin of the many streets whose names begin with the word "Arc." There is no need to explain the reason for a street being christened "Cinc Voltes" (five arches). As a result, it was possible to go from the cathedral to the church of Santa Maria del Mar without stepping out into the street, simply by passing from one rooftop to the next.

Another device was to erect buildings with façades jutting out over the street, thus increasing the living space in the houses in each successive overhanging storey. Carried to an extreme, it is easy to surmise that the inhabitants of the top floor could almost have shaken hands with their neighbors opposite. The practice was brought to an end not because reason prevailed but because one day the City Council decided it was dangerous and prohibited it. The fact is that the streets in general were extremely narrow: there were over 200 measuring less than 3 meters across, and almost 400 less than 6 meters wide. The narrowest was the Carrer de les Donzelles, with its 1.10 meters.

The Barcelona of the mid-nineteenth century had degenerated into a labyrinth of alleyways, further complicated to an unimaginable degree by innumerable cul-de-sacs. To prevent traffic jams, most of the streets were one-way. The greatest problem for drivers of carts and carriages was turning corners; and so, on some of the narrowest streets that were arched over there was a hook in the center of the arch to which a

rope could be tied in order to hitch the cart up a few inches and turn it on its wheels until it was facing down the next street. The handcart became the normal delivery vehicle. For many decades local by-laws prohibited the lighting of the traditional bonfires at street corners on the eve of the feast of St. John (Midsummer Night) for fear that the proximity of the houses might cause uncontrollable fires.

Traditionally, Barcelona could not afford the luxury of gardens and squares, for this would have been considered a waste of space. The only squares that existed until 1830 were the historical Plaça del Blat (now Àngel, 1320), Nova (1355), Santa Anna (1355), Rei (1403), Montcada (1416) and Marcús (1416); the largest was the Plaça del Born, the scene of jousts and tournaments. These squares had already been enlarged and remodeled.

During the first half of the last century several large squares were created, the result of the burning or disentailment of convents, among which were Sant Josep/Boqueria, Reial, Sant Agustí and Medinaceli.

From 1821 onwards, other squares appeared as a result of the occupation of the parish cemeteries that Charles III had ordered to be closed, to which the citizens stoutly objected. The Captain-General Castaños had also unsuccessfully ordered the paving over of cemeteries considered a danger to public health. The following squares are on the former sites of cemeteries that were paved over in 1821: Sant Just, Sant Josep Oriol, Fossar de les Moreres, Sant Pere de les Puel·les, Montjuïc del Bisbe, Sant Miquel, Sant Cugat del Rec.

Other squares, such as the Plaça del Pedró, acquired their present spaciousness simply by being enlarged. Even such an important square as the Plaça de Sant Jaume, which connects but also separates the City Hall and the Generalitat, was no more than a junction of streets until it attained its present size in the first half of the last century after the demolition of a church and adjacent parish cemetery.

The *Llibre Verd,* a curious guide to Barcelona published in 1848, bemoaned the acute lack of squares.

It is not surprising, therefore, that the people of Barcelona should have started the tradition of *fontades,* that is to say, treating themselves to a whole day in the country near a spring, where they were able not only to taste the excellent waters with their medicinal properties but also to breathe in fresh air, gaze at the view and thus relieve their understandable claustrophobia. One of the most frequented walks during that period was the Muralla de Mar, a breezy spot from which one could contemplate the far horizon.

In the Barcelona of the first half of the nineteenth century, there was one cry that eventually became unanimous and was above all differences of class, religion and politics: "Down with the walls!" Down with the walls in order to extend the city and enable people to live without inhuman overcrowding.

A royal order of 1854 finally permitted the demolition of the walls, which was followed immediately afterwards by the approval of the Cerdà Plan, designed to cover the entire surrounding plain with streets laid out on a grid system, forming the area known as the Eixample. Such a transformation was possible thanks to the progressive governments of O'Donnell and Espartero in the reign of Isabel II. The engineer Ildefons Cerdà had conceived the uniform design not because he was inspired by the Roman way of doing things but because he was a utopian socialist who hoped thereby to prevent capitalist speculation.

It was natural, therefore, that the city's greatest transformation should have occurred under a doubly progressive sign, but then this has been a constant factor in the history of Barcelona. Indeed, some of the greatest improvements during the last century, which invariably took place under progressive local governments, have included the abolition of the cemeteries in 1820 and of a great many convents in 1835; the implementation of the Cerdà Plan in 1860; the approval of the Baixeras Internal Reform Plan in 1880. It is in this same spirit that we should interpret the ambitious, imaginative plan for the city squares that has been developed by successive Socialist City Councils in Barcelona. The great English architect Sir Christopher Wren stated that "Architecture has a political

use: public building is the ornament of a country, it lifts up a nation, stimulates people and trade, makes people love their country." It was in this same spirit that the Pla de Palau, the largest square of its period, was constructed many centuries ago, an occasion when Madrid used urban development to make the point that real political power lay not in the Plaça de Sant Jaume, the seat of the Council of One Hundred, but in the Pla de Palau, the seat of the Viceroy.

Despite the ambitious Cerdà Plan, as a result of laissez faire capitalism the Eixample ended up with scarcely a single square in it. The reason for this is that the insides of each block were planned to contain gardens, but speculation swept aside all these green spaces and the city was left without any squares and also with no plans for any parks — a situation as distressing as the previous one.

Since then, the concrete and asphalt culture has been painstakingly nurtured. Density began to increase at an alarming rate. Under Mayor Porcioles (1957–73), the city experienced tremendous growth, but it did so in a spirit of speculation. The series of working-class districts that arose on the outskirts consisted merely of a succession of enormous blocks of flats lacking the most elementary infrastructure; the streets were unpaved and not a single square or garden was included. Everything was reduced to shapeless, empty spaces without even minimal vertebration.

The first democratically-elected City Council was governed by the Socialists under Mayor Narcís Serra, who left before completing his term of office to become Minister of Defence. It was that legislature that saw the commencement of the vast project conceived by the head of town planning, the architect Oriol Bohigas. The strategic proposal consisted in monumentalizing the outskirts of the city that had been abandoned to their fate for so many years. And the most important thing was to build and build, even at the cost of the quality of materials; the situation had got so behindhand that it required shock treatment.

And so from 1982 to 1986, a series of large urban spaces began to appear.

One differentiating note was the quantity: another was the role played by sculpture.

The word "monument" comes from a Latin root that means "to remember." A sculpture installed as a monument is destined to preserve the memory of something that in some way constitutes a sign of identity of a town and a people. Within a short time word went round that Barcelona was fast becoming an open-air sculpture museum. And it was true. Today, a total of around fifty sculptures can be counted; and something even more difficult has been achieved — they are all unquestionably of a high standard.

Some of these sculptures have been dedicated to the memory of a person (*Homage to Picasso*); some pay tribute to a collective memory (*The Republic*); others are important works by great artists (Chillida's *In Praise of Water*). But they all share a common denominator: they play an important role in the urban design. This has been fully achieved, but in addition people have perceived the character that a sculpture confers on a public square: it individualises it, gives it class, imbues it with a personality. A square or a public space with a sculpture in it acquires an added dimension.

Mayor Pasqual Maragall not only continued the course marked out by his predecessor Serra but gave it an extra impulse. Between the construction of new spaces and the remodeling of old squares, the overall results were impressive.

And the fruits soon began to be harvested. Foreign commentators spread the word that Barcelona was a city on the move, a city in which things were happening, a city with an avant-garde style of town planning, etc. Needless to say, the Olympic Games have helped to give it a further boost, if one were needed, and also to focus world attention on Barcelona.

Not only have there been good ideas and words of praise, but in February 1991 Harvard University awarded the city the prestigious Prince of Wales prize for its town planning and urban development over the last ten years. Such support is the supreme confirmation that the course followed was the right one.

It is important to make clear, however, that this municipal policy has not been confined to a specific period of time but is on-going. Indeed, as a result of having to carry out a series of large construction works to meet the challenge of the Olympic Games, new spaces appeared and it was considered appropriate to adorn them with works by renowned sculptors. Thus, at the time of writing — early 1991 — some of the pieces commissioned are about to be placed *in situ*. The list is a truly impressive one: the American artists Roy Lichtenstein, Claes Oldenburg — who will be producing a gigantic matchbox — Walter de Maria and Beverly Pepper. Daniel Buren of France will be giving an artistic treatment to the tunnels along the second ringroad in Nou Barris. The Austrian Rob Krier, also an architect, has modeled with his own hands homages in bronze to the poet Salvat Papasseit, to several historical civil engineers, and to Bosch i Alsina. In addition, of course, there are the Spaniards Paco López — with his evocation of that pioneer mediaeval institution, the Consolat de Mar — Jorge Oteiza and Miquel Navarro; and the Barcelona sculptors Susana Solano, Robert Llimós — who has chosen a high-tension pylon as the support for his work in neon — and the renowned surrealist Eudald Serra.

The selection made jointly by photographer Melba Levick and myself does not aim to be an exhaustive one, although it does try to give an accurate picture of this bold project. It was not a matter of simply taking beautiful photographs, but of showing how the inhabitants of the city integrate so humanly and so naturally with these new works. The people of Barcelona have always had an especially intense and passionate involvement in architecture, art and town planning. The Gothic Quarter, the Eixample designed by Cerdà, the art nouveau houses, the avant-garde ideas of Gaudí and Picasso, of Jujol and Mies van der Rohe and Miró, have all shown their class and personality in the decade of the eighties and are ready and eager to enter the twenty-first century.

A huge Miró for the Parc de l'Escorxador

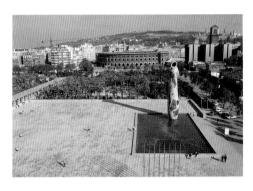

Architects:
Antoni Solanas
Màrius Quintana
Beth Galí
Andreu Arriola

Sculptor:
Joan Miró

Four blocks in the Eixample designed by the brilliant planner Ildefons Cerdà had been taken up by the *escorxador* or municipal abattoir. The time came to move the slaughterhouse elsewhere and as a result Barcelona recovered for public use a very large space (6 hectares) in a relatively central district.

The densely populated city had not only been historically bereft of squares because of its walls, but bourgeois speculation had done away with all the green areas planned by Cerdà in what was to have been little short of a garden city. Given this situation, a park such as the Parc de l'Escorxador was understandably of considerable importance.

One can therefore see why, on completion of the first of the three phases of the project, there was a certain amount of disappointment. It was the year 1983 and this was the first square to be constructed by a democratically-elected City Council. The people of Barcelona still had vivid memories of the Franco era, given over to speculation and the cultivation of concrete and asphalt. They were thus hoping, like manna from heaven, for a "green" square, an adjective that had then acquired a particular cachet. Such a reaction and such an interpretation are understandable on two accounts. First, because the initial phase consisted basically in the erection of Miro's sculpture and its surrounding base, a large paved area in which children could play. This was the fastest, cheapest and most effective solution, whereas a garden takes years to acquire an acceptable appearance and cannot stand up to such purely recreational use. However, the reaction against it was strong: the people wanted green areas at all costs. The controversy then arose between what came to be called "green squares" and the so-

called "hard squares" or "piazzas." It was a futile dispute, born of that aberrant circumstance. People tend to confuse a square with a garden and with a park. In addition, a square in the heart of a large European city can only be a paved square, for beaten earth merely turns to dust in summer and to mud when it rains, thus transforming an area for social communication into an obstacle, and a dirty one to boot. Beaten earth squares are found in Africa, and in villages; the largest and best squares in Europe are paved.

The Parc de Joan Miró inside the Parc de l'Escorxador was constructed after a public competition in which Ricardo Bofill came in second; the design chosen was the one submitted by the architects Antoni Solanas, Màrius Quintana, Beth Galí and Andreu Arriola. The remaining part of the square was devoted to a Mediterranean park, formed chiefly of pines and holm oaks. The transition between the large paved esplanade, where children can play all manner of games, and the park proper is via orderly rows of palm trees. Along one side of the huge park, which is a perfect geometrical square, are a row of low buildings housing various civic amenities for the district.

When Mayor Narcís Serra — later appointed Minister of Defence — asked Joan Miró to collaborate in the project, the artist accepted eagerly. Not only was he undaunted by such a large undertaking but it stimulated him and enabled him to be even more audacious than could ever have been imagined. It should be remembered that he was by then nearly ninety! When he realised now ambitious the project was, and the large urban area that would be recovered for use as a public amenity, Miró, with his innate sense of

balance and proportion, had the idea of erecting a sculpture over twenty meters high.

What shape was it to be? He took inspiration from a sculpture measuring little over a meter that he had created in the sixties and that his close collaborator Llorens Artigas had produced in ceramic: *Femme et Oiseau,* 3.4 meters high. But fate dictated that the work was to be smashed while being transported. He set to work using the same idea, and in a plasterer's workshop produced the model of what was to be *Woman and Bird (Dona y Ocell).* He painted it himself in its rich colors, and the model is now in the Miró Foundation.

Miró always had a perfect sense of the proportions of things. On one occasion he was leafing through a book by Henry Miller for which he had just painted the jacket. In the Catalan edition of *The Smile at the Foot of the Ladder,* the author of *Big South* admits that the ladder was clearly inspired by the one his close friend Miró had painted in *Chien aboyant la lune* when they were both poor and unknown in Paris. Suddenly Miró stopped at one page and pointed to a paragraph ending in the letter "o," a full stop and a bracket, and then told me what a strong impact these shapes would have if greatly enlarged. And he actually put this idea into practice in a large-format painting. But, despite this innate sense of his he wanted to be perfectly sure, and went so far as to arrange for a canvas of similar size to be suspended from a crane at the required height. It was erected near the Carrer del Consell de Cent so that the Arenas bullring — the most imposing volume in the area, particularly because of its round shape and reddish color — would form a backcloth to the work. The original height of 24 meters was reduced to only 22 when the sculpture was finally produced.

Made of reinforced concrete, it was covered in ceramic by Joanet Gardy Artigas, the son of Llorens Artigas. He used the popular Catalan technique known as *trencadís,* which consists of irregular fragments of glazed ceramics set like mosaic and has the advantage of allowing all manner of convex and concave surfaces to be covered without the need for made-to-measure pieces.

Woman and Bird is one of Miró's recurrent themes, here addressed in three-dimensions. The bird is set on top of the hat worn by the woman. However, there is another aspect that is always present in the work of Miró but can often pass unnoticed. The shape is unmistakably phallic, and on it a long black incision can be seen. This symbol, divided in two, had been used by him for a long time to represent the female sex; when the black half and the red half appear with a few threads added at the sides, it indicates a yearning sexual organ. The dual allusion in *Woman and Bird* was intended as a profound homage to sexual love. Miró confessed to me what a fascination sex had always held for him, but not from a pornographic or even erotic point of view. He considered it instead from that magic angle that encompasses the power of love and of reproduction, which involves identifying completely with another person and which possesses the immense capacity for creating another being.

Beside *Woman and Bird,* on the sheet of water, is a strange grating on which the traditional bonfire is lit on the eve of the feast of St. John the Baptist (June 24th). This custom has its roots in a pagan festival to mark the summer solstice, and has a long tradition in Barcelona. The bonfires, built at street junctions by the youths of the district, would reduce to ashes all the old furniture and useless bits and pieces that had no other destiny but the junk dealer's yard. Miró greatly enjoyed such rites, and I am sure that he must watch from afar, and not without a certain emotion, how the people of the city of his birth punctually each year perform the liturgy that evokes this memory.

Woman and Bird by Joan Miró stands imposingly in the Plaça de l'Excorxador.

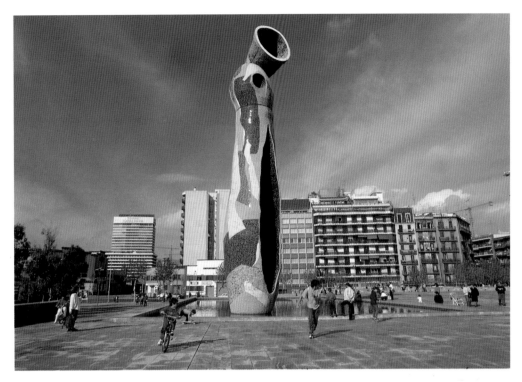

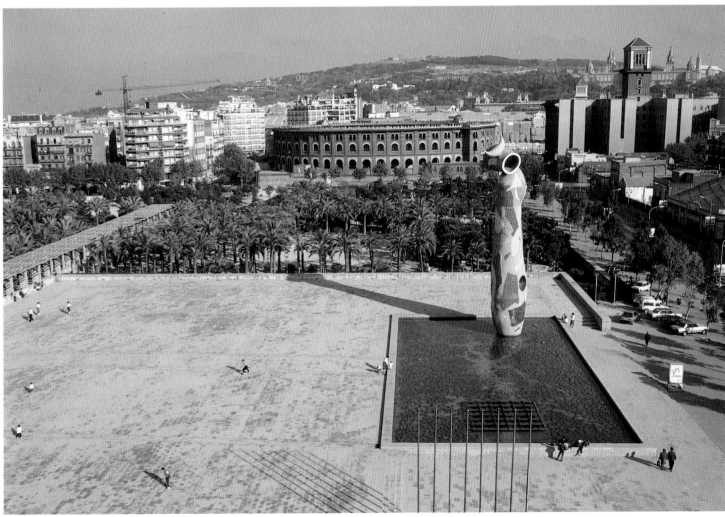

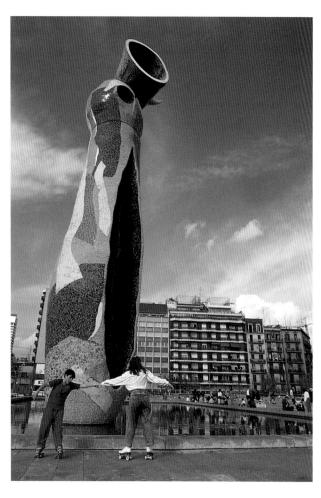

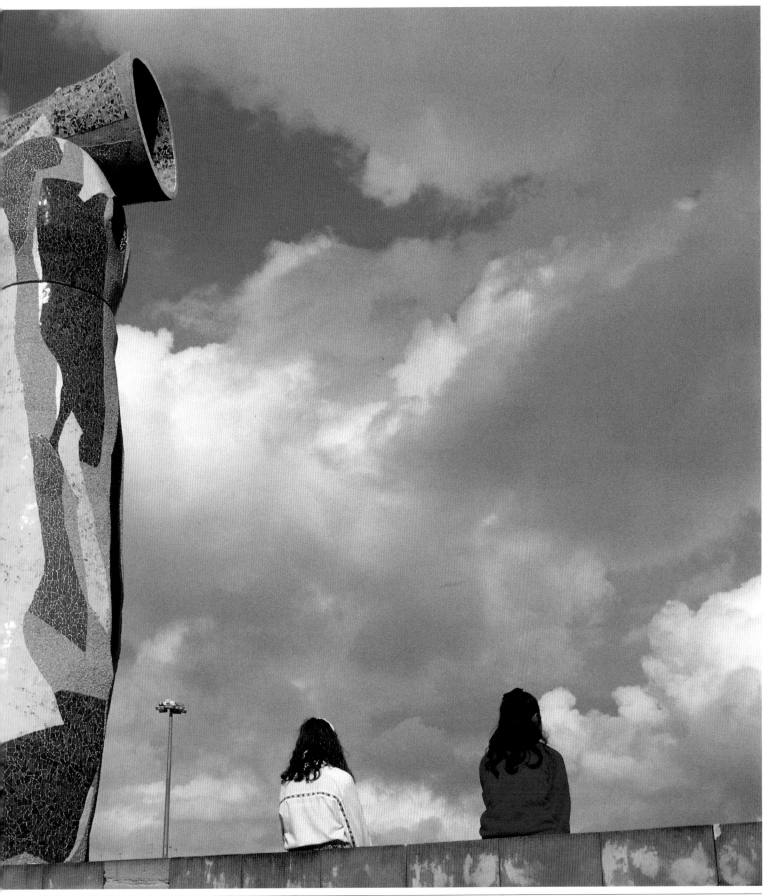

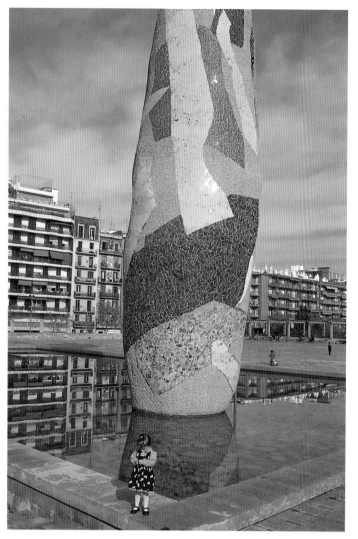

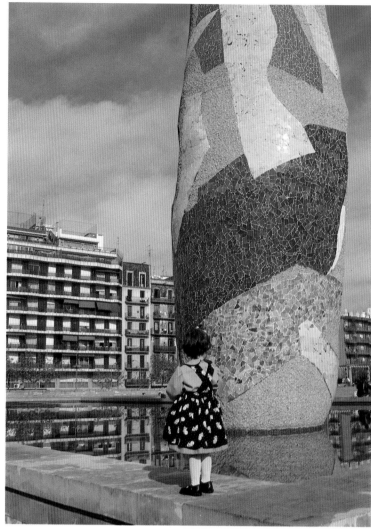

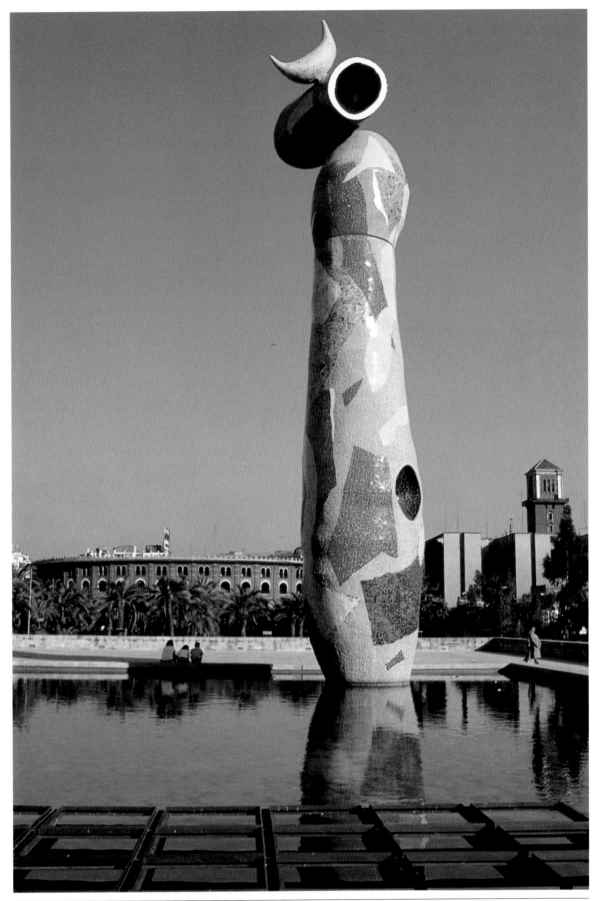

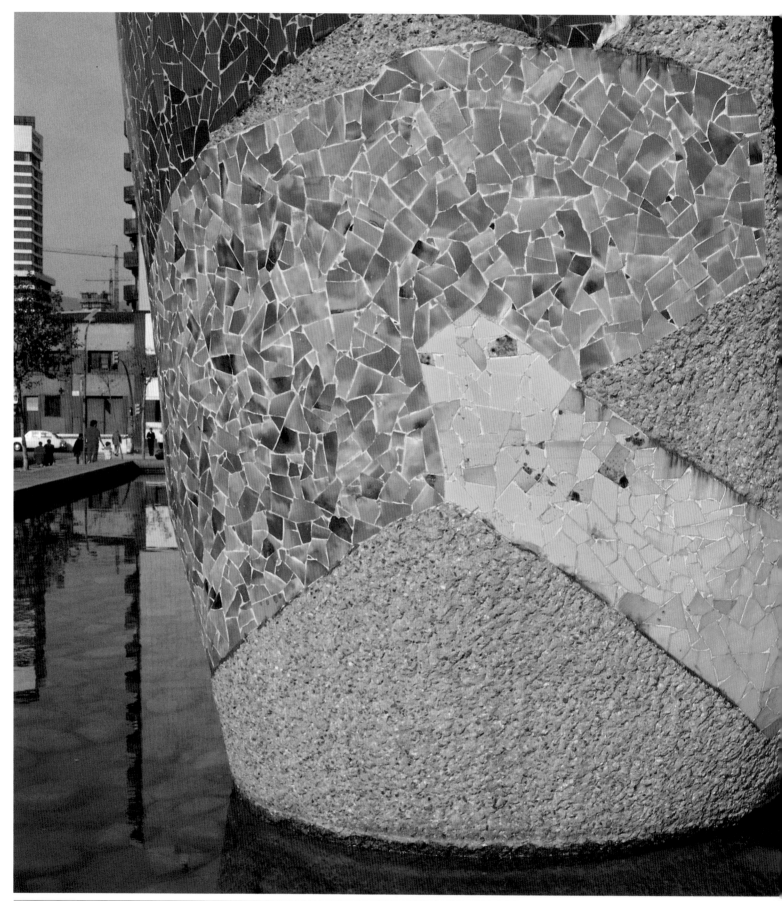

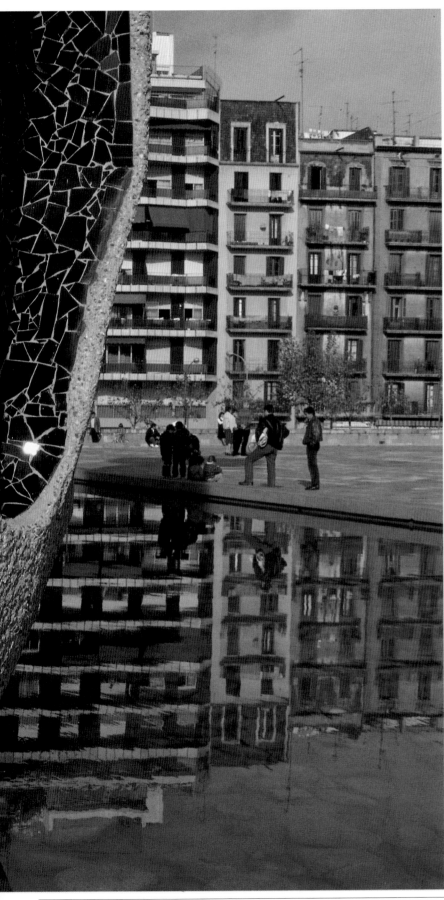

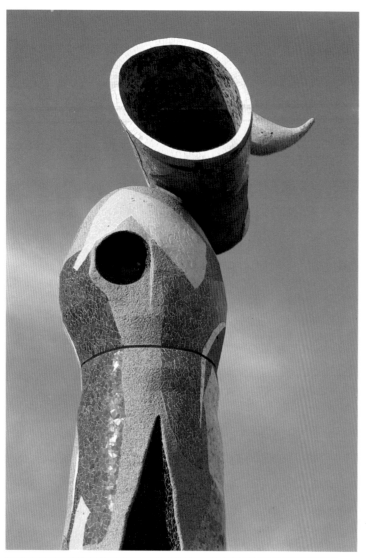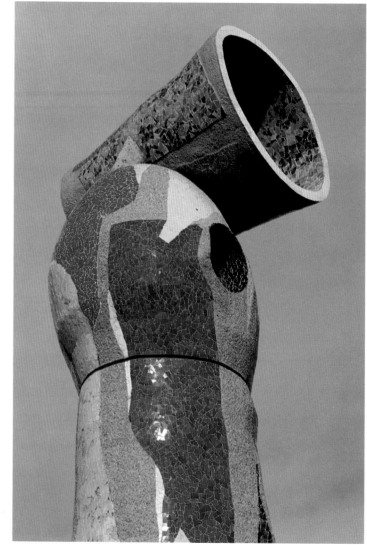

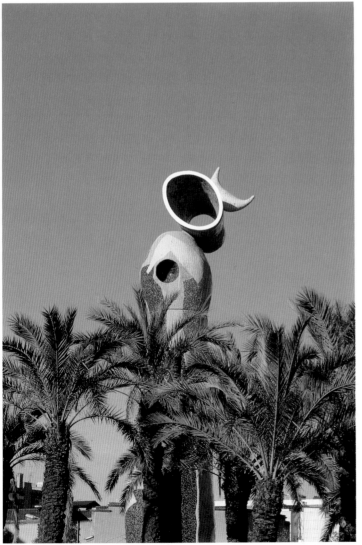

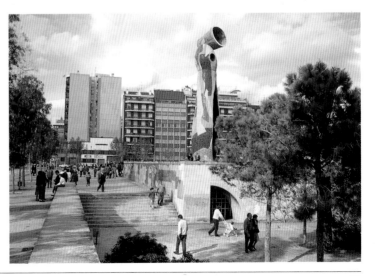

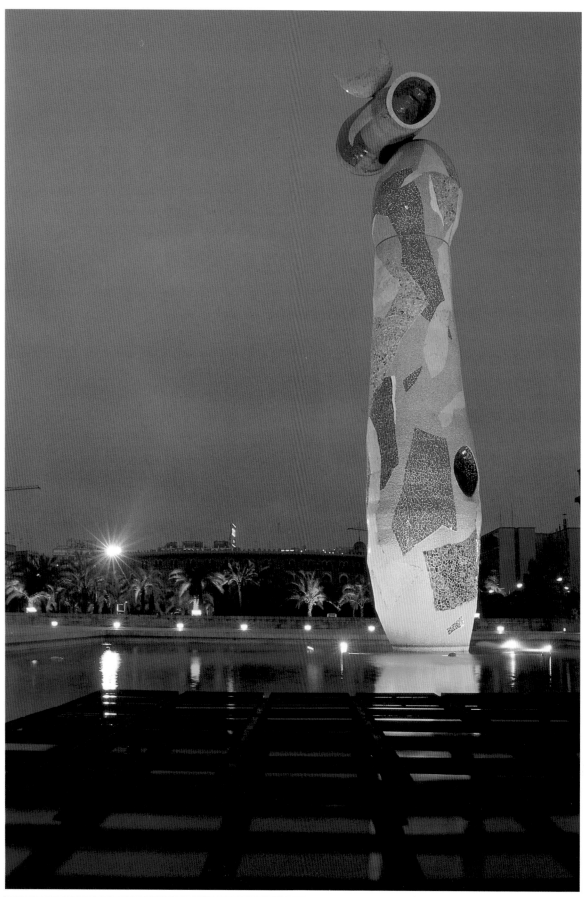

Spectacular celebrations
take place every year
to mark the feast of
St. John the Baptist:
a typical bonfire in the
middle of the pool at the
foot of the sculpture.

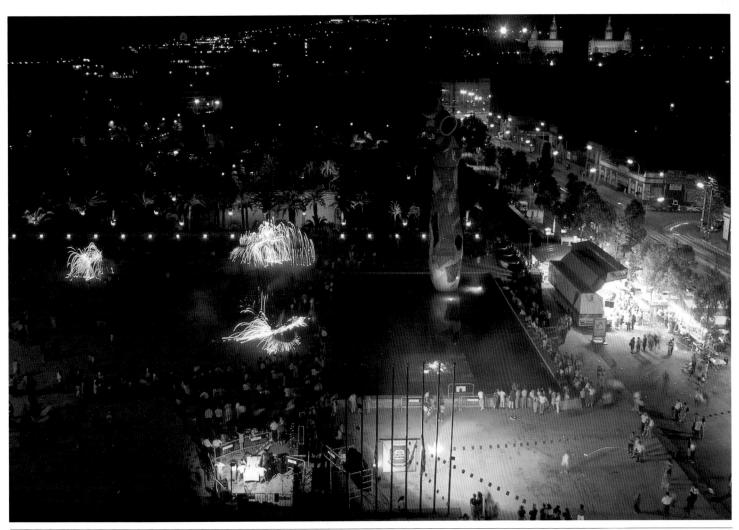

A HUGE MIRÓ FOR THE PARC DE L'ESCORXADOR

The baths of St. George's dragon in the Parc de l'Espanya Industrial

Architects:
Luis Peña Ganchegui
Francesc Rius

Sculptors:
Manuel Fuxà
Andrés Nagel
Anthony Caro
Antoni Alsina
Josep Pérez ("Peresejo")
Enric Casanovas
Pablo Palazuelo

L'Espanya Industrial was very much an institution in Sants, one of the surrounding villages annexed to Barcelona at the end of the nineteenth century. The first day of January 1849 marked the construction of this *Vapor,* the name then given to the new textile mills that had started using that revolutionary form of power, steam. In its time L'Espanya Industrial was considered a real "palace of industry." What had been the first limited liability company in the cotton industry in Spain, and one of the most prosperous of businesses employing over two thousand workers, closed down in 1969 as a result of the economic crisis.

Needless to say, one of the firm's principal assets was the land on which it stood, and it began to be divided into plots and sold off. The Parc de l'Espanya Industrial is the result of the fight by the people of Sants to obtain a large open space in a district of Barcelona that has always had a high density coupled with a lack of public spaces. The fight was not an easy one, but it finally bore fruit and the property developers were halted. And one of the initial development projects undertaken by the first democratically-elected City Council was to design and construct this square. This is why is bears the name of L'Espanya Industrial.

It covers an area of some 50,000 square meters — that is to say, similar to the size of the Plaça de Catalunya. From among the various proposals submitted, the residents chose the design by Ganchegui and Rius. The locals played a decisive part in the project, for the municipal planning department tells me that unlike most residents' associations they knew very well what they wanted.

The Basque architect Luis Peña Ganchegui has designed some outstanding public works, mainly in the Basque Country, which include the Plaza de la Trinidad and Plaza del Tenis in San Sebastián, the Plaza de los Fueros in Vitoria, and a monument in Oyarzun. All these clearly show a complete mastery of the play of planes to produce the most varied areas without the viewer being aware of it. I was always fascinated by the way in which he used simple combinations of horizontal lines, steps, tiers or terraces to achieve the gradation and integration of all the different parts of the work, whether constructional elements, vegetation, or even the sea itself.

Peña Ganchegui proposed a decidedly recreational function for this park, with its advantageous central location. And he explained this in the expressive title of the modern "Baths of St. George's Dragon" — St. George being the patron saint of Catalonia — thus justifying the installation of the largest artificial pool in Spain and the sculptures by Nagel and Fuxà.

The park is a combination of several well-defined areas.

Although it can be entered from any of its several sides, and despite the fact that the most spectacular entrance is from the adjacent Sants railway station, I prefer to follow a more didactic route. About half way along Carrer Muntadas is the main gate. Good sense prevailed in maintaining the district's marks of identity, and the wall and gate of the former plant have been preserved all along this street. Having crossed the threshold of the main gateway, which would now seem to act as a people's triumphal arch, we come to a tower standing on its own, the Casa del Mig, a further witness to the splendor of other times. This building, which currently houses local municipal services, and the adjacent Escola Bresol, now a kindergarten, were painted in rosy pastel shades of a markedly Post-Modern flavor.

This whole area contains 167 century-old plane trees, their interwoven branches providing a gratefully cool shade and a particularly pleasant ambience. This natural "salon" is the point of origin of another space — the lawn — that acts as a link with the pools.

It is in this stretch of our itinerary that we come across the first sculptures: *Landa V* by the Spanish painter Pablo Palazuelo, a protégé of the Galerie Maeght in Paris since the late forties. His abstract, rationalist, minimalist, schematic work, of a highly sober nature, had recently tended towards a breaking down into planes when Paco Farreras, the director of the Galeria Maeght in Barcelona, suggested he try sculpture, which he exhibited in the gallery's medieval rooms in the Carrer Montcada. This piece in steel belongs to that period.

Alto Rhapsody is a sculpture typical of the style imposed by the British artist Anthony Caro, who has created unexpectedly evocative and original forms from bits and pieces found on his implacable and imaginative rakings through junk yards. From the assembly and addition of items chosen for what they suggest to him, he produces sculptures of immense plastic force with a formal beauty that has no relation to the surroundings. At the end of his large retrospective exhibition in the early eighties at the Joan Miró Foundation, the City Council decided that this work should not leave Barcelona.

Antoni Alsina was a sculptor who began to make a name for himself at the turn of the century. This grandiloquent *Bulls of Abundance*, which reflects his characteristic personality, was rescued from a municipal warehouse. I suspect he produced it for the competition for a sculpture for the Plaça de Catalunya in the mid-twenties.

The nude *Venus* by Josep Pérez ("Peresejo") and *Body of a Woman* by Enric Casanovas fit well into the surroundings of the baths.

The large pool with its side canal is a key piece in these baths. Its recreational nature invites not only activity but also the hedonistic contemplation of the games and pleasures provided by the water and the baths. Hence the role assigned to an impressive terrace, distinguished by the force of a magnetic white color and the accentuated pattern of horizontal and parallel lines. The cascades at each end serve to give life to the water.

One of the obvious problems of the place was the façade of the working class houses on the left of the entrance above the canal; here, however, they have an ambiental mission that could not be overlooked, for they were a link with the very origins of L'Espanya Industrial. The architect made use of the transition offered by the wall, and for this reason removed the cement facing to enable the brick and stone to establish a better dialogue with the brick of the workmen's dwellings.

The biggest problem was the extremely unaesthetic view of the very ordinary skyscraper blocks along the back of the park on a level with the railway station. It was impossible to blot out such a backdrop. And so a series of features had to be erected that would focus the eye on the foreground or middle ground, creating an optical illusion, albeit a penetrable one. Such is the role played so aptly by the terraces, the sculpture by Nagel and particularly the row of towers that act as raised lights, as well as observatories if need be. The towers are in a style deeply rooted in Post-Modernism, reinforced with touches of color.

In the terraces leading down to the water, prettily furrowed by rowing boats filled with young people enjoying themselves, rows of slim cypresses have been planted, whose vertical lines perfectly match those of the solid towers.

In the middle of the pool rises the image of *Neptune* sculpted by Manuel Fuxà, another work retrieved from the muncipal warehouse. The god of the sea also reigns, trident in hand, over the still waters of these baths.

Andrés Nagel, the young fellow-countryman of Peña Ganchegui, is the author of the huge sculpture that gives its name to this scene. *St. George's Dragon* weighs some 150 tons and is 32 meters long and 12 meters high. It was made from enormous corten steel plates soldered togéther *in situ*. The mythical animal *par excellence,* protagonist of so many tales from the East, whence he came to reign in the fables of the West, is represented with its wings open, while its enormously long tail descends languidly to the stone platform several meters below. A delightful game is provided for the young, who scramble up the stairs inside the wings and toboggan down the run that winds through the tail, coated in plastic to smooth the steep descent.

The sculptural towers
designed by the architect
Luis Peña Ganchegui.

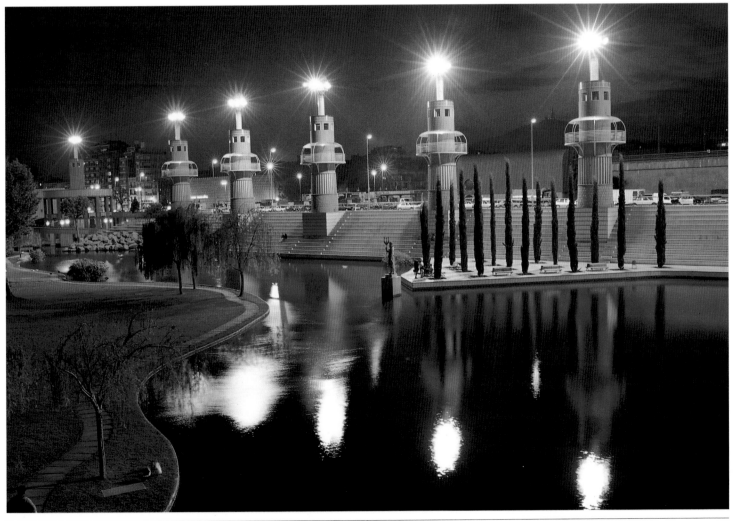

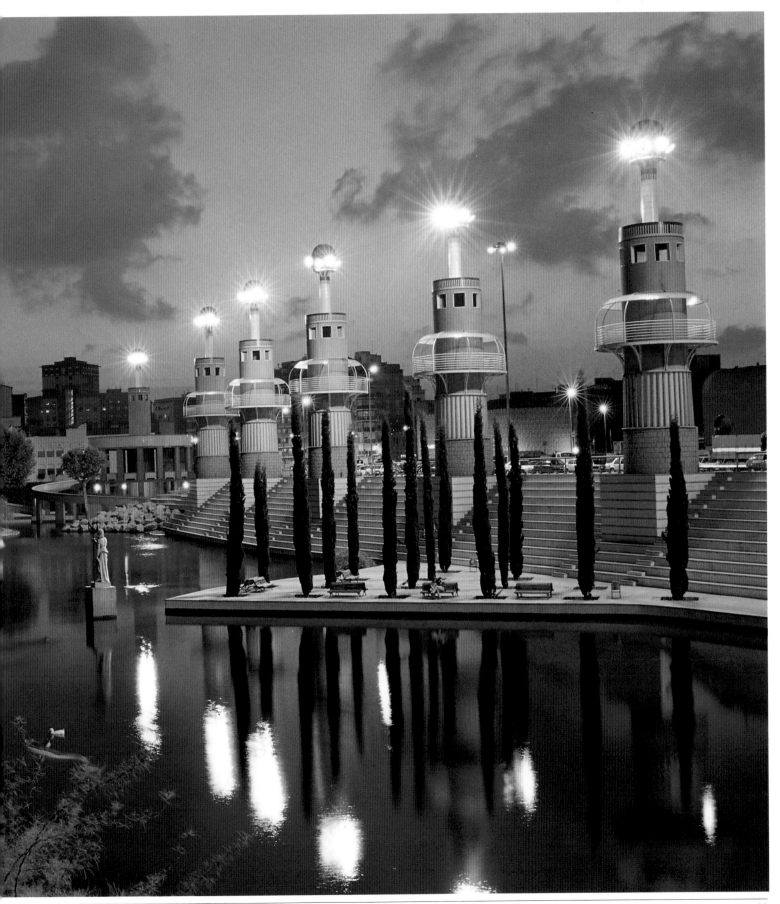

THE BATHS OF ST. GEORGE'S DRAGON IN THE PARC DE L'ESPANYA INDUSTRIAL

Manuel Fuxà's *Neptune* surveys the still waters of the largest artificial lake in Barcelona.

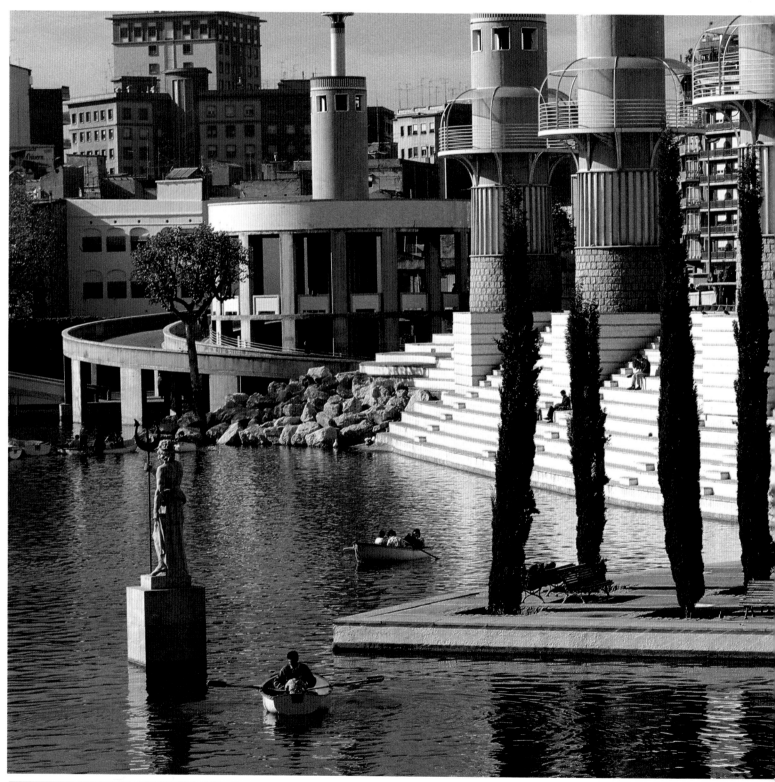

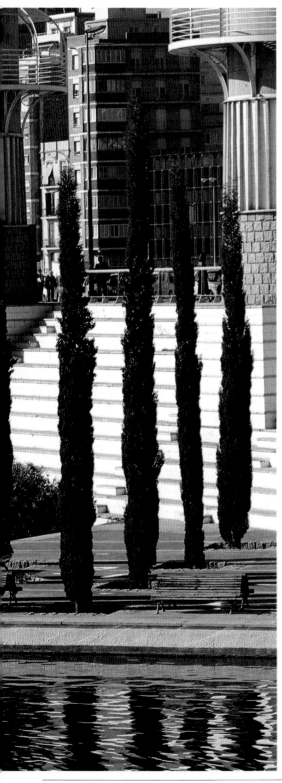

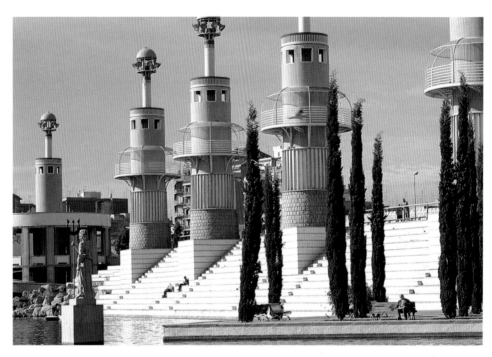

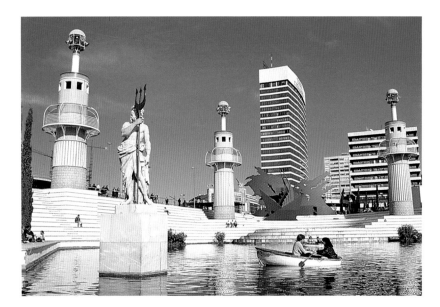

St. George's Dragon by the Basque sculptor Andrés Nagel is certainly the most spectacular and amusing piece in this attractive park.

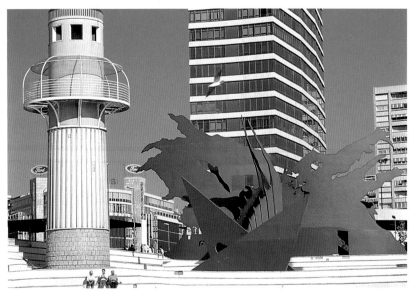

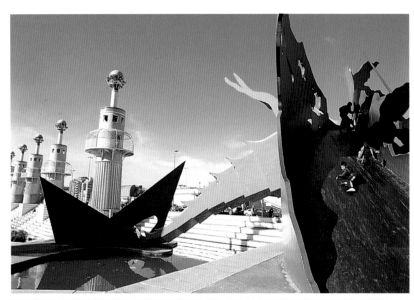

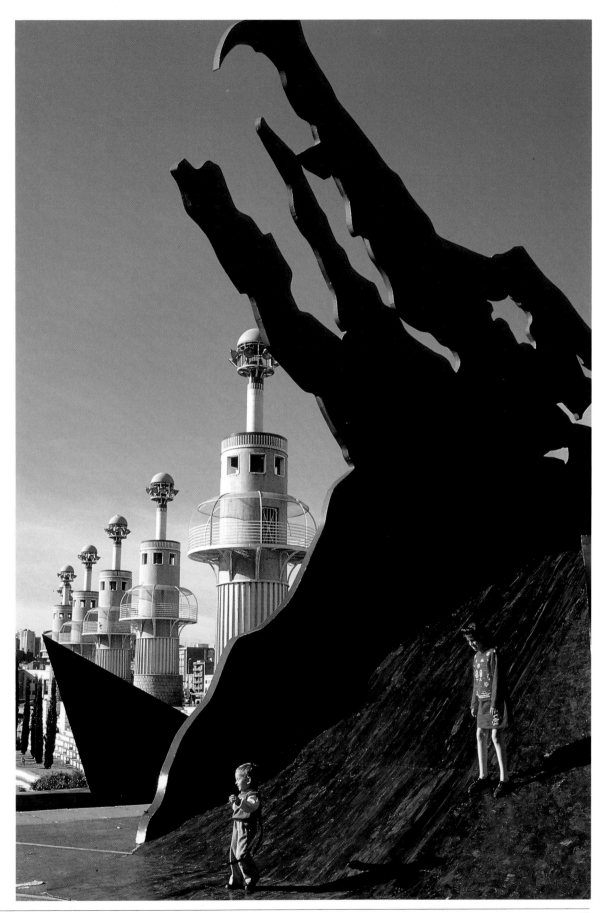

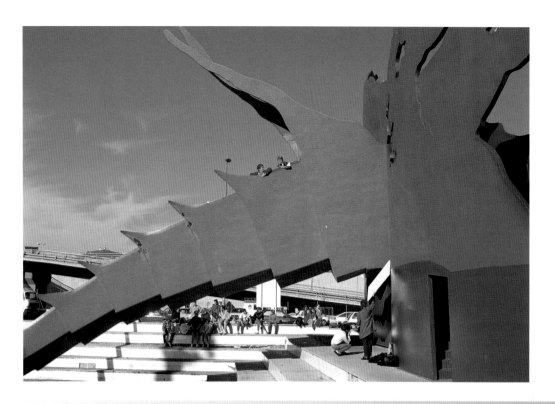

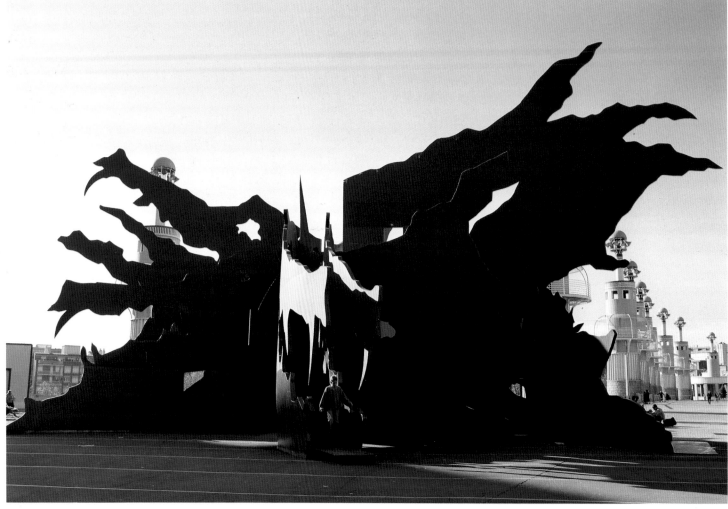

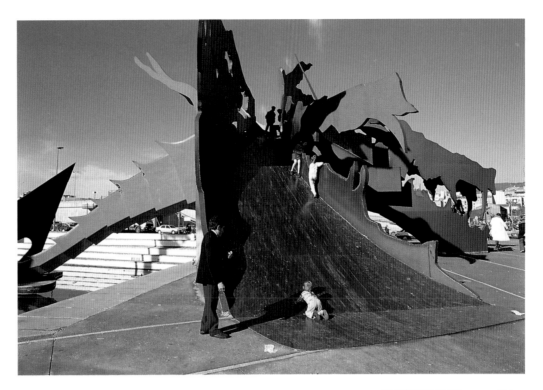

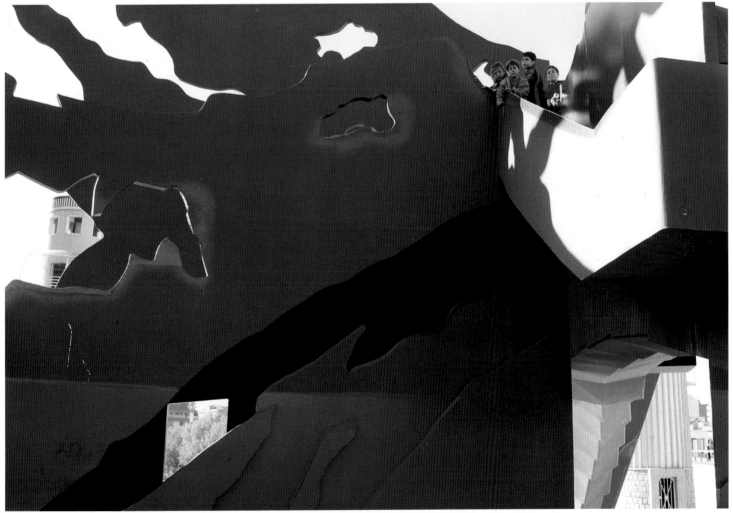

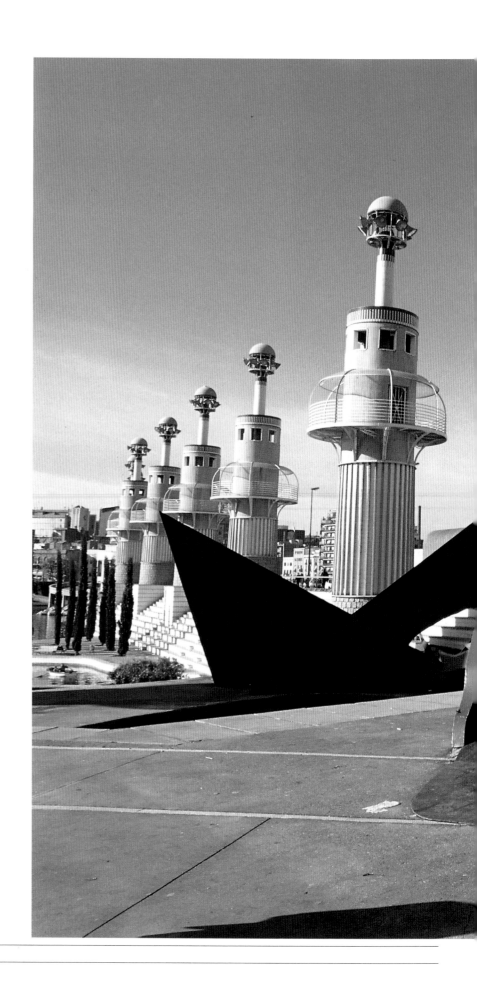

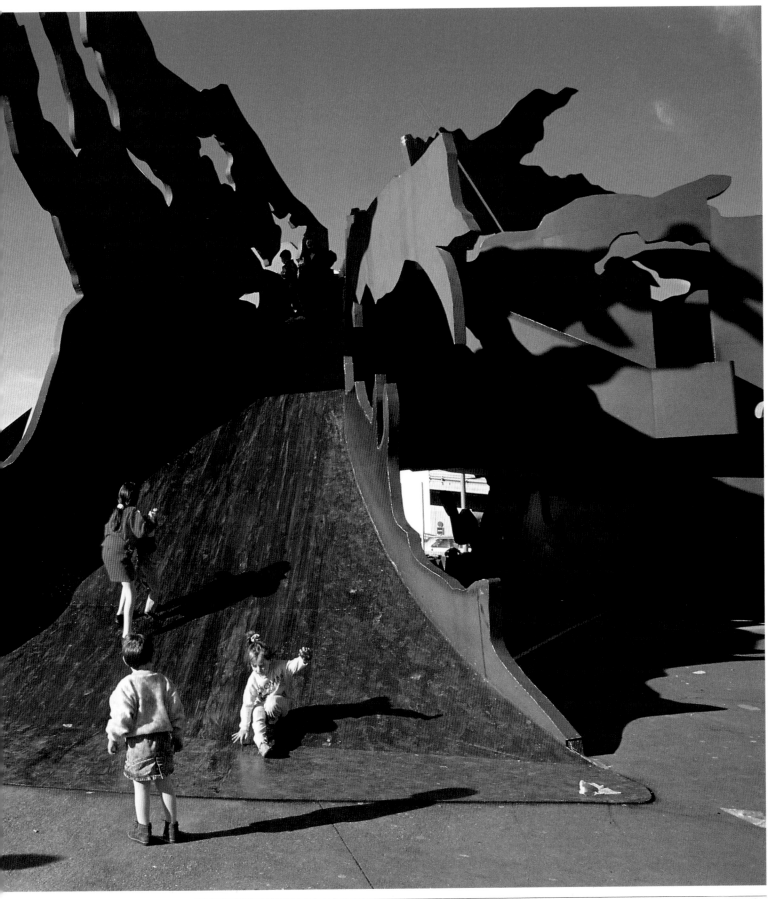

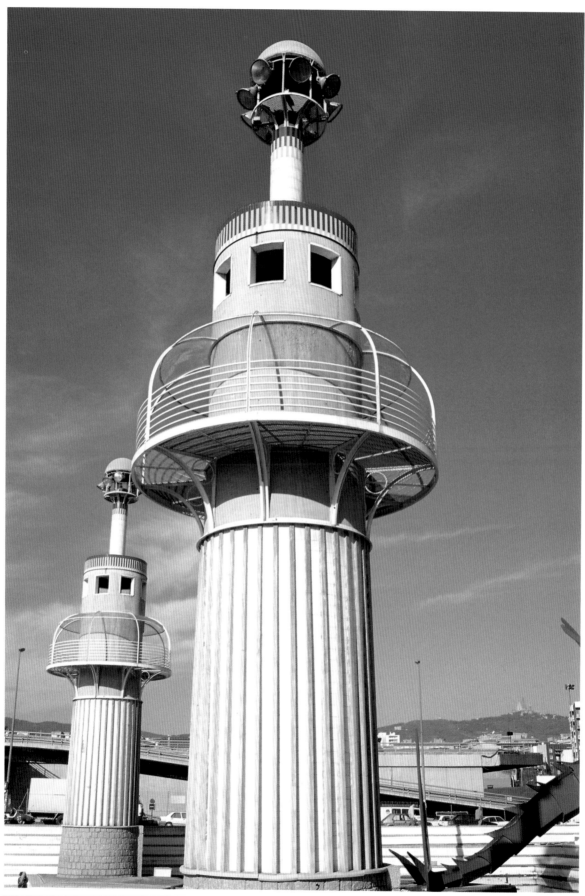

Alto Rhapsody, a
sculpture in the
characteristic style of the
distinguished British
artist Anthony Caro.

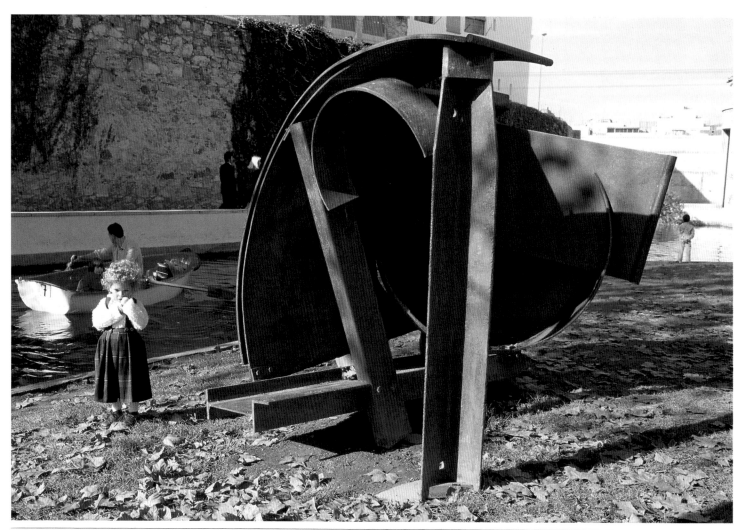

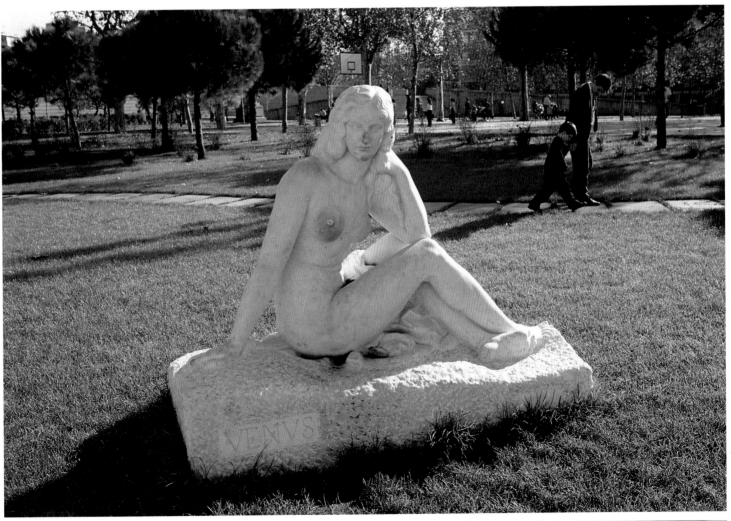

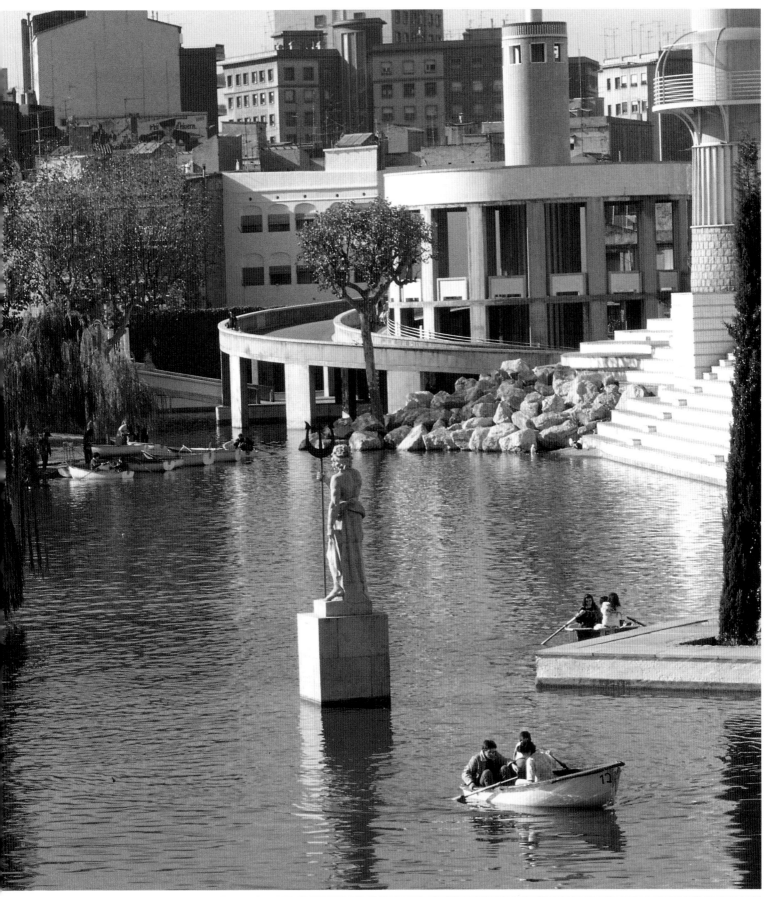

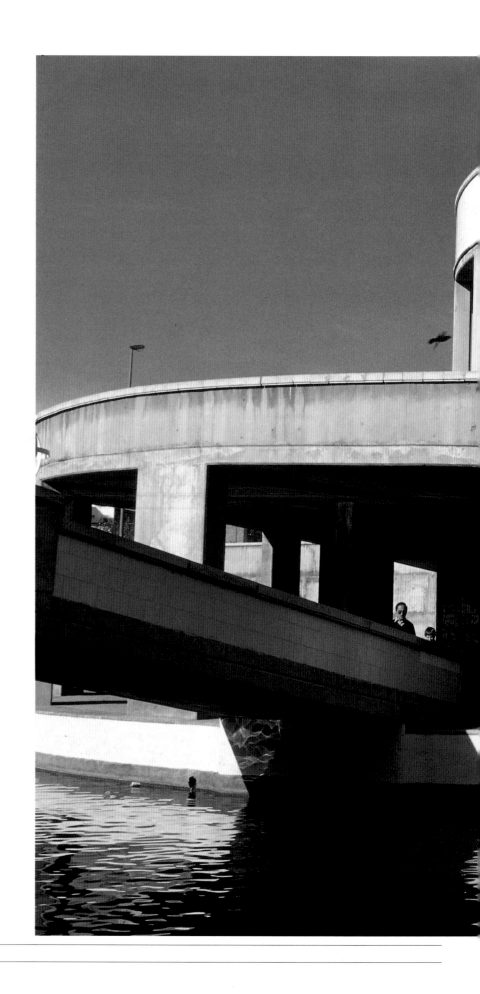

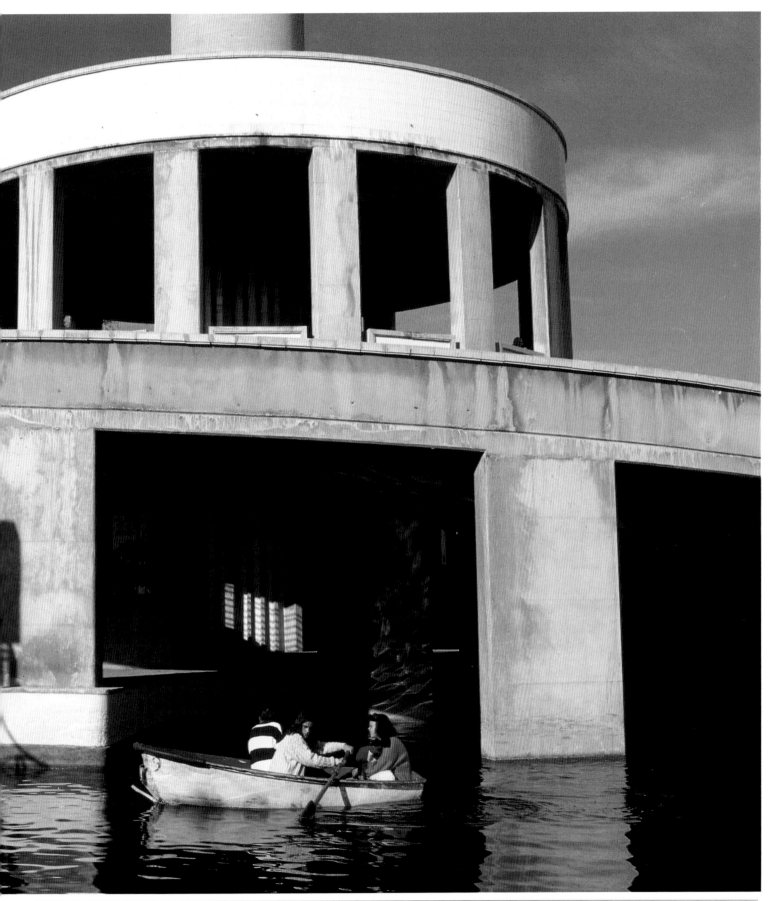

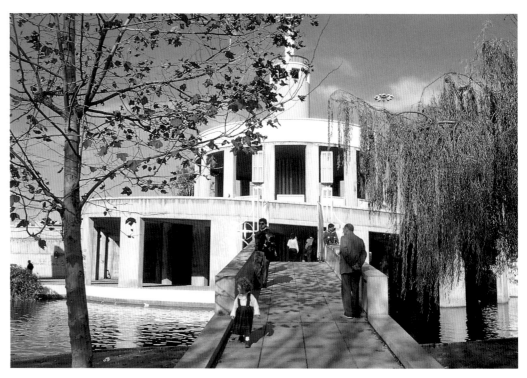

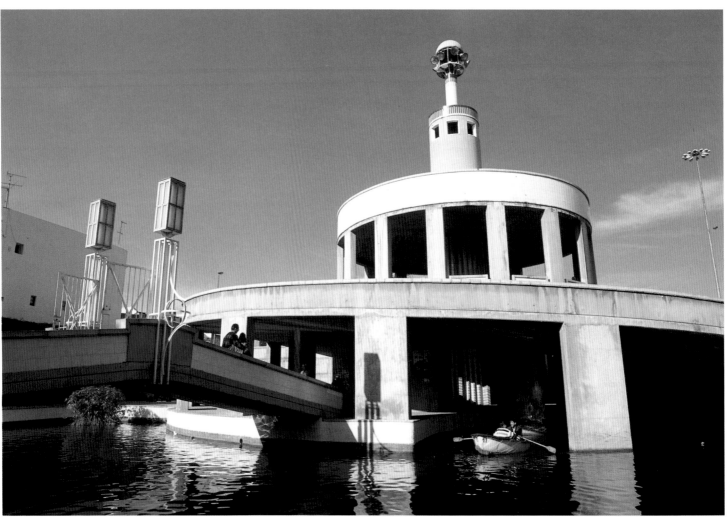

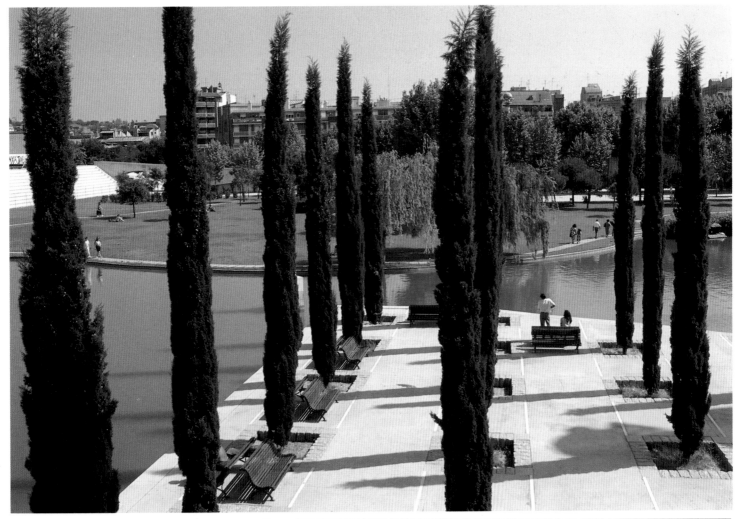

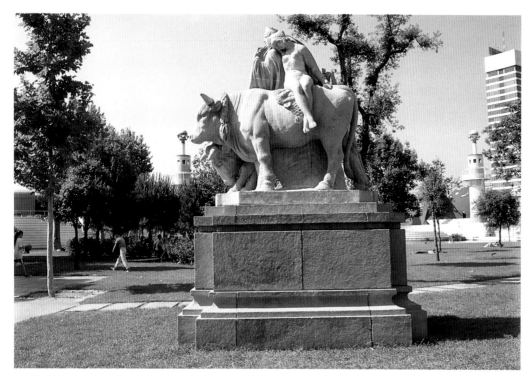

Bulls of Abundance by Antoni Alsino recalls the grandeur of another age.

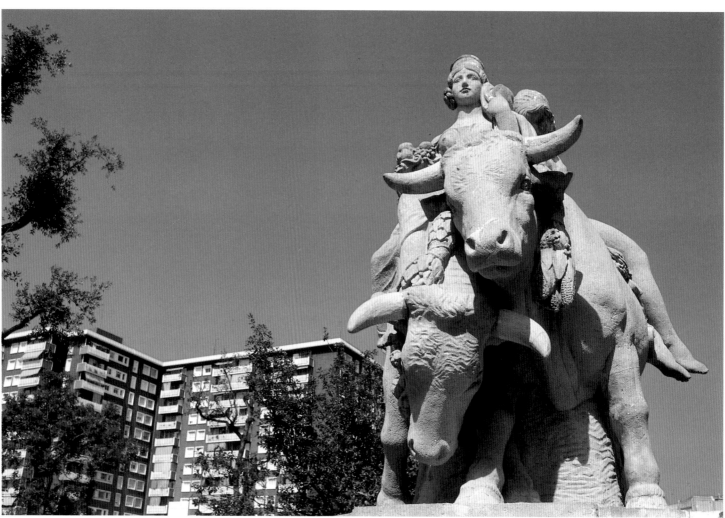

Landa V, an austere work by the renowned Spanish painter Pablo Palazuelo.

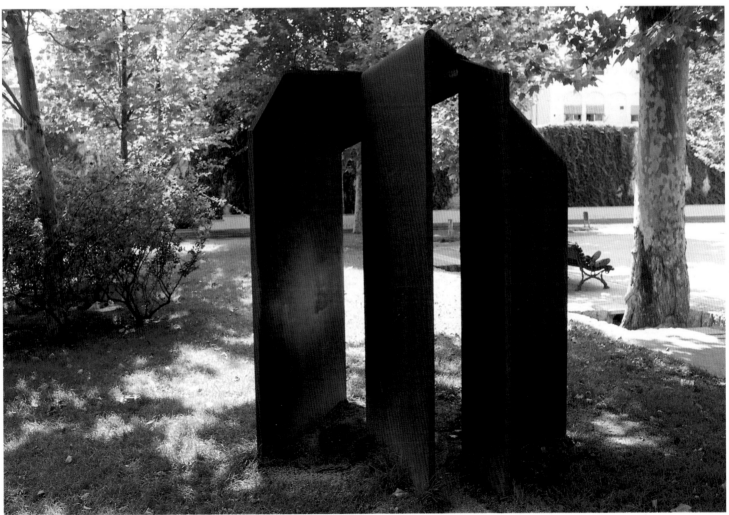

A Bryan Hunt in the Parc del Clot

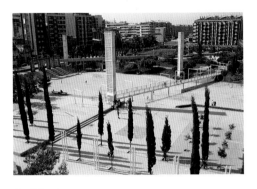

Architects:
Dani Freixes
Vicente Miranda

Sculptor:
Bryan Hunt

Thanks to the work of the architects Dani Freixes and Vicente Mirando, the Parc del Clot has converted what were the vast railway workshops into three hectares of open space for the enjoyment of the public. In this industrial district of Sant Martí it was important to provide such a lung, for although it did not suffer from the traditional high density of the Eixample, it was evident that industry always took first place; the working-class dwellings were of a very poor standard and civic amenities were non-existent. The day of the opening of the park was one of celebrations, particularly since the residents already considered it as belonging to them, a conquest that was theirs by right. I remember an old lady with a whistle in an apartment on one of the top floors of a block on the very edge of the park; she was keeping watch lest hooligans should destroy such a prize, and at the slightest sign of danger she would whistle loudly to call the police.

Unfortunately, violence prevailed over civic duty, and within a few weeks someone had set fire to one of the children's amusements: a small-scale Cerdà grid for youngsters to use as a maze, made of dry brushwood which the flames consumed voraciously. It was the first warning. Shortly afterwards, the large covered area known as the Nova Nau, which could be used for all kinds of activities, was also set on fire. The damage was assessed at over twenty million pesetas.

Luckily, things stopped there, despite the fact that the district is a rough one, roamed by bands of youths hooked on drugs and bent on destruction.

The architects organized their project in two zones clearly defined according to use: the recreational zone, with its large asphalt rinks for *frontón,* roller-skating, cycling, hockey on skates, etc., and the leisure zone dominated by nature, architecture and landscape. The large rink was sunk in order to protect it from the wind and so that the terraces would not spoil the view of the park and would cushion any noise. The earth removed was used to produce an artificial mound, thus creating an interesting landscape with a vista.

But there were other things that conditioned the project, such as user requirements. The most obvious was the fact that people needed to walk across this very new space from one corner to another in order to go from the District Council offices — the old town hall in Sant Martí, a small village annexed to Barcelona at the end of the last century — to the covered market in the Plaça de Valentí Almirall. The local residents had a meeting with the architects and explained this practical aspect, which was immediately taken into account. It is pertinent to recall the normal practice in Britain: when a park is opened, no paths are marked out, and it is left to the comings and goings of habitual users to establish the routes by dint of regular use. It is a sensible practice, for it is a well-known fact that however well marked the direction to be followed may be, people will go whichever way they like in order to cut corners, take short-cuts, or for whatever other reason.

A raised walkway was thus required to link the two points mentioned; nevertheless, while they were about it the architects marked out another line between two other points that needed to be connected: the chimney and La Farinera. They took advantage of this to highlight the vistas with a string of angular arches; once erected, they can be seen to mark most attractively the ideal lines of scientific perspective.

The garden covers an area of 21,500 square meters and contains three well-defined sections: the trees, the garden proper and the visual and acoustic note of the water.

The architectural or constructed area measures 8,200 square meters. Four hundred trees and a generous lawn were planted in addition to flowers and shrubs.

The two features that give this park its distinctive personality are precisely those that have been obtained by preserving the old walls of the workshop, for the architects had the necessary sensibility to perceive their immense aesthetic possibilities. One reason that led them to consider conservation was to maintain a link with the past. And since these had been industrial buildings made of brick with a cement cladding, forming the characteristic urban landscape of Sant Martí de Provençals, the idea of having a wall or two complete with arches reinforced the identity of the park. But the architects were also clever enough to visualize the plastic force of these features, and I have no hesitation in describing this as an exemplary use of industrial archaeology. The brick, in this respect, is a felicitous element. And so too is the slender shape of the large chimney

which, now restored, contributes an interesting example of form.

The combination of the most modern materials with these relics of yesteryear is highly attractive and above all original.

One very successful feature is the stretch of old wall running along the Carrer Escultors Claperós, which as a result of the water falling in a sheet in front of the row of arches, and thanks to its appearance as a consolidated ruin, manages to suggest a ancient aquaduct.

For me the best feature of the park is the little pavilion. It is a·square space, with rounded arches on cast-iron columns. The play of brick and stone, of curved wood and square columns, the relationship between construction and empty space, between the industrial relics and the avant-garde forms, between water and solids, white marble and dark bronze, red brick and vanilla stone, fine materials and the most humble ones — all this produces extremely gratifying sensations. And if that were not enough, overall it possesses a unity that creates an intimate atmosphere contrasting with the open space of the rest of the park.

The pavilion called for Hunt's sculpture to be installled inside it. It even appeared

to have been created specially to house the work.

Bryan Hunt is a young American painter and sculptor of renown — born in 1947 in Terre Haute, Indiana — who has cultivated Land Art, Conceptual Art and Minimalism. He has had large exhibitions at the Joan Miró Foundation in Barcelona, and in Europe and the United States. The work he was commissioned to produce by the City Council is halfway between realism and abstraction. One part of the sculpture, which he modeled with his own hands — what he most likes doing is "pressing the plaster with my fingers so as to leave marks on the surface; I want to feel that I have touched it," he confesses — recalls a waterfall. He has achieved what Leonardo sought for so long: to immobilize the momentary, constantly changing, almost invisible, plastic forms of water. The counterpoint is landscape, which he has attempted to suggest by means of an abstract work. He employed bronzes in three colors with the aim of relating them to each other, as he also related the realist and abstract parts. The result is that the atmosphere he has created in the pavilion transforms the whole place in a truly magical way.

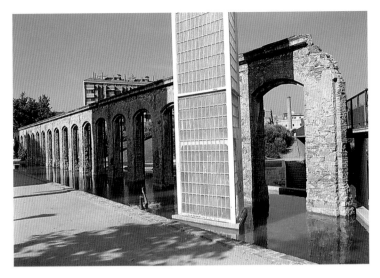

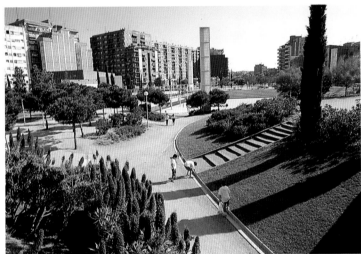

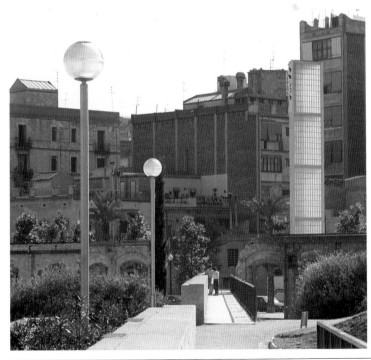

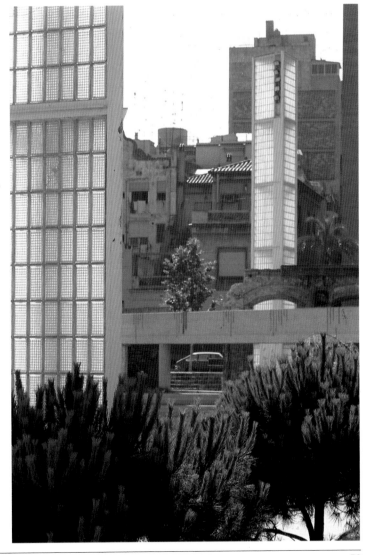

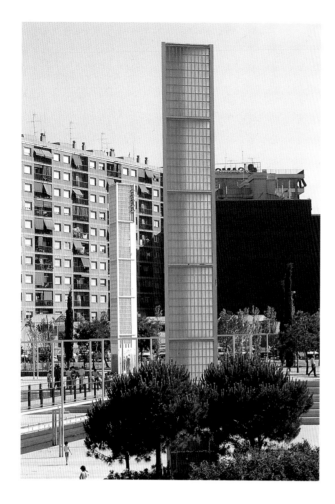

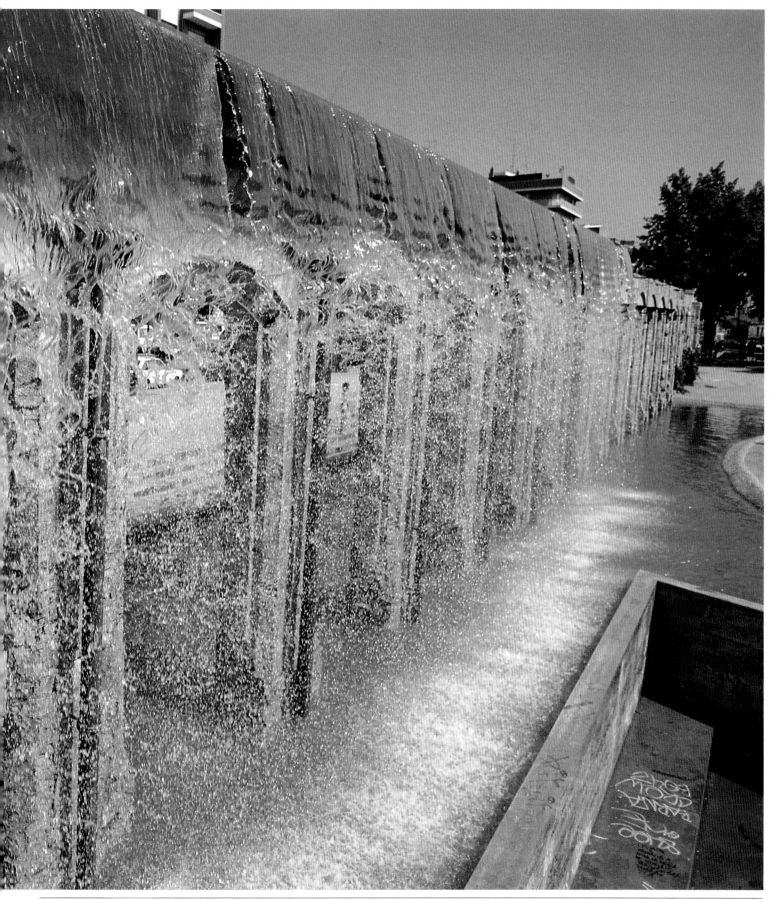

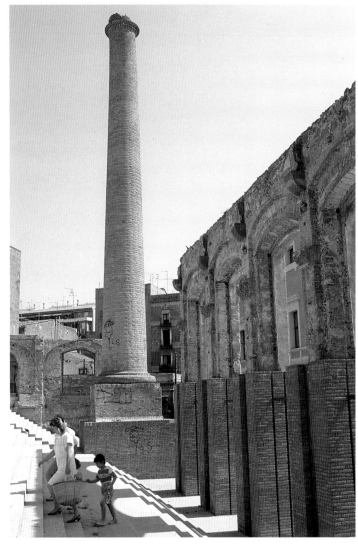

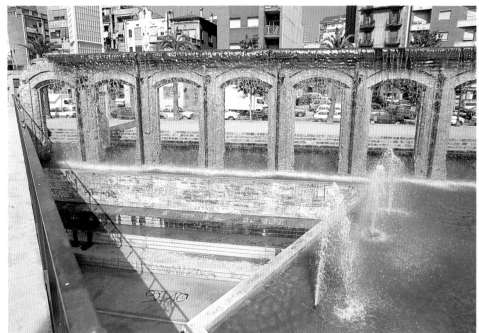

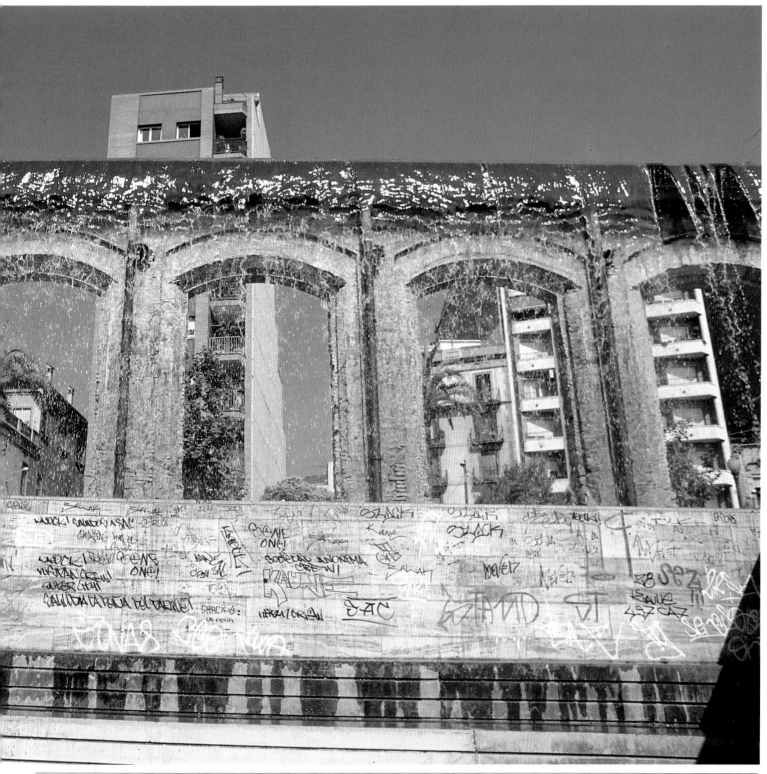

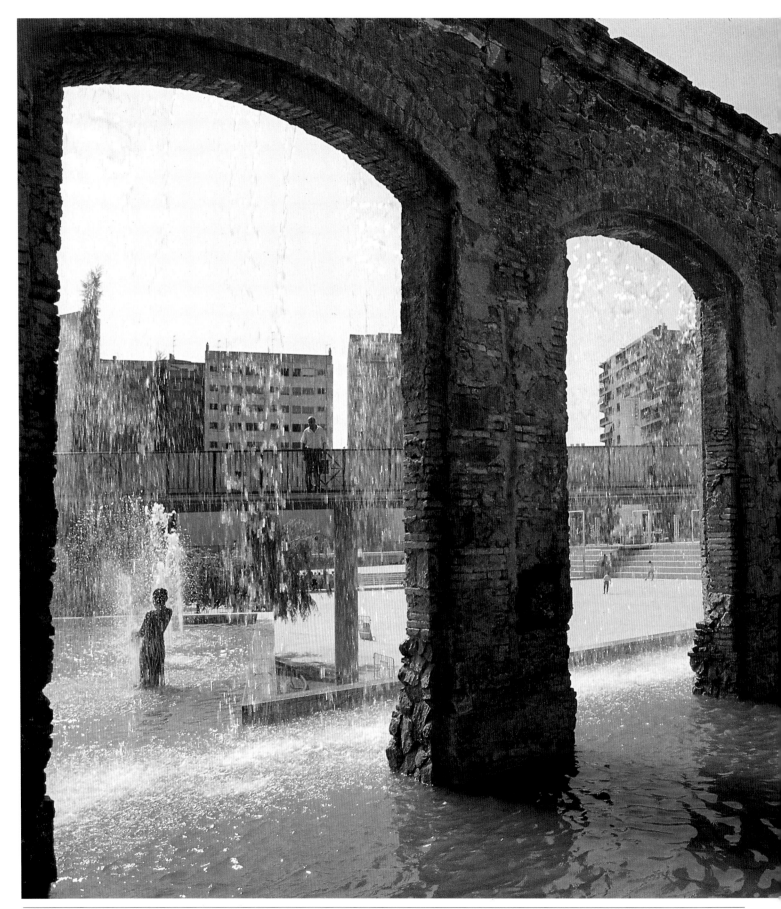

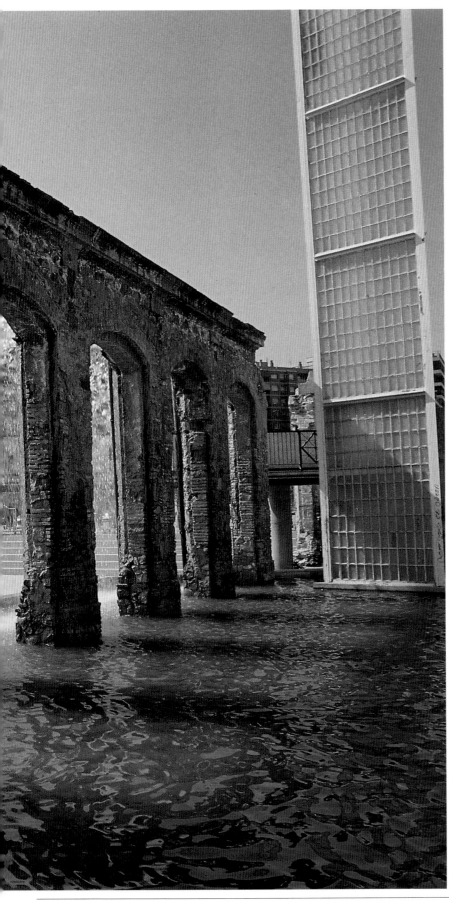

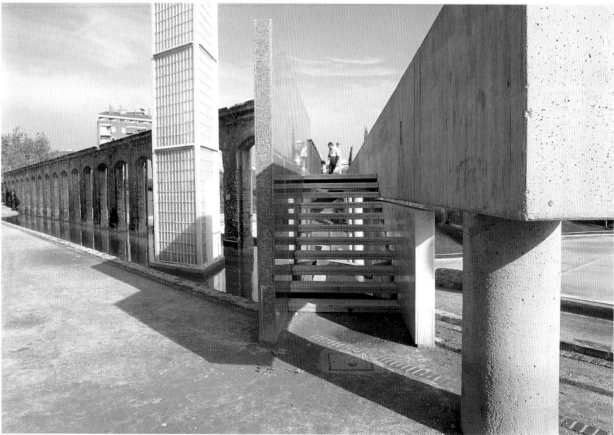

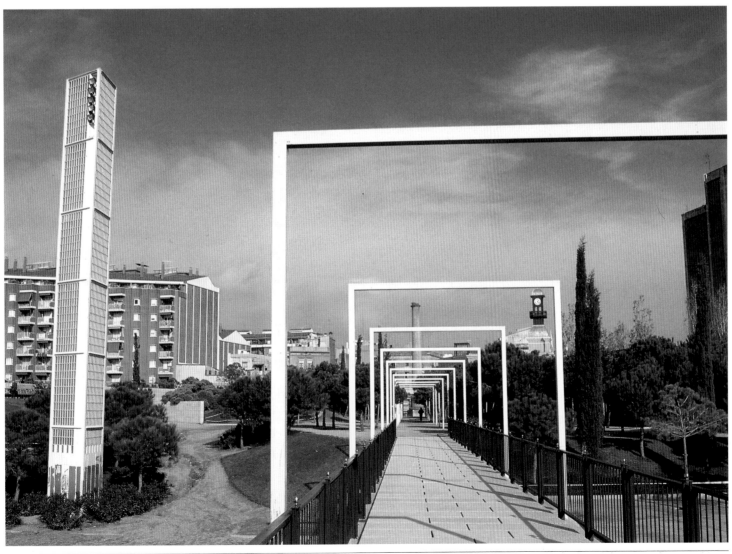

The American sculptor
and painter Bryan Hunt
has created this personal
interpretation of a
waterfall.

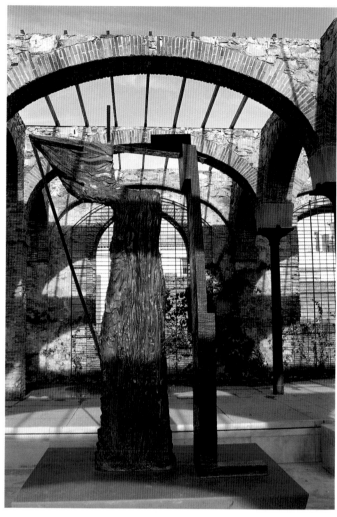

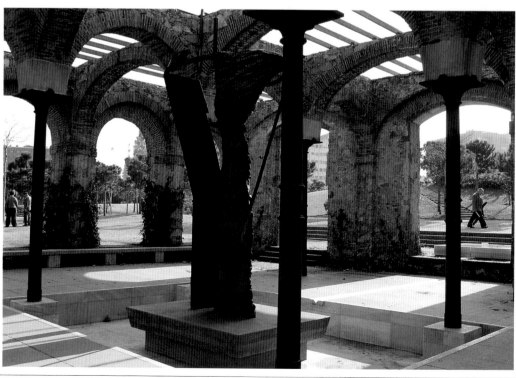

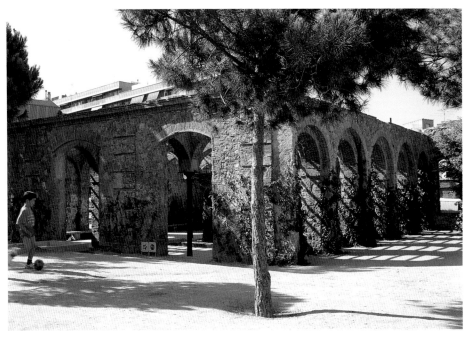

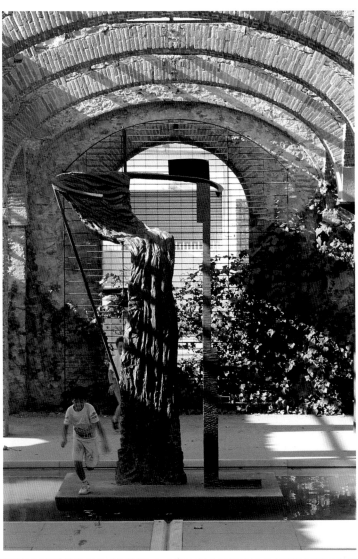

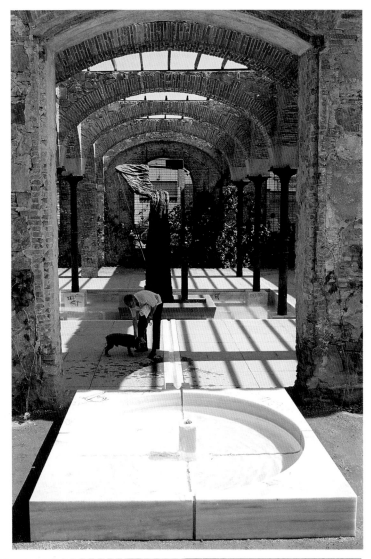

Brossa's visual poem in the Velòdrom

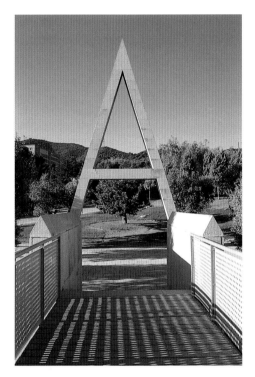

Architects:
Esteve Bonell
Francesc Rius

Sculptor:
Joan Brossa

One thing is to go to the Velòdrom, but quite another thing altogether is to enjoy the visual poem inscribed there by Joan Brossa. This was the first work in which his poetry was able to leave the confines of a mere sheet of paper, or even an object, and attain the status of a large sculpture. Justice was thus done to this great poet, who has paid dearly for his radically avant-garde approach.

When Esteve Bonell and Francesc Rius — the architects who designed a cycling stadium that is considered the best in the world — erected this attractive building, they correctly perceived that the land-scaped garden along one side deserved to be distinguished with a sculpture that would enhance the surroundings. Esteve Bonell, an admirer of Brossa, thought this was a good place for him to materialise one of his visual poems.

Since the poet conceived the work as an initiation route — *Transitable Visual Poem in Three Parts: Birth, Journey — with Pauses and Intonations — and Destruction* is the descriptive title bestowed on it by the author — it was particularly important in this case for it to be situated in the best place for people to view it and then continue along the established route.

The starting point is at the foot of the steep steps leading up to the attractive metal bridge. As we climb the steps one by one there emerges in front of us, in all its grandeur and solemnity and with the precise degree of lentitude that each of us imposes, the vertex of the first letter of the alphabet. Despite the fact that it is shorten-ed by distance, its height of sixteen meters gives the pyramidal figure sculpted in vanilla-colored stone just the right pro-portions.

After covering the short stretch to this first piece and passing under it, the large "A" of the *Birth* in some way takes on the role of the great door that gives us access to the rest of the poem. Just beside it is an open space. Originally, Brossa wanted to put seven black metal Thonet swinging seats there, but he feared that in this rather isolated place the whole thing would become a focus for acts of vandalism. So he decided to dispense with these and replaced them by a number of classical benches, which do not of course have quite the same impact.

We then come to a gentle grassy slope on which are strewn various punctuation marks; these are the *Pauses and Intona-tions* along the way. The full-stop, comma, question marks, exclamation marks, etc. were carved by a stonecutter in the same artifical stone of which the A is made, and are in proportion to the size of the initial letter.

At the end of the path is the conclusion of the poem: *Destruction*. It is represented by the same letter A, carefully broken into pieces and thus lying on the ground.

The plants meticulously placed all round the area are of special importance. There are groups of twisted, sculptural olives, a carob tree and greyish cypresses con-trasting with the coldness and precision of the letter A, together with a mass of weep-ing willows that act as a backdrop. The grass proves to be an appropriate material with which to establish the gradual transi-tion between Brossa's work and nature. And the initiation route is clearly marked by the reddish color of the brick dust: the neophyte must be guided lest he lose his way.

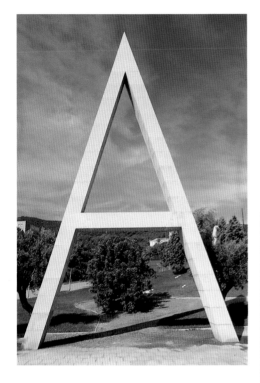

The first letter of the alphabet marks the start of the three-part visual poem by Joan Brossa.

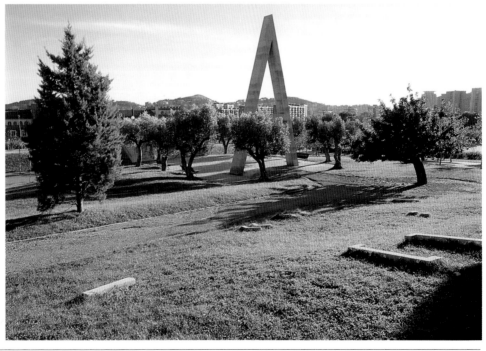

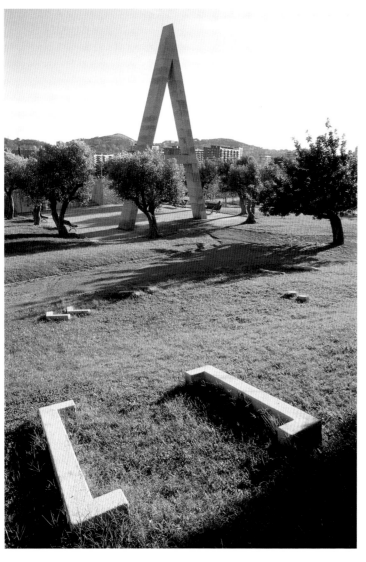

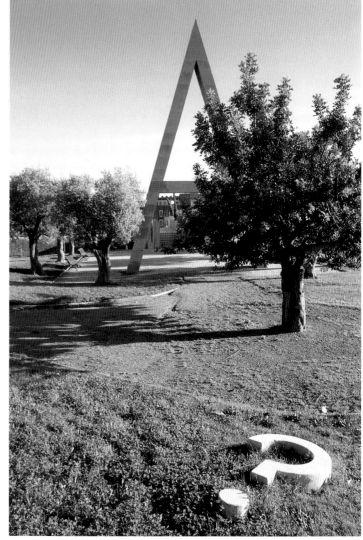

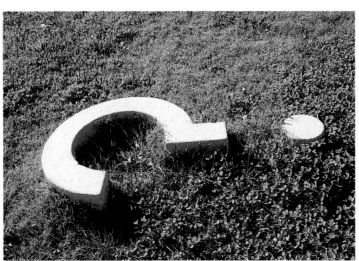

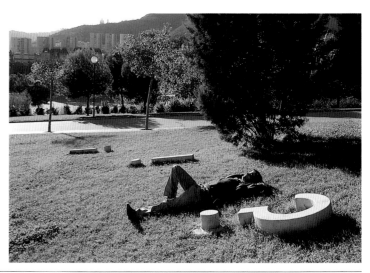

The punctuation marks represent the section of the poem that Brossa calls *Pauses and Intonations*.

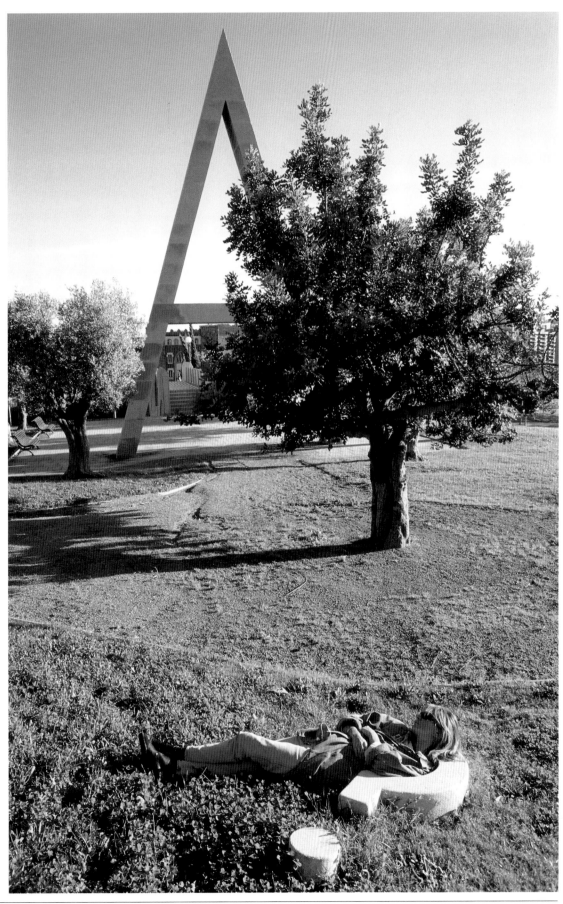

The initiation route ends
with what the poet
describes as *Destruction*,
represented by a broken
"A."

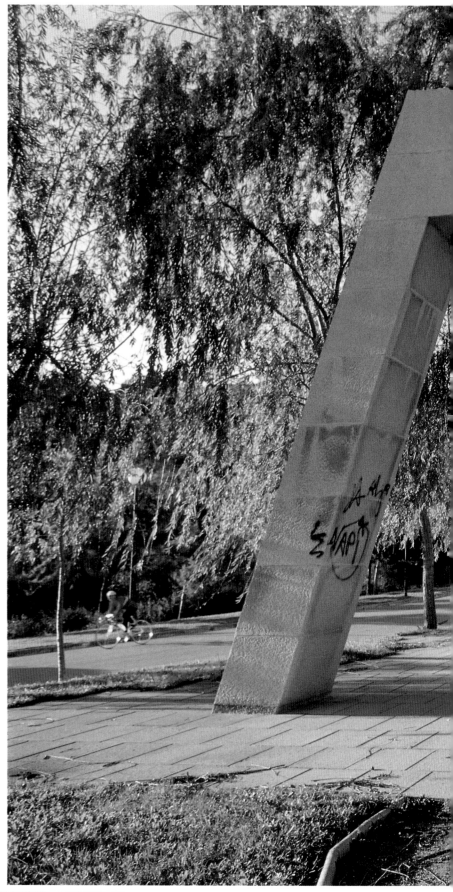

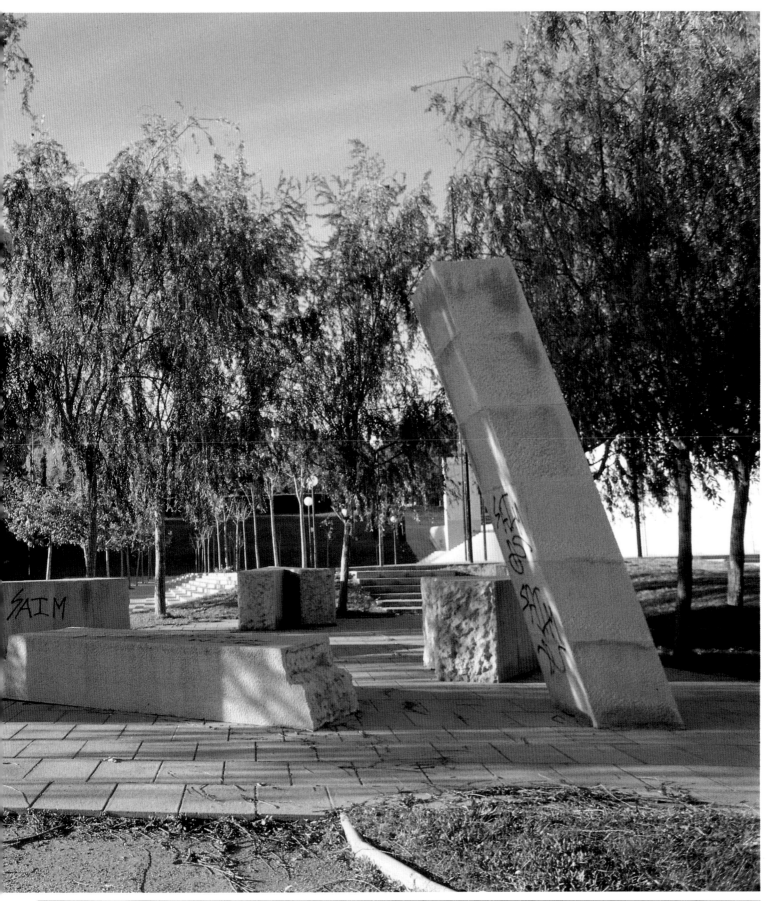

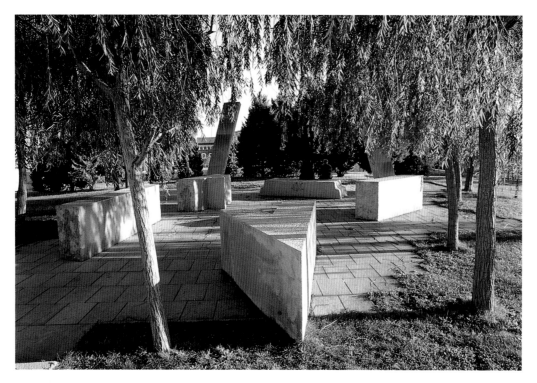

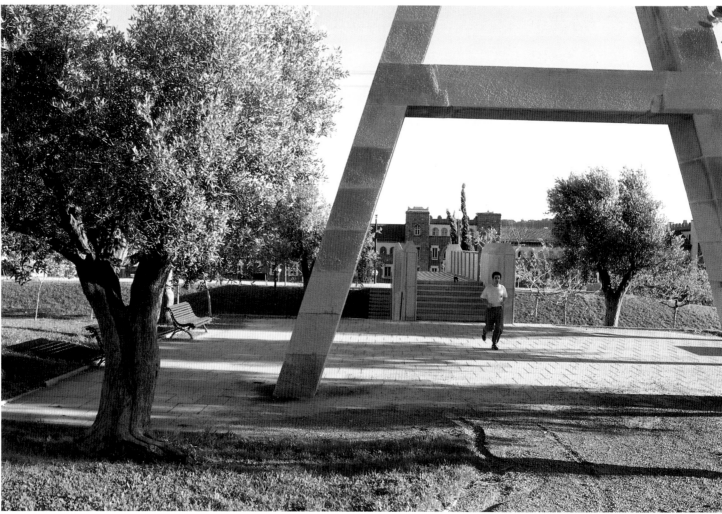

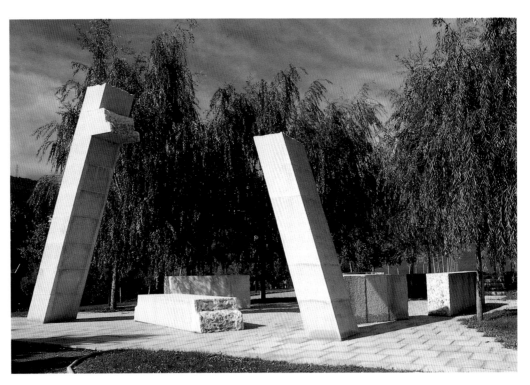

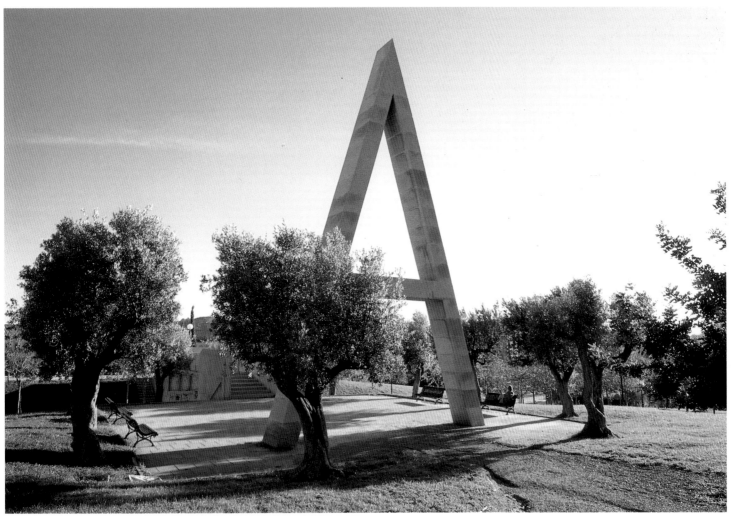

Roqué's 306 meter sculpture along the Avinguda de Rio de Janeiro

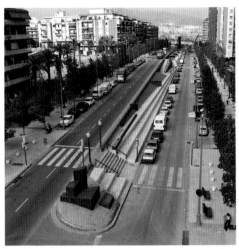

Photo: Rocco Ricci

Architects:
Paloma Bardají
Carles Teixidó

Sculptor:
Roqué

If I had to choose one place that best reflected the title of this book, it would without doubt be the Avinguda de Rio de Janeiro, where the avant-garde Barcelona sculptor Roqué has placed the city's largest sculpture. I would choose this place because the artist has shown the extent to which his creative intervention has been able to transform an urban area. It is a fruitful lesson in teamwork — between sculptor and architects — and it is also a highly encouraging lesson, for it shows precisely the possibilities of such an intervention in an urban area.

The work is no less than 306 meters long. A glib statement, but it remains to be seen in reality exactly what such dimensions mean. Nevertheless, its success lies in the fact that no single part of it seems over-sized. On the contrary, the sculpture fits its surroundings like a glove. This was in some way to be expected, although the surprising thing has been the degree of perfection achieved. The result is due to the manner in which architects and sculptor have worked together, and to their professional expertise.

Here is urban sculpture *par excellence,* the result of laborious preliminary work to adapt it to the terrain. It involved a detailed study of the surrounding area to see to what extent the sculpture should intervene in it. What a pity there can be no "before" and "after" comparisons, which would be really astonishing. The buildings giving on to the Avinguda de Rio Janeiro were already there, though the essential work was still to be done: constructing the street itself as a basic means of communication. All that existed was an enormous embankment that accentuated the difference of level between the two sides. The panorama was indeed a depressing one.

When the then coordinator of muncipal planning services, Josep Antoni Acebillo, suggested to Roqué that he collaborate in the project, he accepted without hesitation. For not only did he realize how attractive and important it was, but by temperament he always seeks continual challenges. This is why, despite his youth, his work has been characterized by a constant experimenting with both forms and materials. After a long visit to England, where he had profitable contacts with the great Henry Moore, he has produced works in black and white marble, stone, concrete and various metals; his last exhibition, at the Galeria Maeght in Barcelona, was a fine example of the images suggested to him by the intricately-worked balconies of his native city.

Over a period of four years from 1985 to 1989, the architects Paloma Bardají and Carles Teixidó kept up a constant working relationship with Roqué. What is so stimulating now is to contemplate the results in order to see the immense effort that went into adapting the work to the terrain and the landscape. One can perceive the intense desire to subordinate forms and materials and even color to a final result that is so perfectly integrated and integrating. Proof of this is that the sculpture has nothing whatsoever in common with his previous work. Roqué has honestly started from scratch.

With the exception of the beginning and end, where height plays a contrasting part, the rest of the work runs at ground level along the center of the avenue. Subtle and accentuated differences of level, inclined planes, ramps, steps, railings, a wall turned with the same delicacy as a shaft of wood, geometrical volumes assembled together or interrelated in isolation, visual

features, etc. — each piece has been carefully studied and thought out, but above all we should note the relationship and the dialogue between the individual parts and the whole, and the tensions achieved by the juxtaposition of colors and materials.

Brick — of the type known as *carquinyoli* — and reds, concrete and blacks, stone and ochres, iron and dark browns. And more: for even the green of the grass plays an important role in this global harmonization.

In order to calibrate the full extent of the research that went into choosing the materials, it should be noted that the con-crete was subjected to a very creative treatment. Not for nothing was it used in the larger volumes that mark the start and finish of the sculpture. To obtain the right tone and intensity of black, it was injected with a special pigment from Germany; but in addition, rounded pebbles tinted with red paint were mixed with the concrete, so that the texture would produce subtle variations of tone.

The volumes of the large blocks at each end were created on the basis of a disturbing, unorthodox geometry that produces unexpected edges and unsuspected cuts. There is an uninterrupted, though discontinuous, formal relationship between the two groups, for standing on the grass or lying along a step or affixed to the turned brick wall is a beam here, a parapet there, a gentle curve further on. This was the only curve Roqué allowed himself, for the straight line is the dominating line in the black sculpture.

The work is submerged in the general uproar of the traffic. It is well worth getting out of one's car or off one's motorbike and taking a walk along this attractive piece that cannot fail to produce pleasant sensations in even the most insensitive person.

Bardají-Teixidó-Roqué have been awarded the FAD Prize for Urban Design. A well-deserved accolade.

View of the longest
sculpture in Barcelona,
by Roqué.

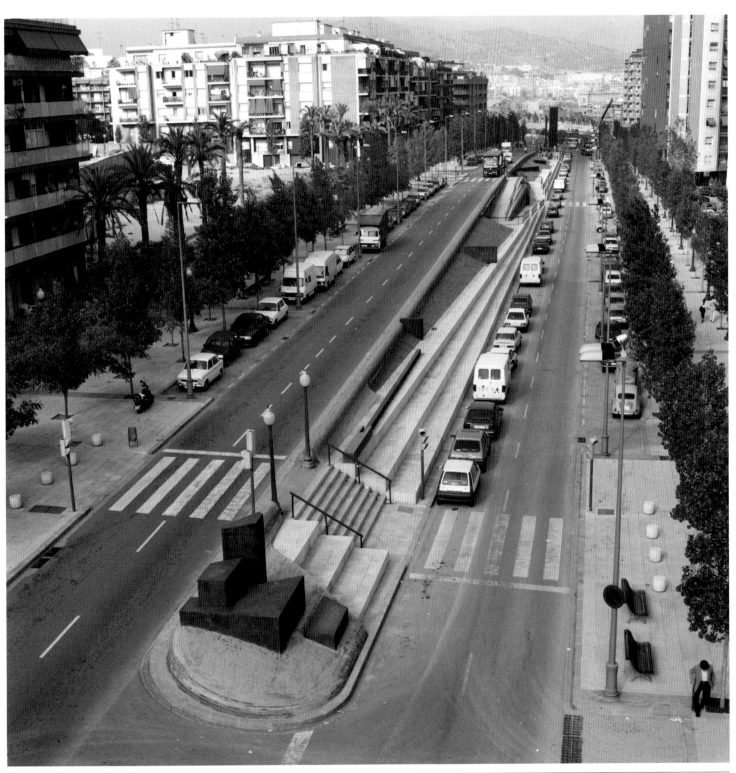

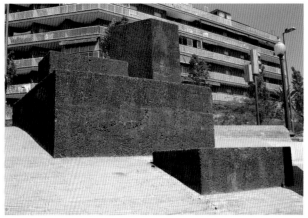

The austere, solemn
volumes at the start of
the sculpture.

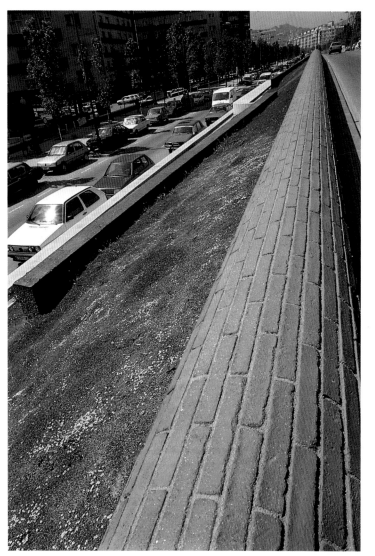

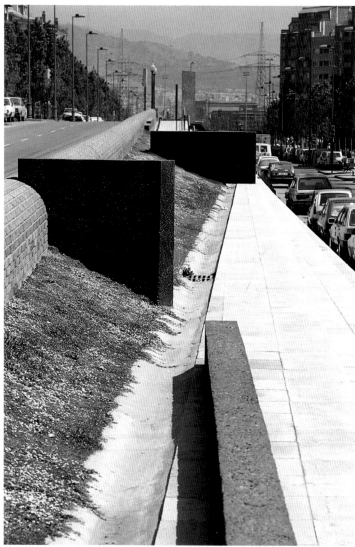

Immense care has been
taken in the design of
every single detail.

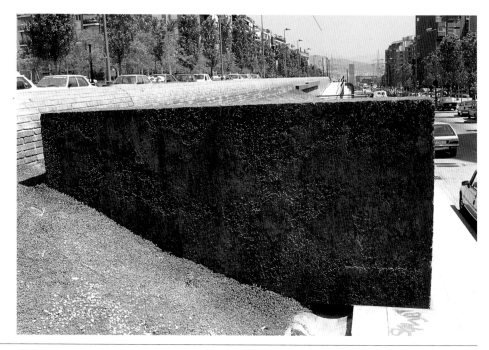

The other end of this
unusual work is marked
by highly sculptural
forms.

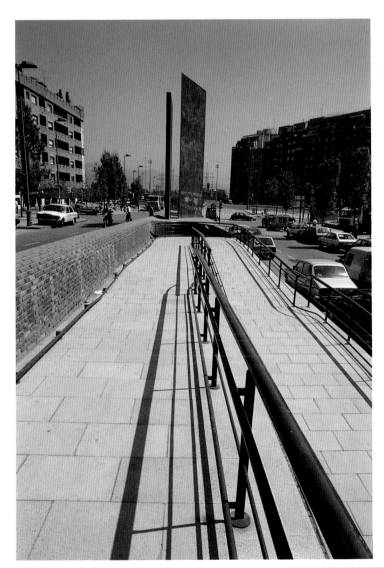

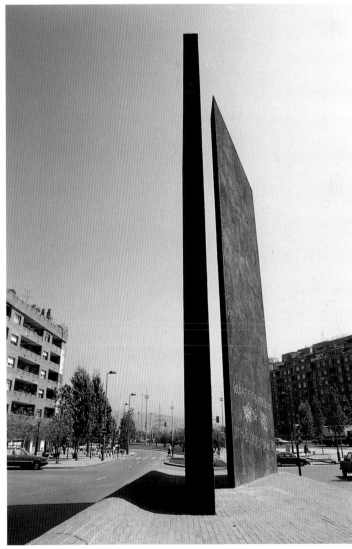

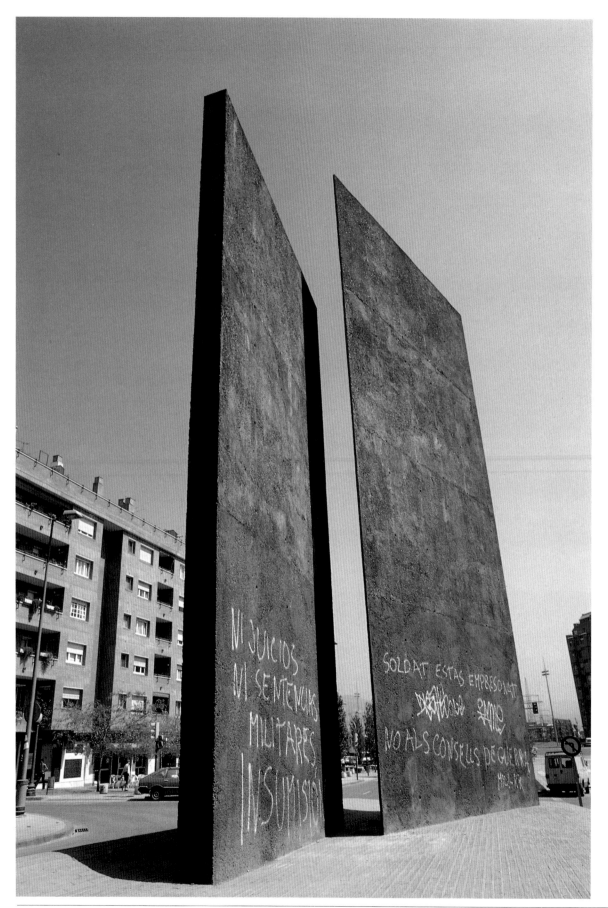

The Chillida created in the Creueta del Coll quarry

Architects:
Josep M. Martorell
David Mackay

Sculptors:
Eduardo Chillida
Ellsworth Kelly

The Parc de la Creueta del Coll has been created in the space gained gradually day by day out of what used to be a quarry. And whereas it was from here that the stone was extracted in order to build the city little by little over the centuries, it is now the city that is in turn doing its bit to dignify the place and transform it into a public space of the first order.

A City Council such as Barcelona's, which has turned its public spaces into a real open-air sculpture museum, was bound to want to enlist the participation of the great sculptor Eduardo Chillida.

The way it happened was as follows: Chillida was asked to collaborate and was delighted to accept, but on condition that he had a space that inspired him. He was then shown several places that were in the process of being remodeled, but as soon as he saw the Creueta del Coll he had no need to look further. It was inevitable that he should be captivated by that impressive, unique, natural wall of pure rock.

It was when he saw that the architects Josep Maria Martorell and David Mackay had designed a large pool that he decided the time and the place were right for materializing an idea he had been mulling over for a long time. This was *In Praise of Water,* based on the proposition that the liquid element should collaborate with him in creating the other half of the sculpture. It was an original and very personal interpretation of the ancient legend of Narcissus, but in this case the work was to be suspended a short distance above the sheet of water, which would reflect it and thus duly provide the other half.

The architects Martorell and Mackay understood perfectly the task they had to perform in that formidable place. As in a museum, the fundamental principle is not to detract from what already exists. The most important aspect of the Creueta del Coll is the natural space, and therefore only a few light touches needed to be added in order to tidy up and highlight the salient features of that solemn, imposing hollow. They began by using materials that were not out of context, and then set about demarcating areas, consolidating the surroundings, emphasizing certain vistas, and intervening with austerity only where strictly necessary. In this way, on reaching the enormous pool, the visitor hardly notices the subtle terracing and is bewitched by the overall grandeur and purity.

Immediately on entering the park we come across a large piece by the American sculptor Ellsworth Kelly: a menhir, pure and simple, proudly indicating the existence of a special place and at the same time welcoming the visitor. From there, one can already glimpse the wall of stone framing the suspended Chillida. *In Praise of Water* is made of reinforced concrete, weighs 54 tons and is 6 meters high, 7.8 meters wide and 4 meters long. It was created right there at the foot of the quarry wall, for the shuttering was erected at the point at which the sculpture was to be suspended, it was filled with concrete and as soon as this had set the newly born sculpture was slowly stripped of its complex wooden casing. Suspension was not easy, but the four steel cables held it in the air in the correct position, where it now remains, enhanced by a slight but perceptible oscillation that gives it life.

Chillida first started using concrete in the seventies, as soon as he decided to take up the challenge of lightness, which he naturally had to tackle from the point of view of weight rather than frivolity. This

substance, which was absolutely new to him, immediately provokes the conceptual and visual image of a material always associated with a base, anchored to the ground, capable of supporting things by its very immobility. The unorthodox Chillida, however, suspended it; such was the case with *Meeting Place,* which caused such controversy in Madrid during the Franco regime and became the first exiled sculpture on being rejected by the City Council and finding refuge in the Miró Foundation in Barcelona.

With *In Praise of Water,* the sculptor again suspends an enormous mass in mid-air, but as he himself says, the fundamental idea here was to make the reflection on the sheet of water provide the missing half of the work.

Although the visitor's first view of the sculpture is always from the front, the best angle from which to see it in order to understand the work in all its depth is just behind it, that is to say, with one's back to the natural stone cliff. Looking upwards, one sees it in suspension; looking downwards, one can see the reflection that provides the necessary duplication.

But there is yet another point from which there is a spectacular view. This involves going up behind the quarry to the top of the hill, from where we can look down at the cut face with the pool and the sculpture at its foot; in the far distance we can also see the big water — the Mediterranean. A wonderful panorama.

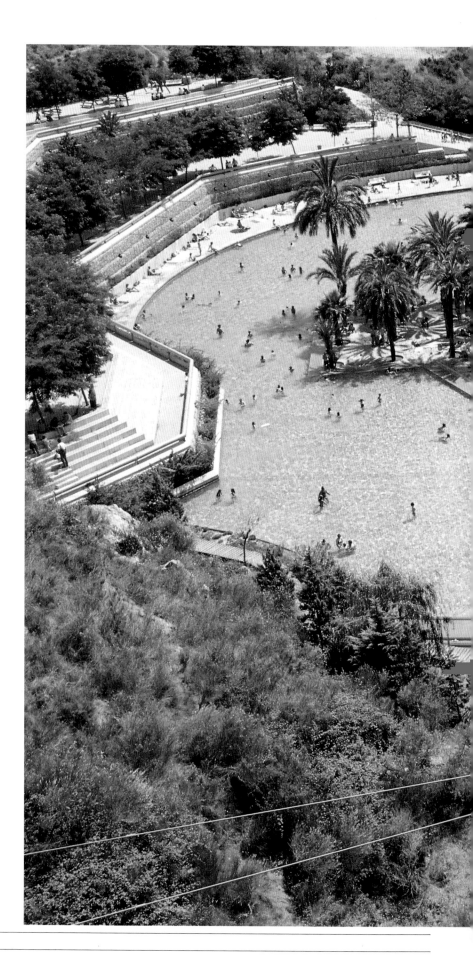

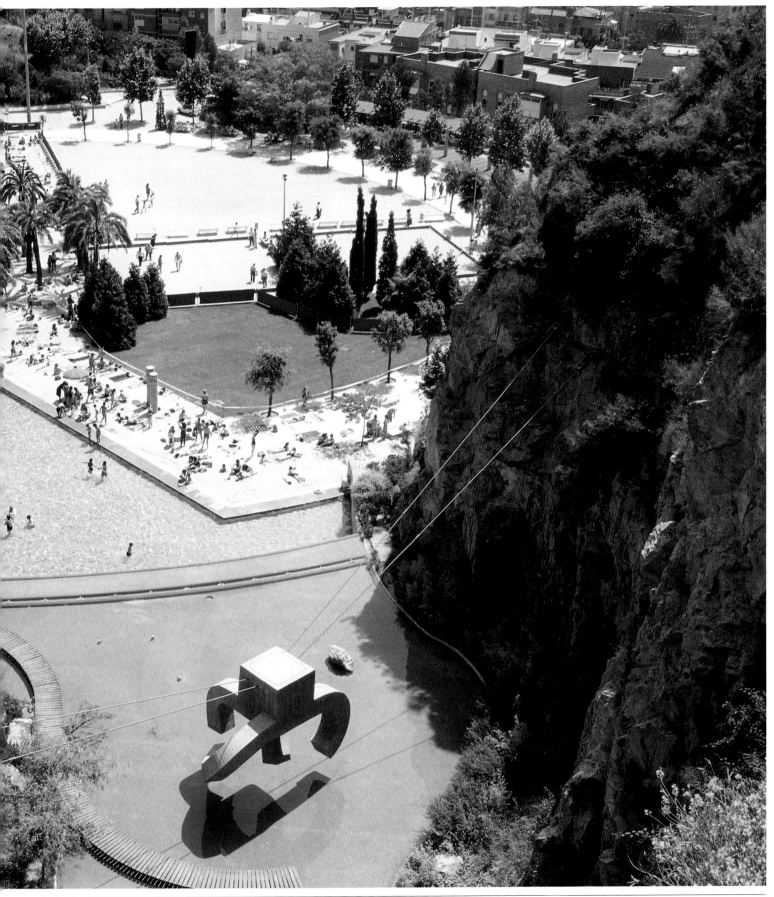

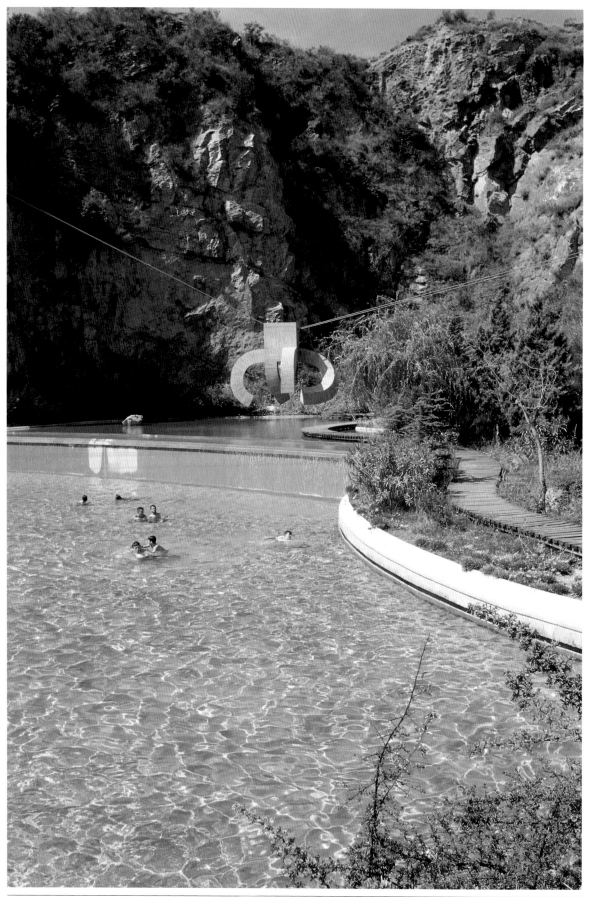

In Praise of Water, one of
Eduardo Chillida's most
daring works.

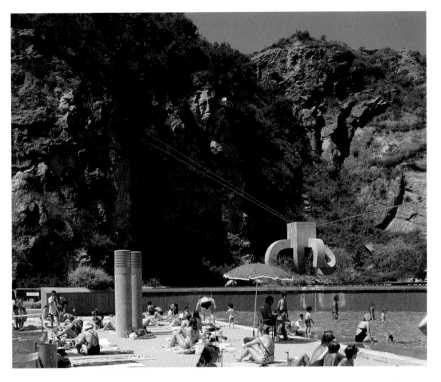

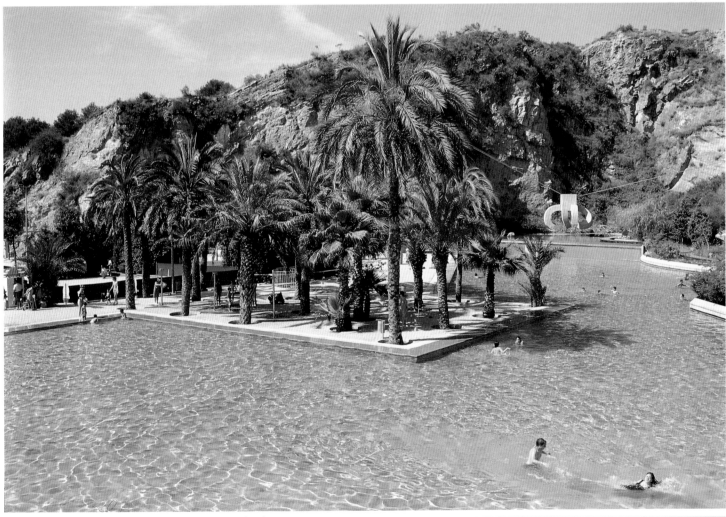

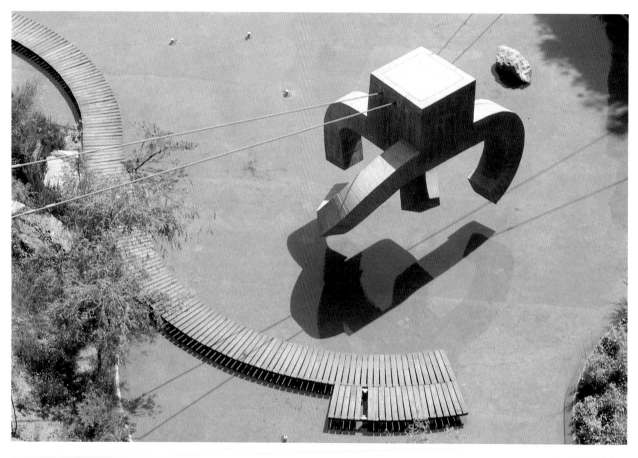

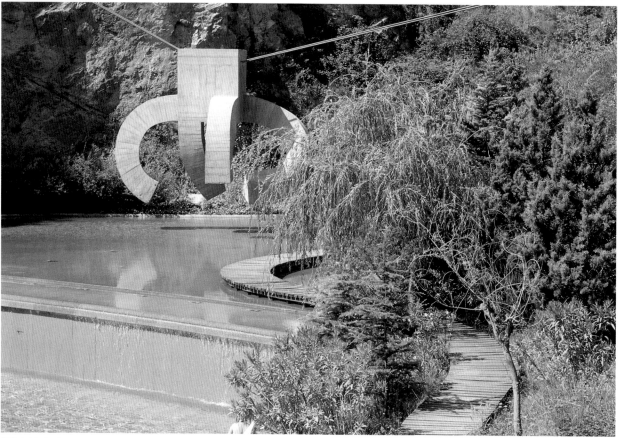

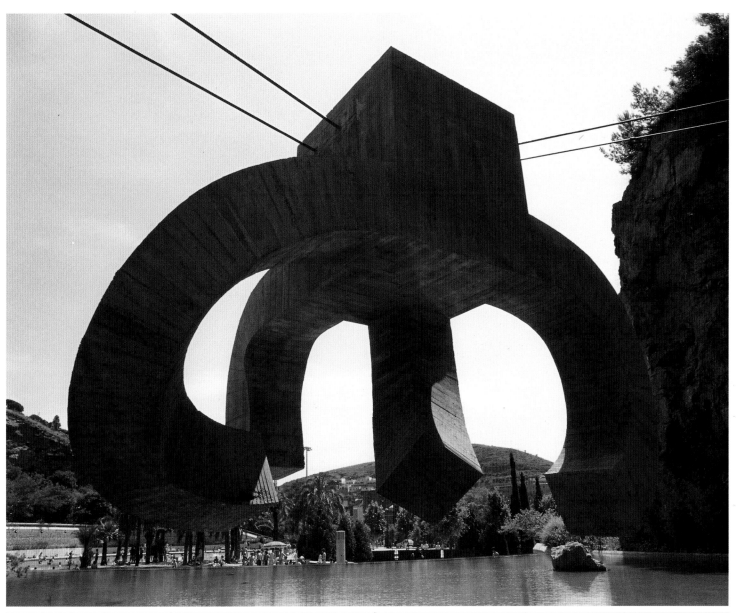

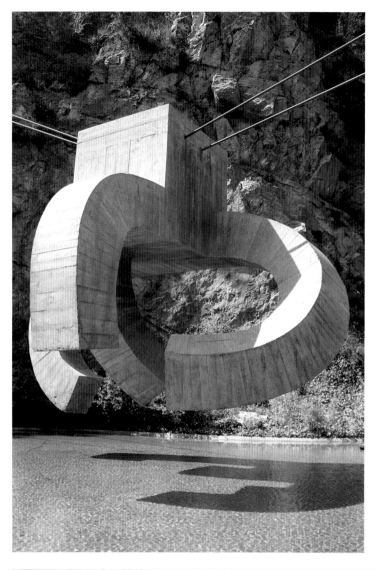

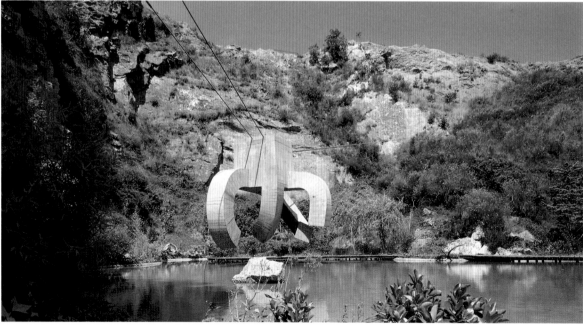

Ellsworth Kelly's menhir marks the entrance to the park.

The Plaça dels Països Catalans or sculptural urban design

Architects:
Albert Viaplana
Helio Piñón

The aspect of the empty site that appeared like a cyst on the end of the Avinguda de Roma, outside the recently built Sants railway station, was more than desolate; it was frankly hopeless, for it was enough to dissuade anyone from attempting to produce order out of such chaos.

It should be borne in mind that the area is under the powerful influence of large thoroughfares and spaces. Indeed, it is bounded by Carrers Viriat and Sant Antoni; it is marked by the long vistas of Carrers Numància and Tarragona, as well as by Avingudas Josep Tarradellas and Roma; and it is thrown out of balance by the great weight of two places of such importance as the railway station and the Parc de L'Espanya Industrial. And if all this were not enough, there is the added aggravation of the arbitrary parking of cars, and the arbitrary environment created by skyscraper blocks mixed with houses only a few storeys high.

The architects Albert Viaplana and Helio Piñón are the most creative and avant-garde, the most original and imaginative professionals on the contemporary Barcelona architectural scene. I would not dare to say that they were the only ones capable of taking up the tremendous challenge of producing a design that would solve the seemingly insoluble problems of all kinds that were concentrated in this area; I do, however, venture to declare that they were at least capable of pulling a landscape out of their sleeves as if by magic; a unique landscape, but one that has the strength to change its immediate surroundings.

Viaplana's thinking pencil drew lines and curves, suggested a scientific perspective, sketched a pergola-shaped structure, marked a horizon, proposed masses and empty spaces, etc. And these drawings then became a reality that to the astonishment of the sceptics and the envious, but especially the mediocre and the short-sighted, contained all the features that had appeared in the highly creative plans. In this respect it was reassuring to observe the lesson given by Viaplana/Piñón in exhibiting their sculptures and models in the Espai 13 at the Joan Miró Foundation in Barcelona in 1990.

If we were able to discipline our sight and operate by subtraction, much as the photographer does with his camera, it would be worth taking a look at the Plaça dels Països Catalans from the air and eliminating everything that existed around it when the architects started work, in order to see simply the trapezoid platform on which they so ably arranged their made-to-measure designs.

And with consummate strategy they placed upon this landscape a uniform, dark, neutral carpet — dark enough to demarcate the territory, which nonetheless was staked out with metal posts that catch the eye simply by being slightly slanted. They erected a long pergola, distinguished by its sensual undulating roof, which has the subtle irony of being adorned with the image of a cat, a cat that could only be of the metal breed. They also erected an austere, solemn, minimal, square awning that gives the impression of calling for some ritual. A thick metal mesh covers both the pergola and the awning, producing a welcome shade that justifies such an arbitrary design. The colonnade of fountains does much more than paint a patch of water against the background: it traces a pattern of ephemeral lines and a succession of splashes, an entertaining diversion for the youngsters wanting to take an unconventional shower in the heat of the summer.

The excellent design of the long sinuous bench, of the chessboard, the round bollards, the screens to aid the climbers, the clock, the freize of bars supporting the awning — all these bestow a grandeur on the prosaic nature of street furnishings.

This is a landscape. For cannot an urban landscape be entirely in metal and be painted in the dark grey color appropriate to it?

It is interesting to see the transformation brought about simply by the night and a cunningly arranged lighting. Indeed, one should take a walk when darkness has fallen, for it acts decisively as a separator, shutting off the aggressive surroundings and giving physical and even solid consistency to the whole square created by Viaplana/Piñón.

The Plaça dels Països Catalans is an invigorating and encouraging experience that clearly shows the direction and depth that can be achieved by anyone wanting to create a personal topography using a personal language. These two architects confirm the viability of an avant-garde that creates new forms, transforms the environment and thus performs a planning function. This is why this square can justly be described as real sculptural urban design.

The whole square is a
truly sculptural creation.

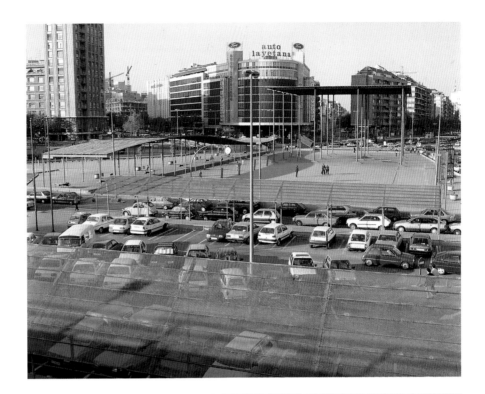

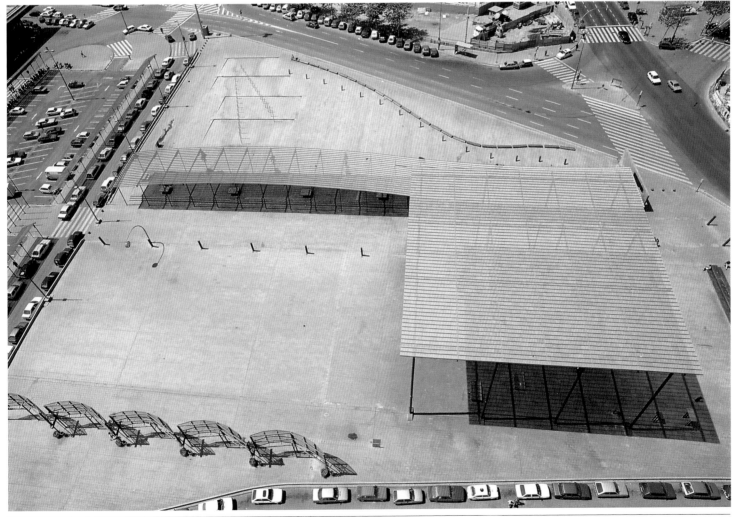

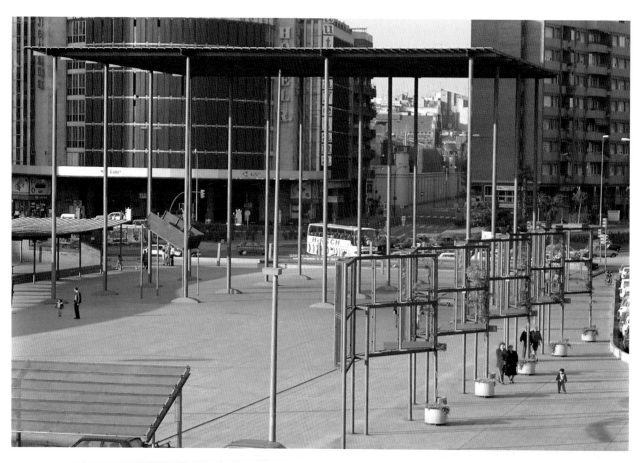

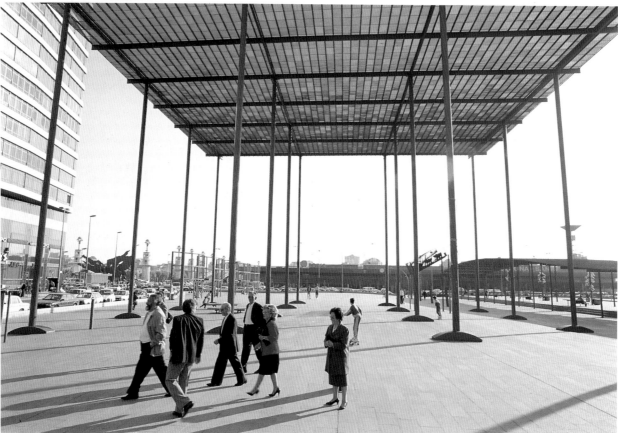

Viaplana/Piñón have created innovative, avant-garde forms.

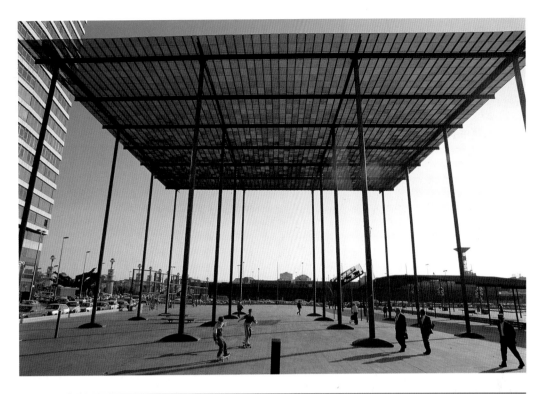

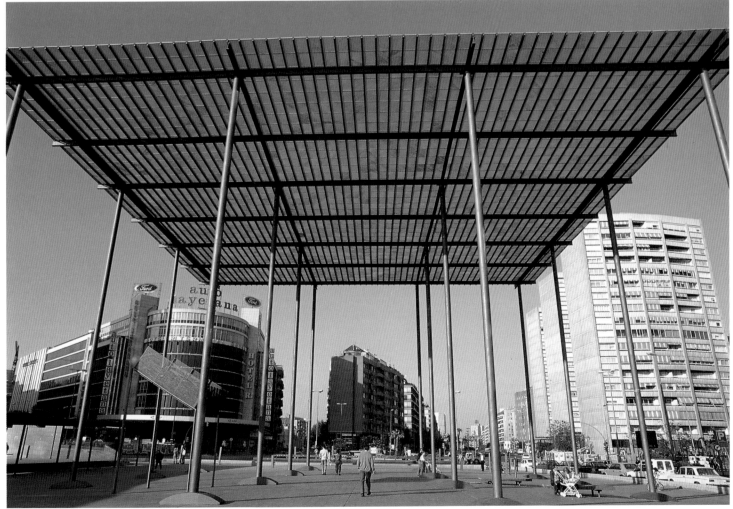

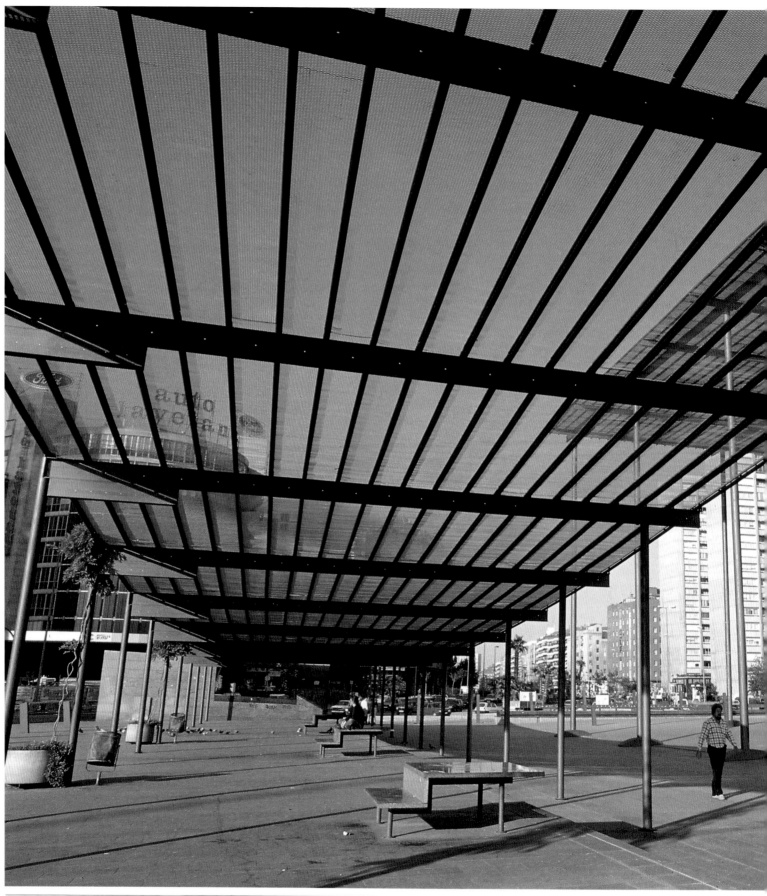

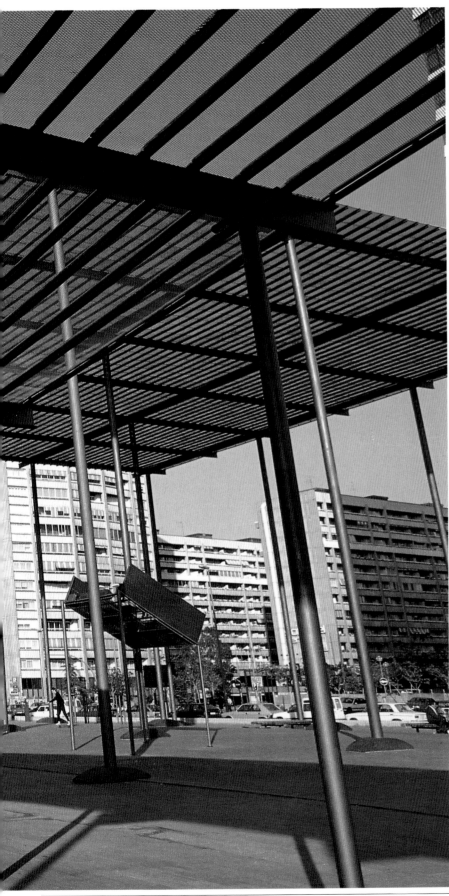

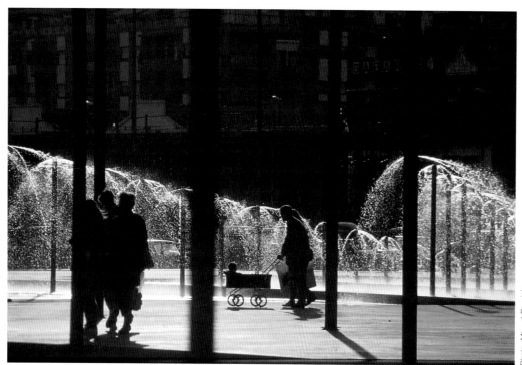

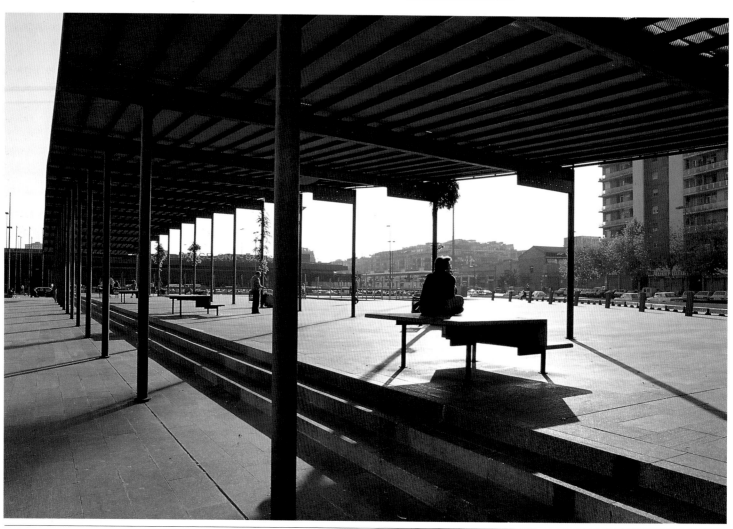

THE PLAÇA DELS PAÏSOS CATALANS OR SCULPTURAL URBAN DESIGN

Corberó evokes the Balearic Islands in the Plaça de Sóller

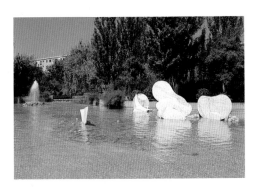

Architects:
Andreu Arriola
Josep Lluís Delgado
Josep Maria Julià
Carme Ribas

Sculptor:
Xavier Corberó

When the person then responsible for the new planning image, the architect Oriol Bohigas, stated that the new policy would consist in monumentalizing the outskirts of the city, this was the first square to be duly completed. By "monumentalizing," he obviously meant erecting monuments, because the sculptures contributed decisively to conferring personality, unity and direction on these urban spaces; but they also served to underline marks of identity, for the people immediately considered them as their own. I still remember the interest that the inhabitants of the Plaça de Sóller showed in the construction of that huge square. What most touched me was that at the beginning, when democracy had only been established for a few years, the people had understood that something was being done there that would then belong to them, and hence they would talk about "my square" or "our square." I was certain then that things had started off on the right foot and that the result was bound to be good, for a sense of ownership implies a potential defender of the object owned. However, from there to thinking that there would not be a single sign of graffiti nor a single act of vandalism would be unpardonably naive.

The municipal architects Josep Lluís Delgado, Josep Maria Julià, Carme Ribas and Andreu Arriola were the authors of the Plaça de Sóller, located in the middle of Can Porta, in Vilapiscina, between Horta and Sant Andreu. It covers an area as large as Plaça de Catalunya. The square consists of two clearly differentiated sectors: one dominated by earth and the other by stone. The latter is elevated in order to overcome the sharp difference of level, and the space underneath it is used to house local civic services. A large lake is the feature employed by the architects to establish the transition, and this in turn separates and links the two sectors — the natural space or park and the architectural space or terrace.

It is precisely in this lake that the renowned Barcelona sculptor Xavier Corberó has placed his work, for not for nothing is it titled *Homage to the Islands,* by reason of the name of the square — Sóller being a small port in Majorca — and the names of the neighboring streets, which also recall the Balearic Islands.

The sculpture is composed of numerous pieces of different types of marble. In the center of a shallow stretch of water that suggests the Mediterranean, emphasized by a pile of rounded rocks denoting the shore and *terra firma,* Corberó has arranged a poetical recreation of the sun (a large yellow onyx disc), the moon (waning, in white Almeria marble), the clouds (sheets of rosy Portuguese marble cut into the most capricious shapes), and a ship (a piece of undulating white marble three meters long). Forty items in all, perfectly finished and of great delicacy, that reflect his characteristic way of working.

Because of the transparency resulting from the lack of depth or thickness, it is obvious that at different hours of the day, and particularly under the artificial lighting that bathes the sculpture after nightfall, its appearance alters considerably, and it is worth seeing the incredible changes and even transformations that this ambitious work undergoes. Corberó, who feels a deep respect for the sea — the great water and the horizontal *par excellence* — has here culminated his personal tribute to the Balearic Islands.

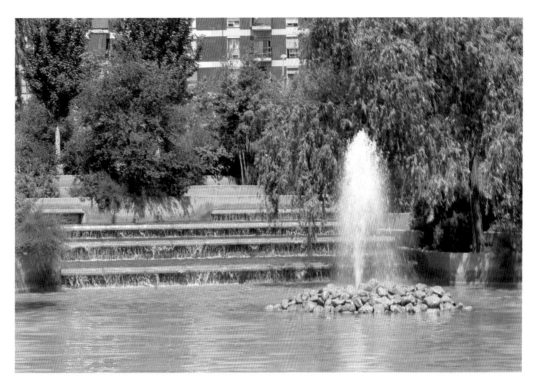

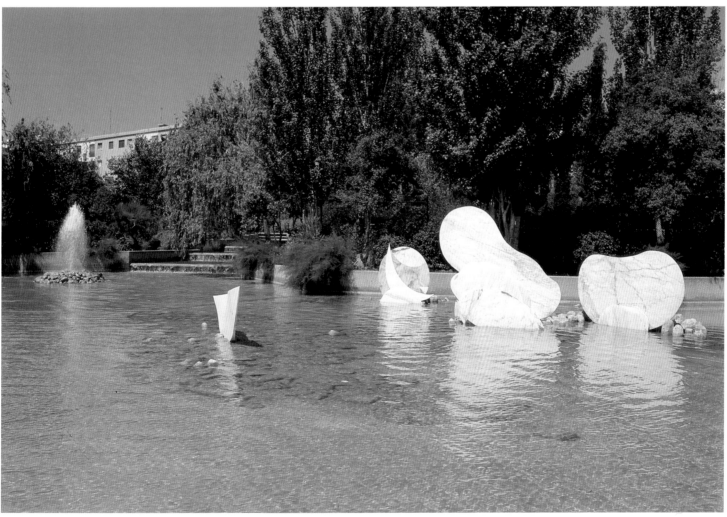

The Catalan sculptor
Xavier Corberó paid this
personal tribute to the
Balearic Islands.

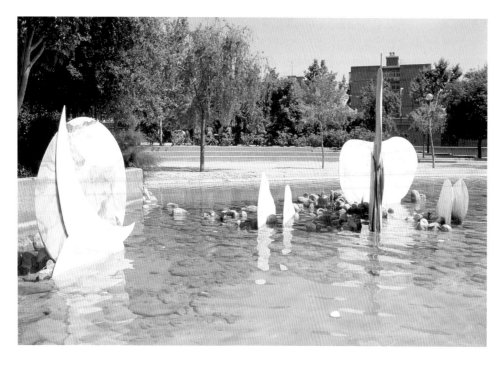

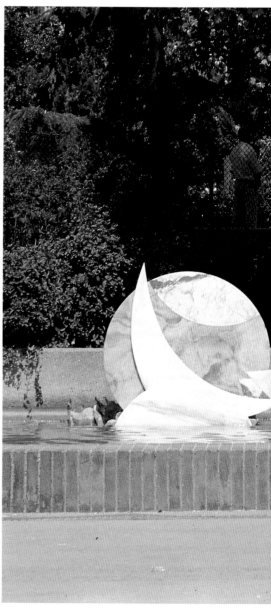

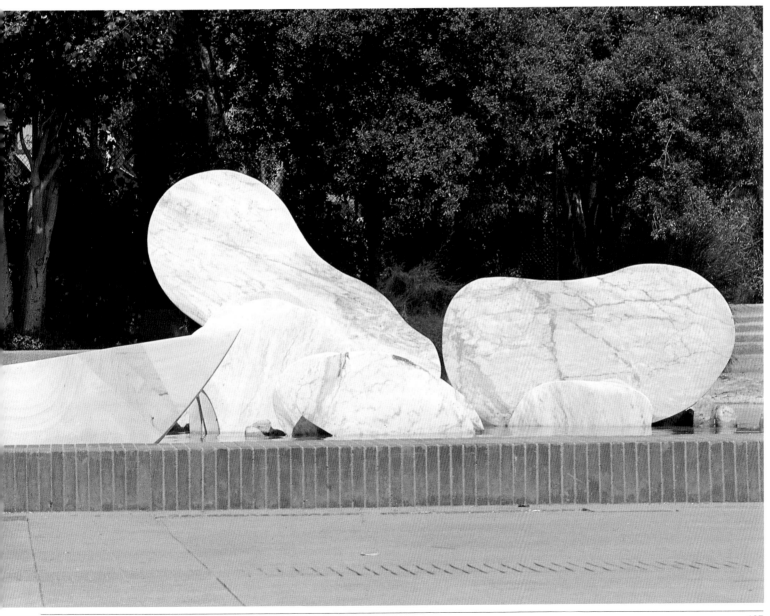

Forty-two juxtaposed
forms that evoke ships,
the moon, the sun and
the clouds.

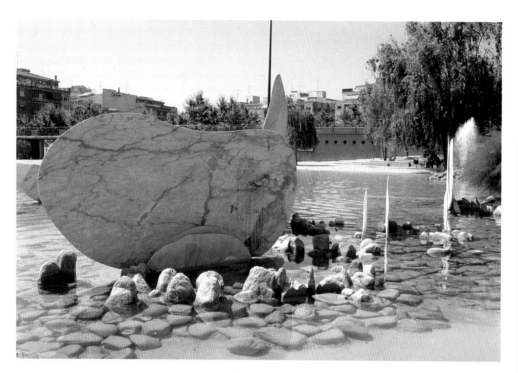

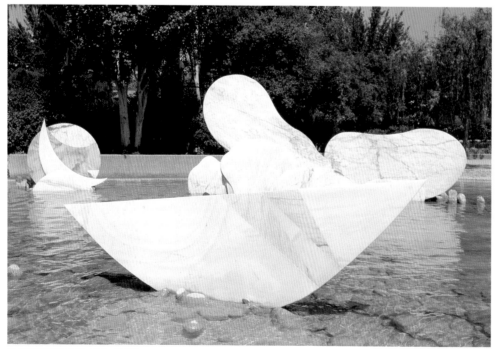

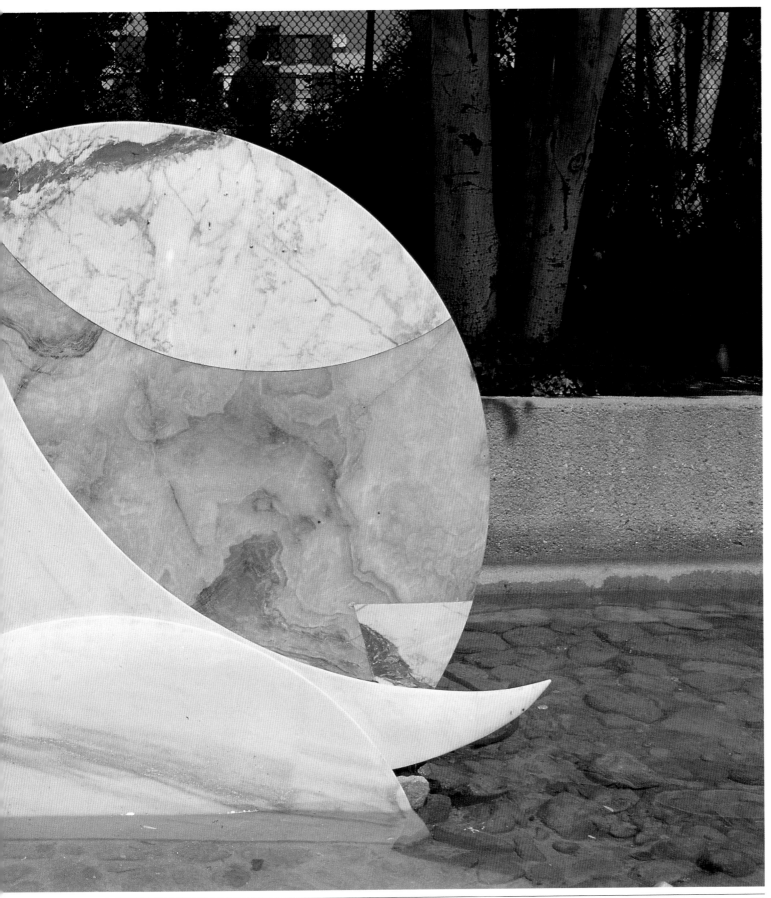

Homage to Picasso by Tàpies

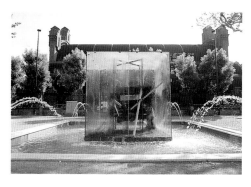

Architects:
Roser Amador
Lluís Domènech

Sculptor:
Antoni Tàpies

The painter Antoni Tàpies did not want to dedicate a monument to Picasso, and so the title of this work significantly includes the word "homage," which clearly better matches Picasso's unorthodox, provocative and progressive temperament.

Nor did Tàpies want to produce a work in fine materials such as bronze or marble or stone, so closely linked to the conservative type of monument generally to be found in public places.

What he set out to do, on the other hand, was to emphasize Picasso's express intentions, the anti-decorative and nonconformist nature of art, for the truth is that he always fought, often violently, against the trite, conservative concept of beauty and harmony and even art for art's sake, that is to say, deprived of any ideology.

"When I haven't any blue, I use red." "What saves me is doing it worse every day." "No, painting is not for decorating flats, it is an offensive and defensive weapon against the enemy." Remarks by Picasso quoted verbatim leave no doubt as to his intentions. In order to reinforce even more strongly the rebellious nature with which Tàpies proposed to imbue his sculpture, he rewrote them with his brush on the sheet in which a large piece of furniture is wrapped.

He decided on this big sofa not with the primitive idea of piling up pieces of furniture, since this might have led to a certain dispersal. Instead, the sofa on its own is categorical and central, and its style fits in with the idea of something antiquated rather than ancient, detestable and worthy of attack.

Far from any dangerous conceptualism, the sculpture reveals itself as didactic and exuding an immense plastic force. A decisive feature was the incorporation of the bars, an element of strength, which in the manner of darts constitute an aggressive attack against the sofa. But these bars have more prosaic roles to play, such as supporting the roof, concealing the pipes carrying the water to the top of the cube and keeping the sofa tilted in the air. This inclined angle is another interesting feature, for it avoids immobility and gives the work a very positive movement, in addition to an aggressive image, by producing an unusual impression of bustle in a piece of such weight and size.

The idea of having water pouring onto the cube continuously and in irregular fashion was a brilliant one. In my view, it produces an atmosphere that is somewhere between magical and imprecise. But, in addition, the constant flow of water gives strength and even life, both qualities of movement. It is important to note the very different appearance the sculpture takes on at night, when it is bathed in artificial light. For the cube receives the light — it does not emanate from inside it — and it is very diffused, producing a somewhat soft, somewhat disturbing image that is enhanced by a range of colors very different from those it possesses during the day.

It must be acknowledged that the City Council once again lived up to the avantgarde style it preaches, for in such capitals of art as Paris or London the authorities would never have dared to erect a work of this nature — or so the poet Jacques Dupin confided to Tàpies.

It was not a matter of placing the sculpture just anywhere in the city. The architect Oriol Bohigas careful chose the site so that it would serve to revitalise the surrounding area, in which the Parc de la Ciutadella and the Born are fundamental features. As regards the Passeig de Picasso itself, this sculpture by Tàpies, the Zoology Museum and the conservatory known as the *Umbracle* constitute a counterpoint to the plan to finally complete the continuous arcade opposite designed by Fontseré that was begun during the Universal Exhibition of 1888.

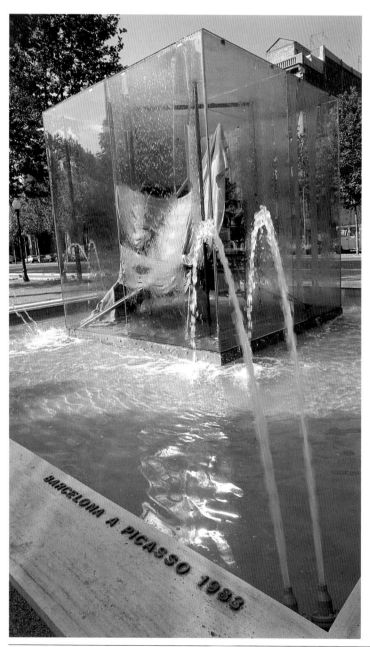

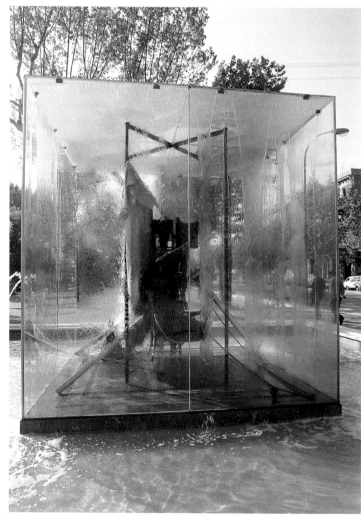

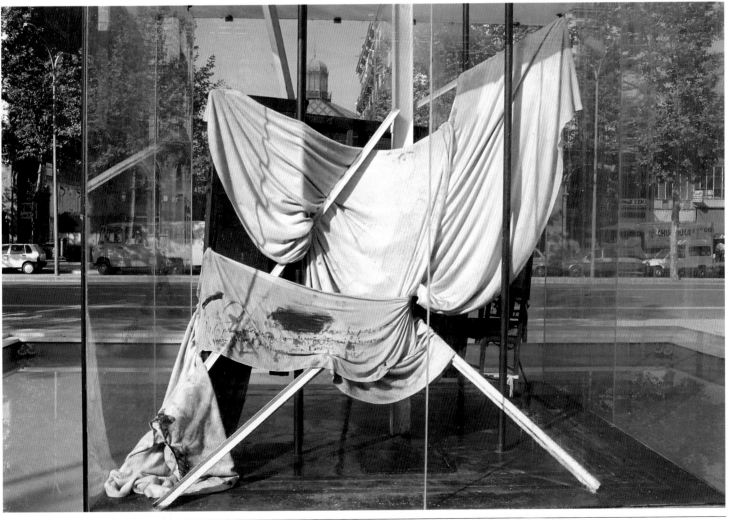

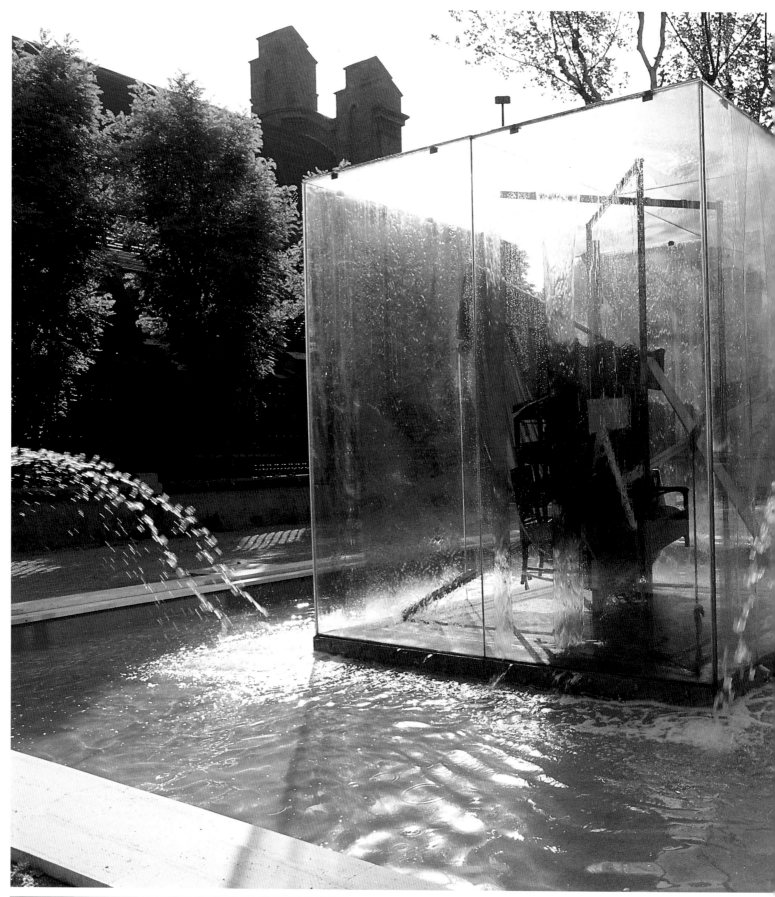

Chillida in the Plaça del Rei

**Sculptor:
Eduardo Chillida**

When *Topos* was acquired by the Barcelona City Council, Mayor Maragall asked Eduardo Chillida to choose the place in which he wanted his sculpture to be situated. Whenever the Chillidas visit Barcelona — Pili, his wife, not only accompanies him every time, because he confesses he is lost without her help, but in addition she fulfills the by no means easy mission of being the perfect complement — they stay at the Hotel Colón, recommended years ago by his friend Miró, who always used it himself. So walking back to the hotel through the Gothic Quarter, Chillida was bound to come upon the Plaça del Rei. "Here," he said immediately.

"But, you're mad!" replied Pili. "They'll never let you put it here."

It was a reasonable remark, for this space that enchanted Le Corbusier, that is on a par with any square in Florence, is perfect, complete and so austere that it admitted nothing but emptiness.

As it turned out, there were no problems at all and the sculpture was placed at the entrance to the square. Then came the surprise: there are certain forms in *Topos*, characteristic of some of Chillida's other works, that follow a pattern almost identical to those in the tower that is misnamed after Martin the Humane. This watchtower was given its name by the people a century after the death of the sovereign, on account of the fact that he suffered from a lung infection and liked to retreat to selected places such as the palace of Bellesguard, where Gaudí built a splendid house. This tall tower, rising beside the Palau Reial, seemd a healthy, airy place worthy of the memory of that beloved king. However, to me it suggests one of those sinister buildings steeped in the metaphysics that De Chirico painted.

The Plaça del Rei is a space that possesses an intense atmosphere. The horizontal line, a golden rule in that Catalonia enriched by the Gothic style, dominates here in very evident fashion. And it serves as the container for an emptiness that imbues it with all its grandeur, in the way of the consummate masters of Oriental art.

In this privileged place Chillida installed his work, which established an exciting dialogue with other great examples of mediaeval art from the time when Catalonia was a Mediterranean power. It is important to note that this Basque, whom I consider the best sculptor in the world today, marries to perfection with what is the oldest open space in a Barcelona that historically has lacked squares. This is the square most heavily steeped in history, and in addition it has managed to preserve over the centuries — that is to say, for more than five hundred years — its simple yet forceful shape.

Topos is sometimes daubed in paint. Chillida does not mind too much. When it was shown for the first time at the large Europalia exhibition in Brussels, it was the only work that merited a paint spray. And he admitted to me what a satisfaction this was, for it was an anonymous way of acknowledging the quality of a wall that he had wanted to give it when this formidable dihedron was cast in the Basque Country. For it is important to remember that *Topos,* in Greek, means "place," and there is nothing like a wall for marking a place.

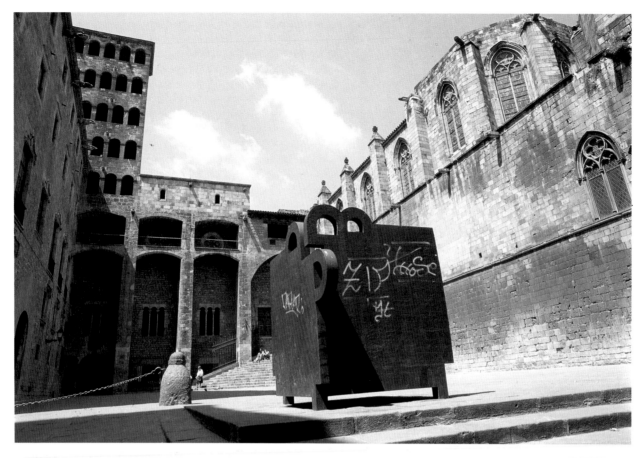

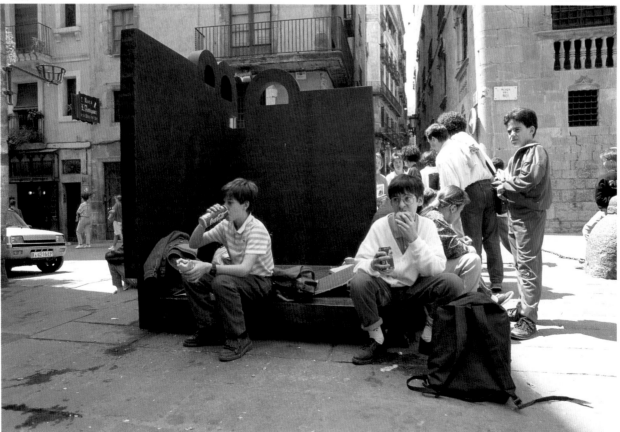

Chillida's formidable
sculpture maintains a
dialogue with this
historical square.

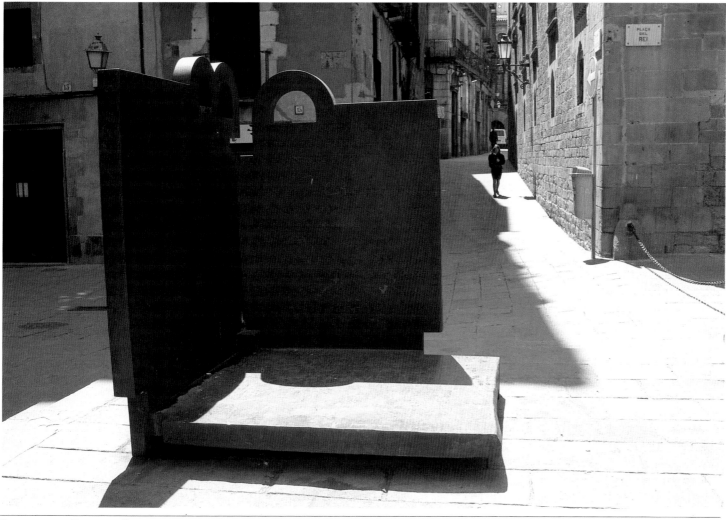

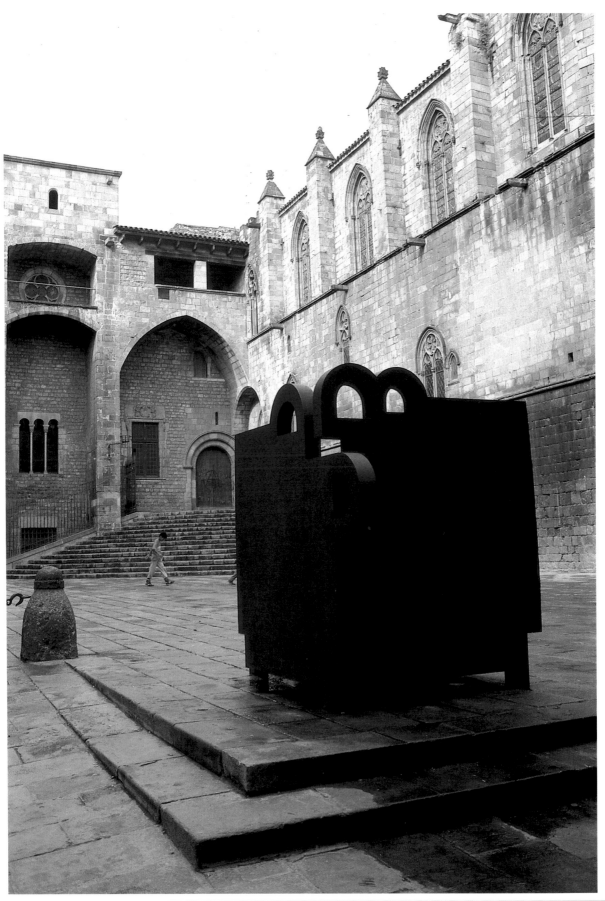

Calatrava's sculptural bridge

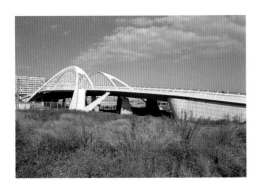

Architect:
Santiago Calatrava

The purpose of this bridge was to link Carrers Felip II and Bac de Roda. It was commissioned from Santiago Calatrava, who was already known to the City Council through having designed the overhead traffic signals along the Avinguda Diagonal.

Santiago Calatrava comes from Valencia, and is not only an engineer but also an architect, designer and sculptor. This can be seen in all his works, particularly the more technical ones, for they are conceived with a degree of creativity that is radically different from that of his colleagues. An engineer does not generally have any problem about his constructions remaining upright, and thanks to new materials and advanced technology he can defy nature and time without any of the complications that existed years ago. In addition, external appearances have become simpler, less massive and more graceful.

Santiago Calatrava takes his inspiration from the lessons in structure provided by animal anatomy. But at the same time he admits to being fascinated by Brancusi, the sculptor who imposed austerity and the essence of form.

He confesses that he finds it more difficult to design a small-format piece for everyday use than a bridge, for the external landscape exercises a considerable influence, and on both scales it is his fascination with anatomy and also with poetry that prevails.

This bridge by Calatrava always seems to me like the enormous spine of a crouching animal whom time has sent to sleep and whom the centuries have preserved and transmuted in another, different, innovative form. The whiteness, which accentuates the strong yet subtle lines traced fluidly in space, is the matt white of bones, of bones exposed to the air.

In the same way that the great names of classical ballet are able to execute the most complex steps and pirouettes in a seemingly effortless manner, transmitting to the spectator nothing of the difficulty involved but merely a sense of gracefulness and weightlessness, so Calatrava has made this enormous mass, the embodiment of tension and strength, project an image of astonishing lightness. I think he has achieved this in two ways. On the one hand, by the dialogue between the visual lines and the stress lines; and on the other hand, by creating an interior space. This reminds me in some way of the effect achieved by Giacometti in the early thirties with a sculpture that had a decisive influence on all the Surrealists: *Suspended Ball*. By merely suspending the edges of a cube around the central mass of the work he immediately produced the sensation of enclosing the space. While some artists need to install categorically positive forms that enclose the negative or spatial form, Giacometti, who possessed an innate sense of space, accomplished it with the minimum of pieces. Calatrava has here designed a bridge that gives precisely such a feeling of lightness, as if all the space contained inside it would exert an upward thrust with the intention of elevating it.

The bridge has been completed, and it is a sight worth seeing by night, when it presents a truly ineffable image.

When the surrounding area has been finished, it will be like the backbone of a vast green space, measuring 50,000 square

meters, since the old railway line is eventually to be converted into gardens. Calatrava was certainly the most appropriate person to resolve a problem of urban communication, but above all to install a sculpture that would add such a strong artistic note to the overall area that no vistas or thoroughfares could detract from it.

Calatrava's sculptural bridge has been awarded the Puente de Alcántara prize. Justice has been done.

The architect and engineer Santiago Calatrava has proved to be also a sculptor.

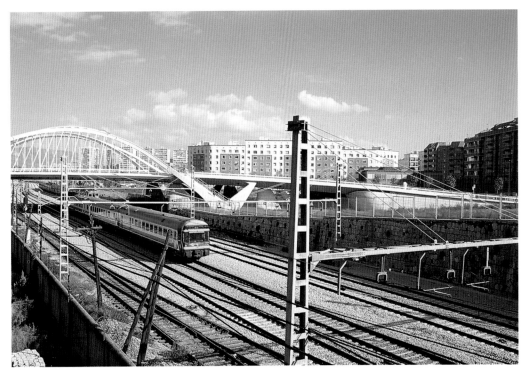

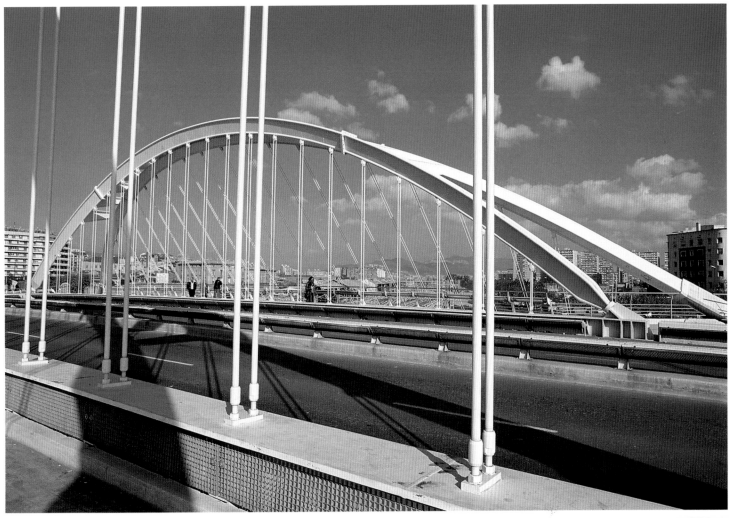

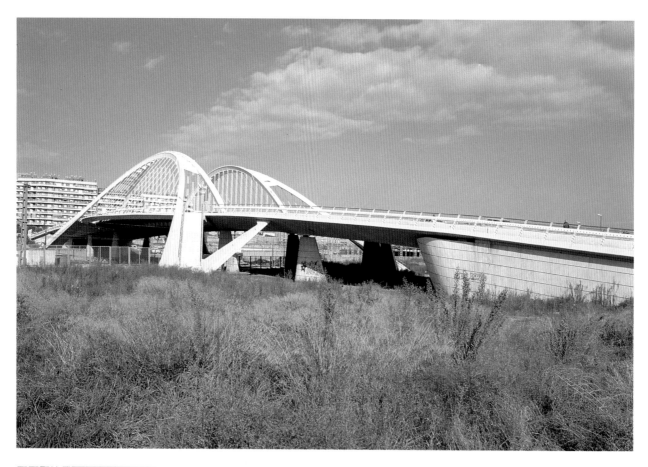

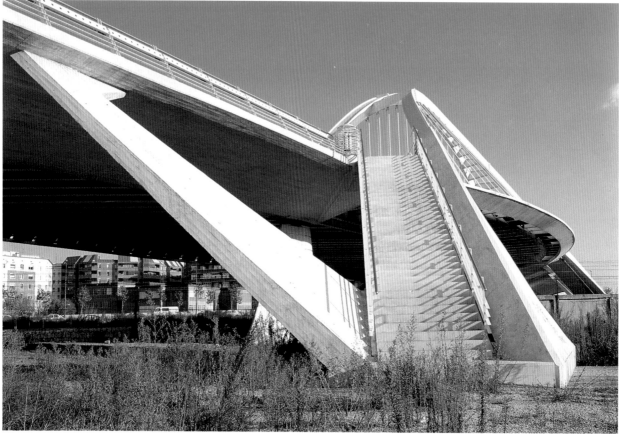

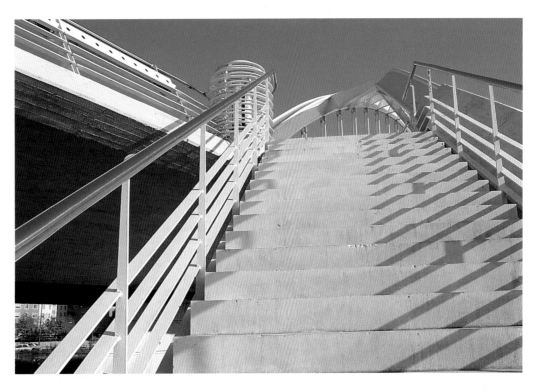

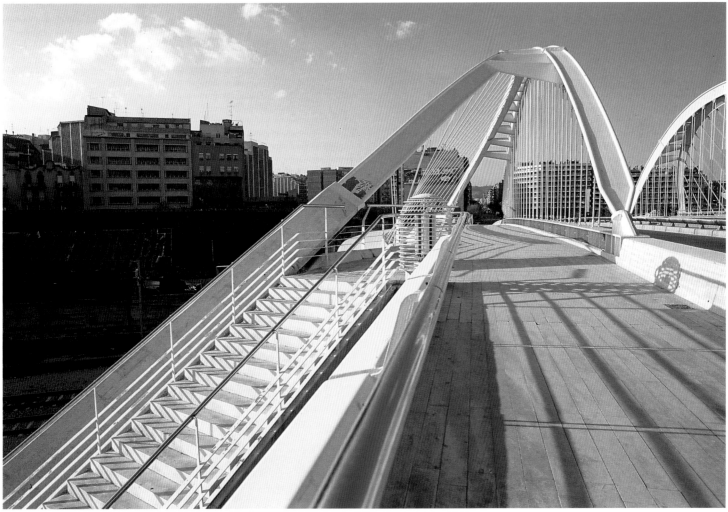

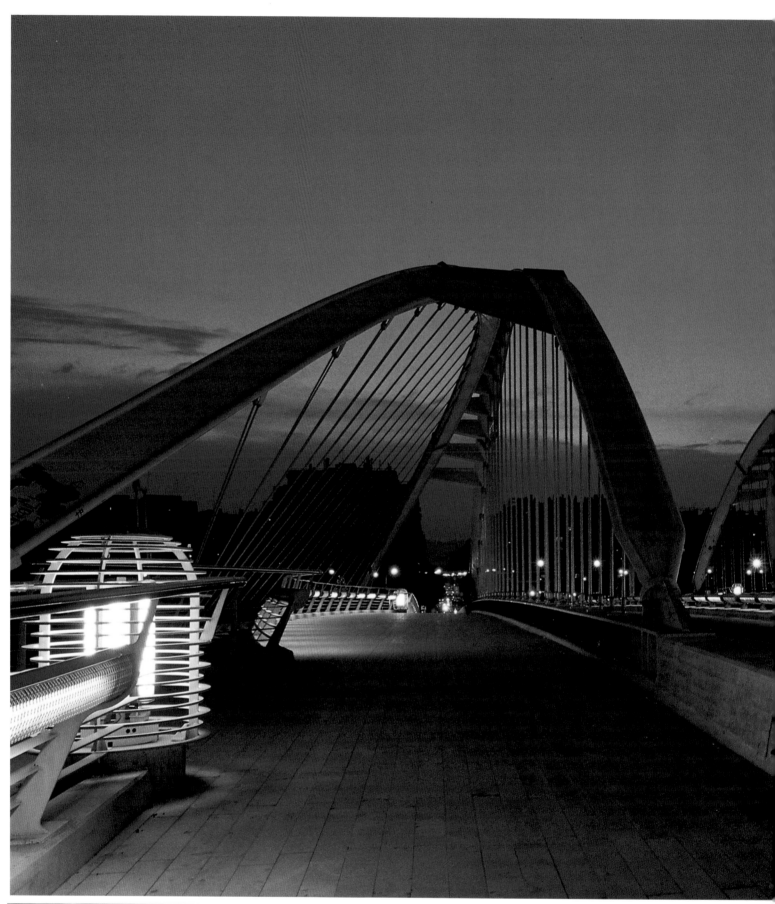

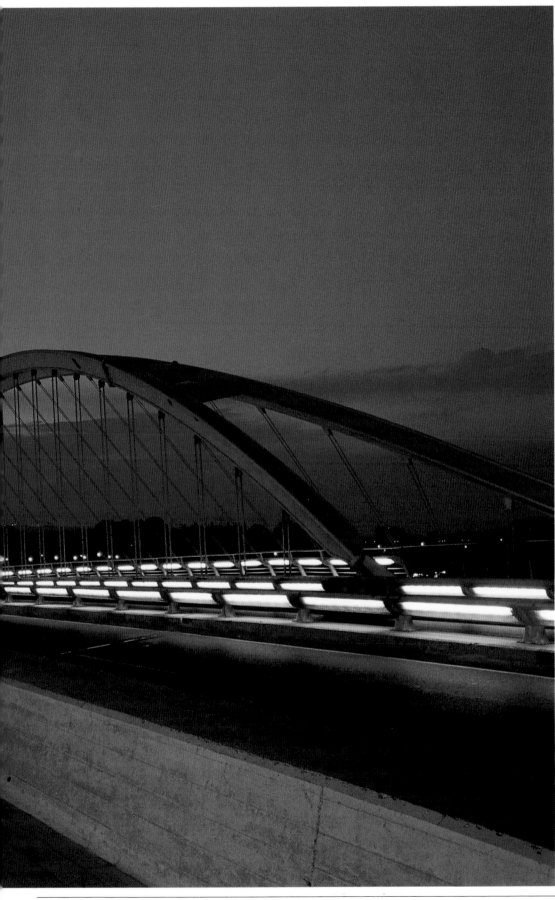

Every detail has been
carefully thought out.

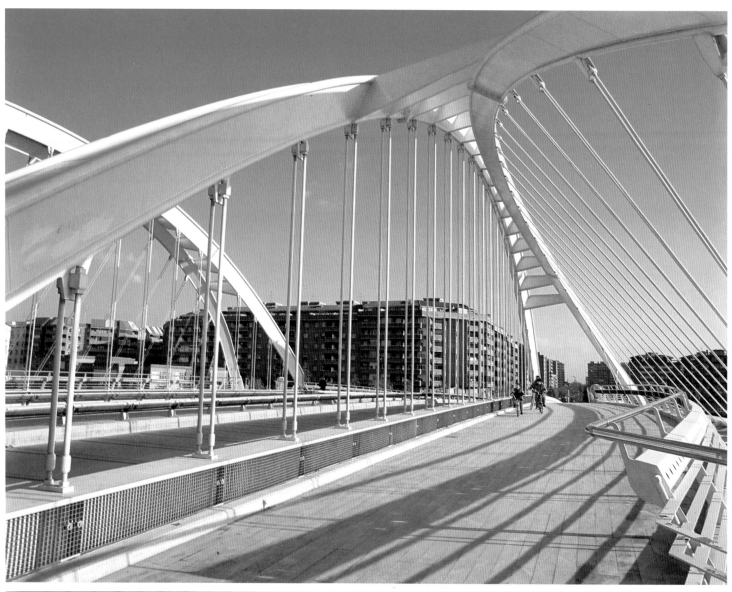

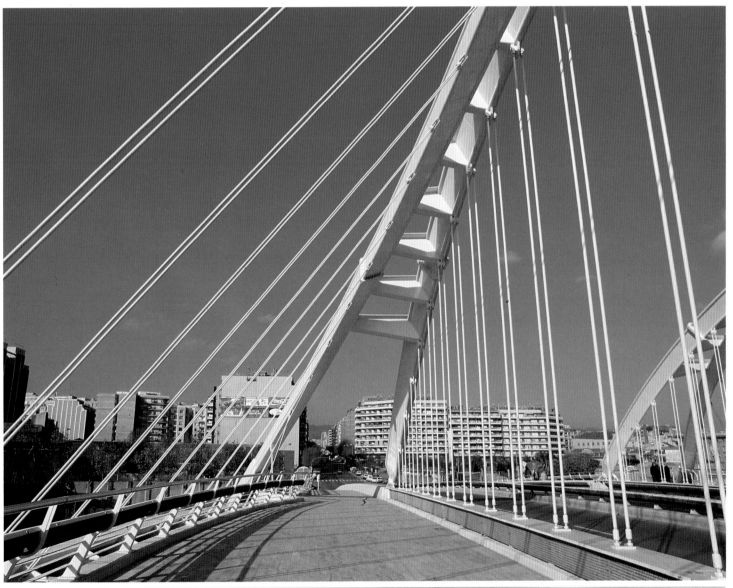

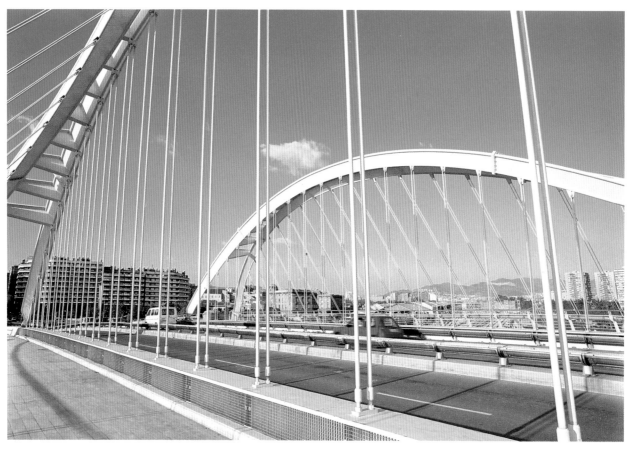

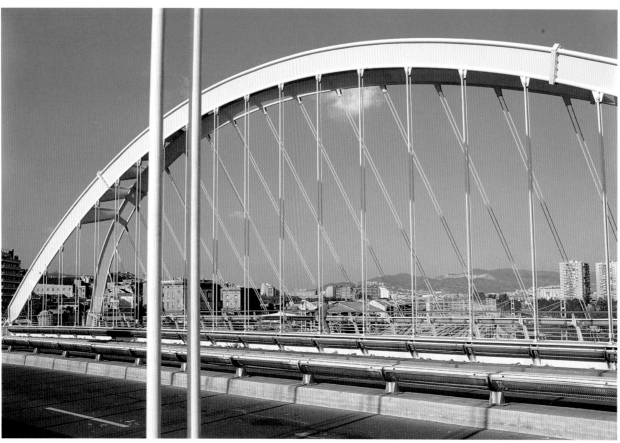

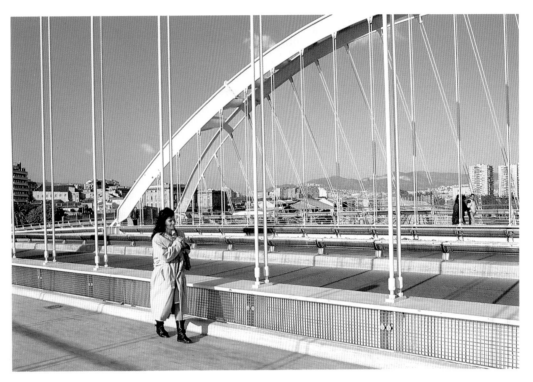

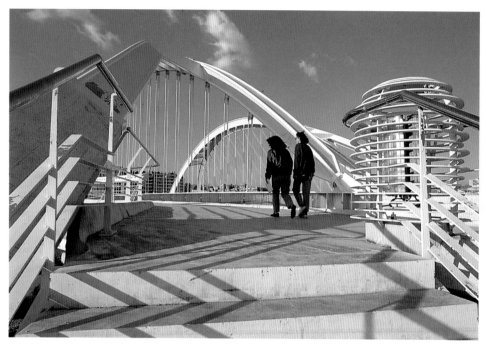

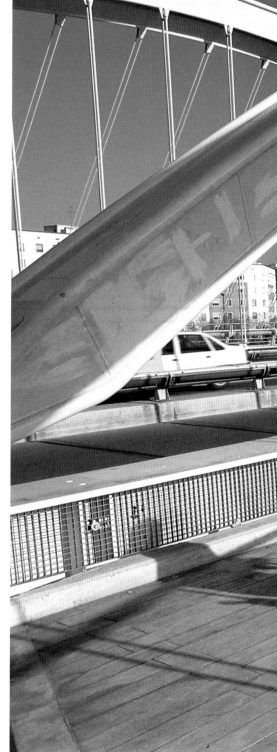

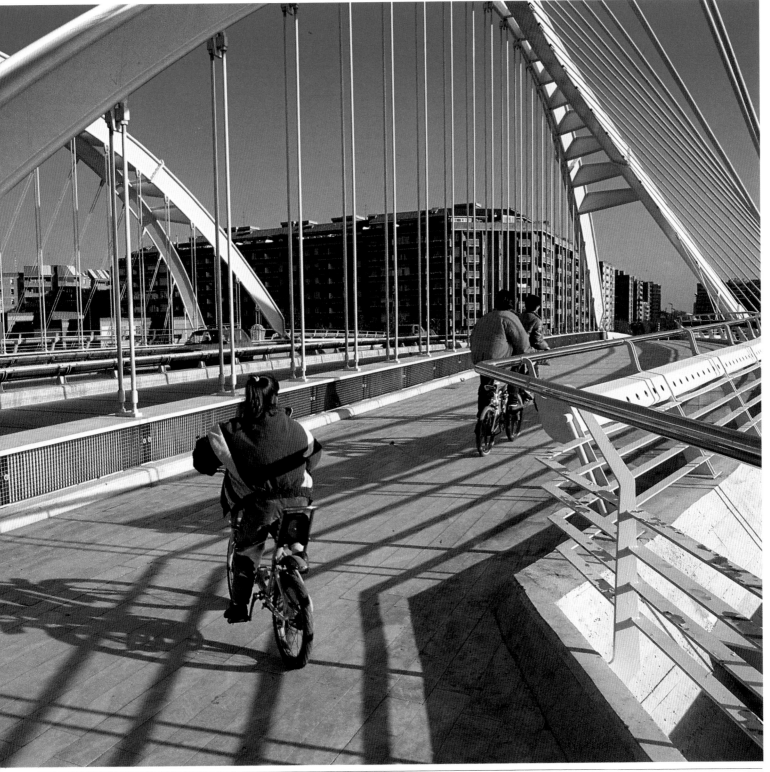

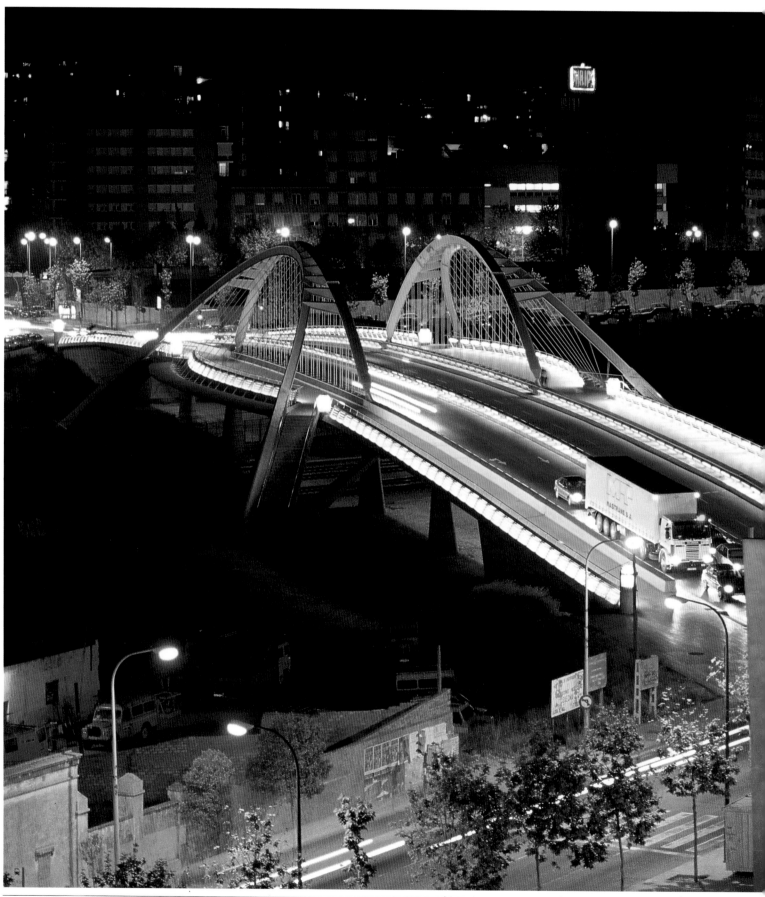

Serra's great wall for the Plaça de la Palmera

Architects:
Pedro Barragán
Bernardo de Sola

Sculptor:
Richard Serra

The Plaça de la Palmera owes its name to a slender, solitary palm tree — brought from the Americas by nostalgic nabobs — which was planted on a piece of open ground where the pattern of the Cerdà Plan can still be discerned in a certain fashion. And I say in a certain fashion, because in this district of Sant Martí we can see how this demarcated space recalls the regular blocks designed by that brilliant town planner, although it does not possess the exact measurements of those of the Eixample.

This space was gained for the public by the first democratically-elected City Council in exchange for a planning outrage perpetrated in that field in which the laissez faire capitalists liked to speculate. To be precise, a well-known hotel grew to a height beyond that permitted by municipal by-laws, and a case was brought against it which was won by the Council. Instead of ordering the demolition of the illegal storeys, it demanded this plot of land instead.

The square was designed by the municipal architects Pedro Barragán and Bernardo de Sola around a sculpture that dominates the surrounding space: one of the largest works created by the young but already well-known American sculptor Richard Serra, born in Majorca in 1939.

When he was approached in San Francisco to produce a work for Barcelona, whose first democratic mayor was a Socialist also called (Narcís) Serra, he was immediately delighted with the idea. At that time, in the early eighties, Richard Serra had already imprinted the personality of his work around the world: minimal yet highly individual, austere yet exceptionally forceful, linear yet able to transform the essence of a space. And this is exact-

ly what he has achieved here, as if by magic. His idea was to erect two walls. Yes, two huge, concentric, plain walls, in which the lines and the two-dimensional format triumph, are more than sufficient to divide the square in half, forming an independent space on either side. Once again he has accomplished the astonishing transformation of a space through an intervention reduced to its minimum expression. His favorite material is steel, and of the various types he prefers corten steel. The problem this caused here was the high cost involved. He then hit upon the solution of turning an intellectual wall into a reality — a wall made of brick and clad in powdered marble to give a subtle texture and also to make it as difficult as possible for paint to adhere to — on the understanding that if the painters of slogans acknowledged it as a wall, so much the better, for graffiti would have the virtue of reinforcing the quality of a complete wall that Richard Serra's sculpture perhaps did not possess at the start.

The architects, in their turn, designed two entirely different zones on either side of the wall, which further helped to underline its essential nature as a divider.

And so we find in one section an open, uncluttered space of bare, warm earth, in the middle of which is another sculpture: the natural, slender, flamboyant palm tree, flanked by two acacias.

On the other side of the wall is an intimate, delicate, sheltered space, almost one might say a furnished space, though the furniture is in the shape of trees: pines and poplars that provide cool shade. Nearby is a small round pavilion that acts as a shelter. The paving and a slight change in level have also been used unfussily by

Barragán and De Sola to round off the whole.

In a corner of the square is another sculpture, a functional one. It is a tall, slim, metal tower that firmly dominates the square, flooding it with a light that banishes the dark night.

The famous American
sculptor Richard Serra
erected one of his walls
to form two radically
different spaces.

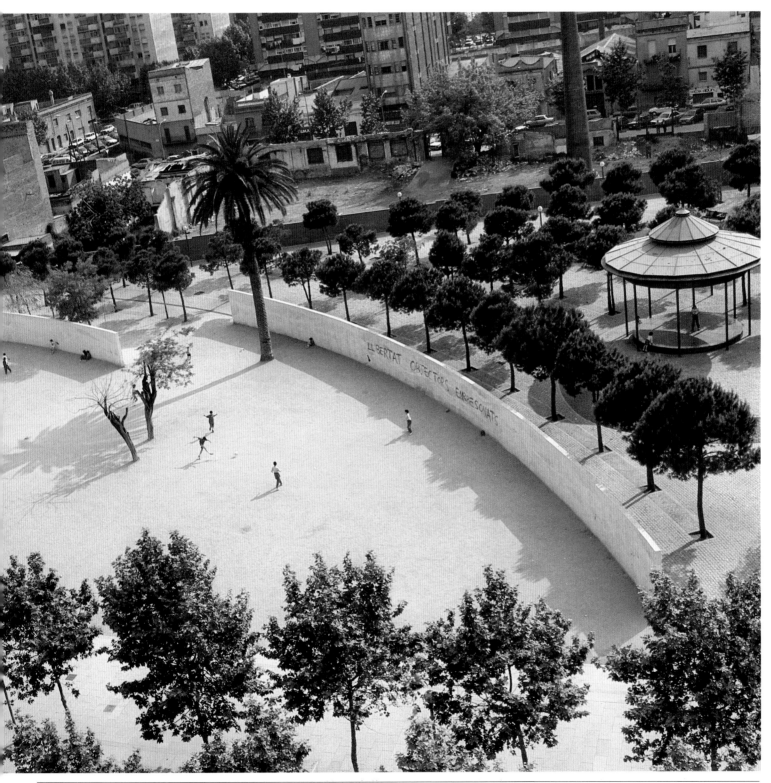

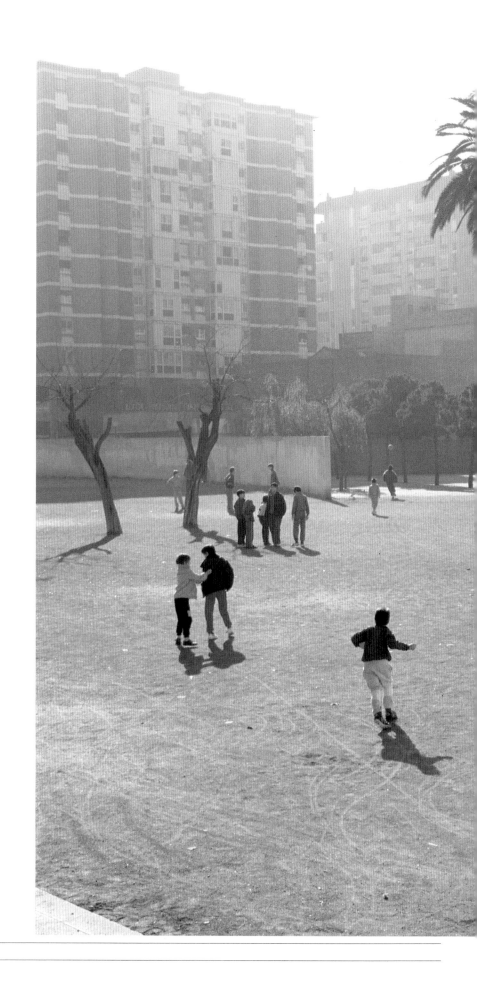

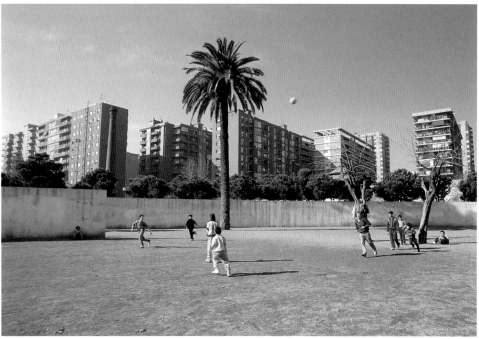

The illumination tower, designed by the architects Pedro Barragán and Bernardo de Sola, deserves to be seen as another sculpture.

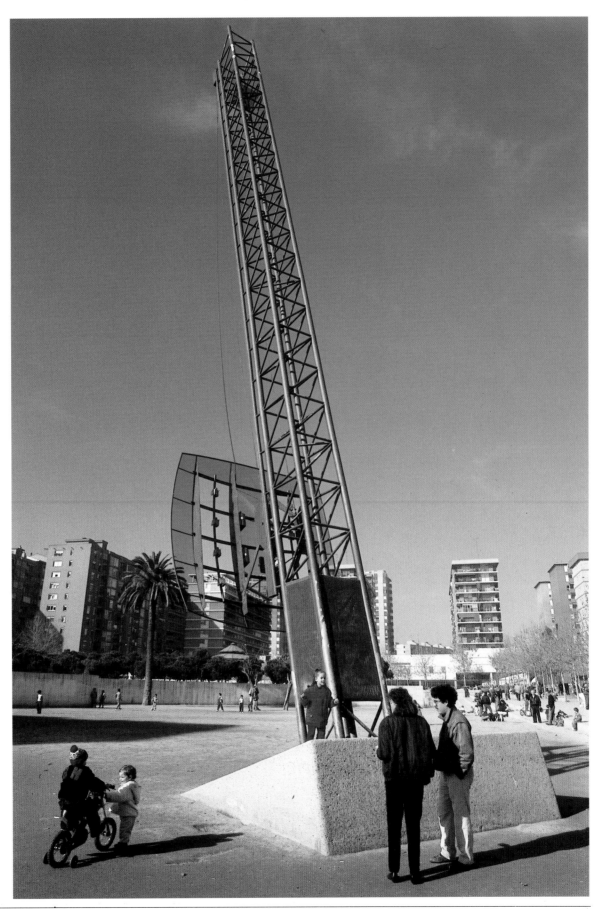

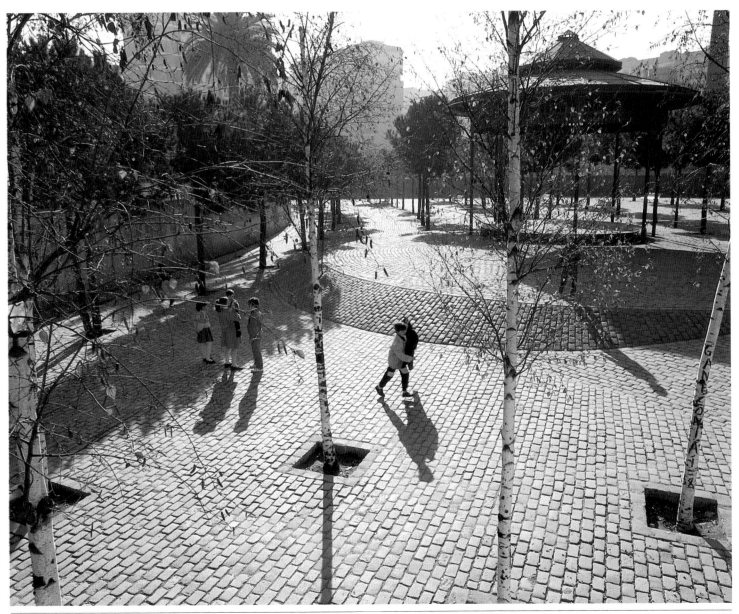

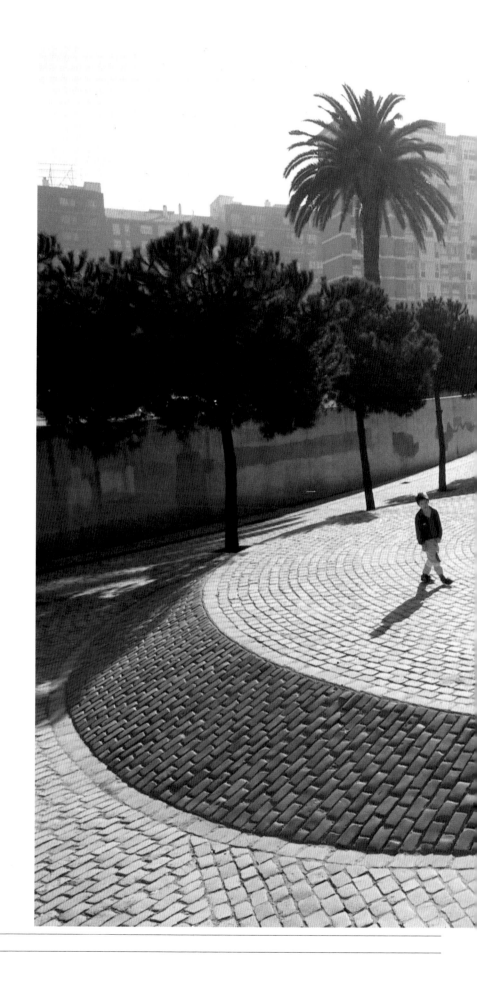

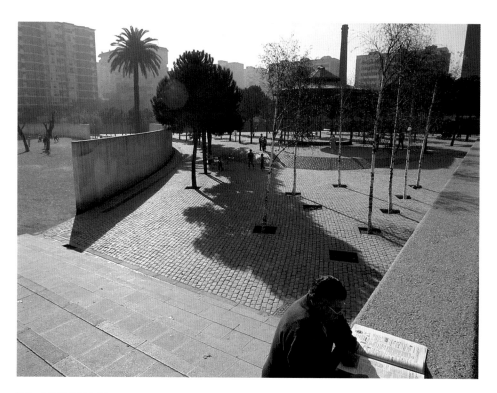

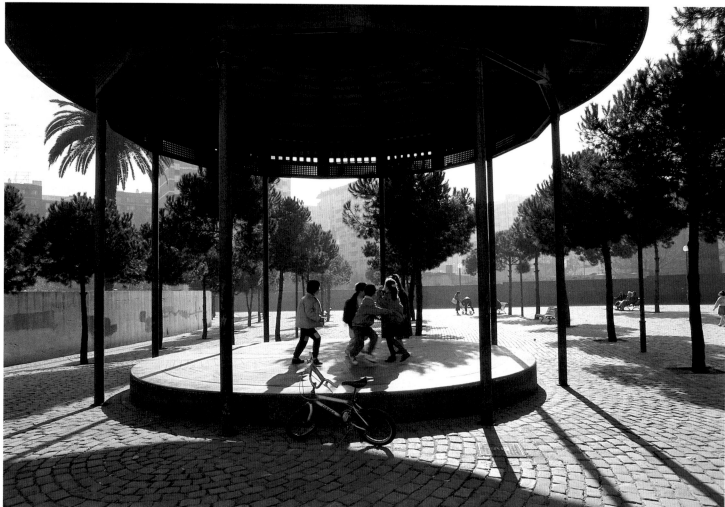

The sea created by Pepper in the Estació del Nord

Architects:
Andreu Arriola
Carme Fiol
Enric Pericas

Sculptor:
Beverly Pepper

The Estació del Nord and its surroundings are an immense area that has been incorporated into the city as a result of a radical transformation. Having taken up the railway line, maximum use has been made of the available space. Whilst one wing of the former station will be converted into a police barracks, the other will become the coach station that Barcelona has for so long needed and lacked, and the central part of the building will be used for the Olympic table tennis events. But in addition to the station building there are the former tracks together with the waste ground in between, which cover not a few hectares. As well as gardens, the area will be used to house the future Teatre Nacional de Catalunya, designed by the architect Ricard Bofill, and the Auditori, the home of the Catalan National Orchestra, designed by the architect Rafael Moneo.

The Estació del Nord park was planned by the architects Andreu Arriola, Carme Fiol and Enric Pericas in conjunction with the American sculptress Beverly Pepper. The large park, measuring 17,000 square meters — once the adjacent properties have been expropriated it will cover a total of 22,000 square meters — is articulated in two clearly differentiated sectors: sun and shade. The sculptress explains that when she suggested this alternative — which always involves complementary elements, the *yin* and *yang* of the same unity, for after all shade is the consequence of lack of light which emanates from the sun — she had in mind the *Sol* and *Sombra* of the bullring, being an ardent admirer of the art of bullfighting. In the sun she installed *Fallen Sky,* and in the shade *Spiral of Trees.*

Beverly Pepper started working in advertising when she was nineteen years old; by the age of twenty-one she had become Vice-President of a large advertising agency. While designing advertisements during the day, she spent the evenings painting. And she finally gave it all up for art: both her work and the United States. She moved to Paris, and after working in two-dimensions she felt an imperious need to place those forms in space; and so it was that she entered the world of sculpture. She generally concentrates on Earth Art in the form of ephemeral works.

The Parc de l'Estació del Nord inspired the two pieces mentioned above. If the Tower of Babel was a spiral construction that reached upwards to the sky, her *Spiral of Trees* is not just a particular interpretation of that glorious undertaking but exactly the opposite: the spiral is made of sky and revolves in an earthwardly direction. Needless to say, the trees delicately adorn this concentric circle that never had any pretensions of defying anybody, least of all a lesser god.

Although *Fallen Sky* has been defined by its creator as just that — a piece of fallen sky — to me it signifies a rough wave that as a result of a sudden swell emerges beautiful, sumptuous and awesome before the amazed eyes of the peace-loving citizens of Barcelona relaxing in that tranquil landscape. This initial impression has made me realise that before the first settlers established themselves on Montjuïc, this area was under water.

Pepper has executed these two magnificent pieces in *trencadís* (irregular fragments of glazed ceramic), a material

which, although new to her, she chose in order to pay her own particular tribute to Gaudí and Miró. They cover six hundred square meters in all, produced by the ceramicist Joan Raventós in his kiln in Sant Feliu de Llobregat: soft colors that are enriched and transformed as the light alters and the seasons change; ambitious works that have successfully recreated the attractive landscape of the Parc de l'Estació del Nord.

Beverly Pepper created a
unique wave in the Parc
de l'Estació del Nord.

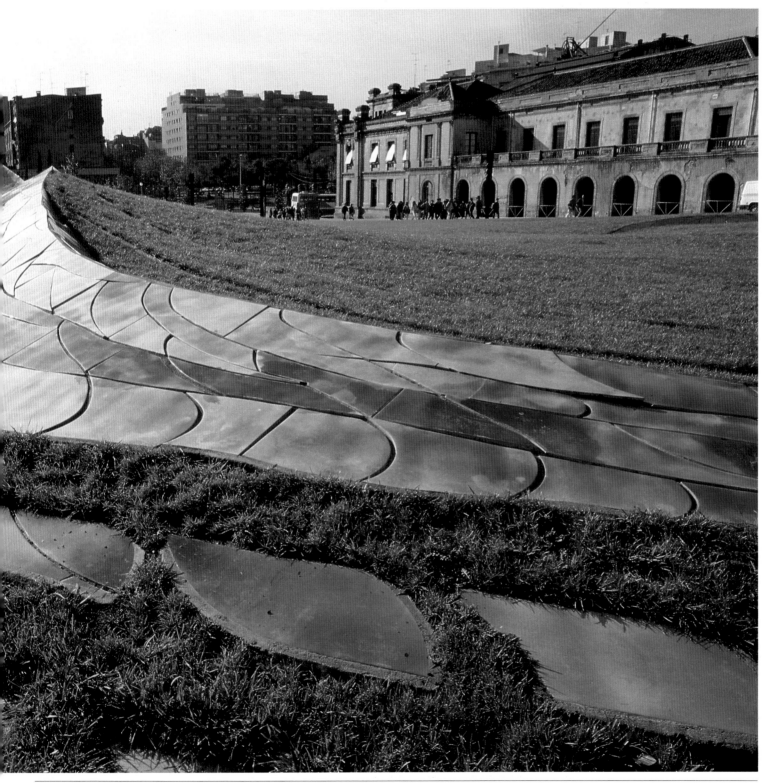

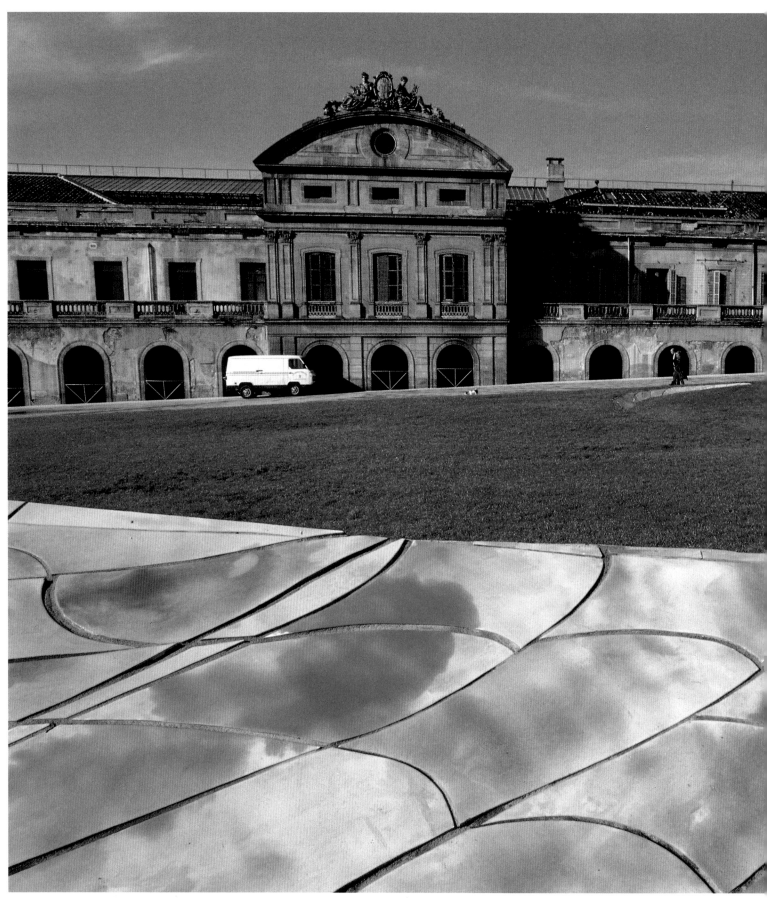

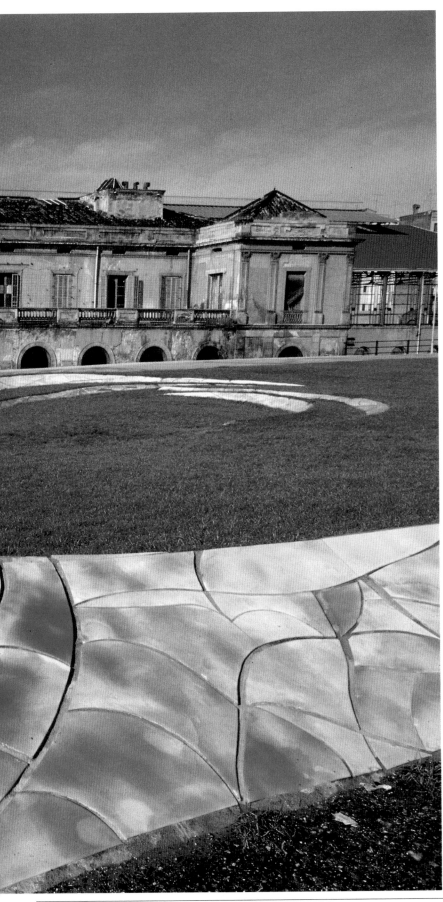

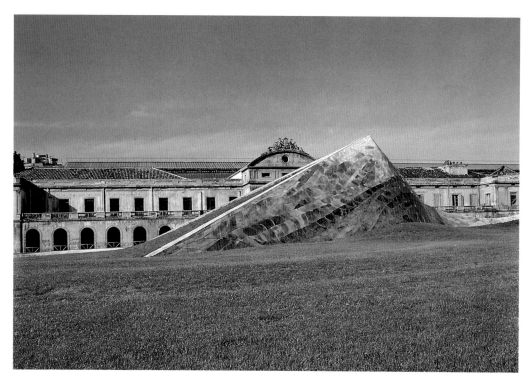

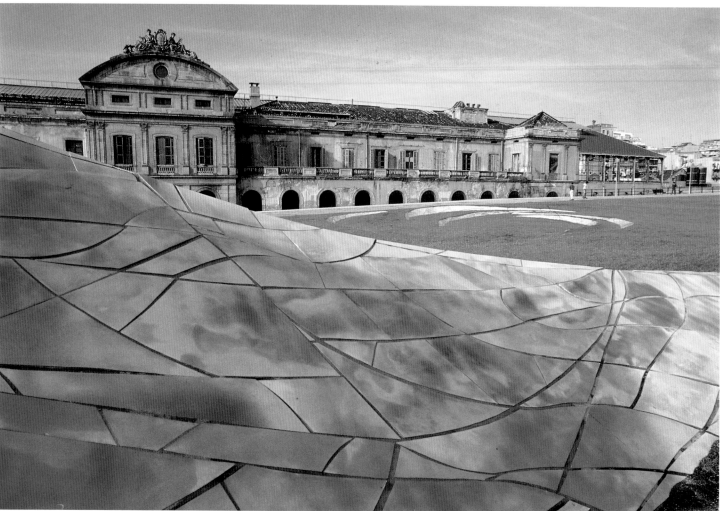

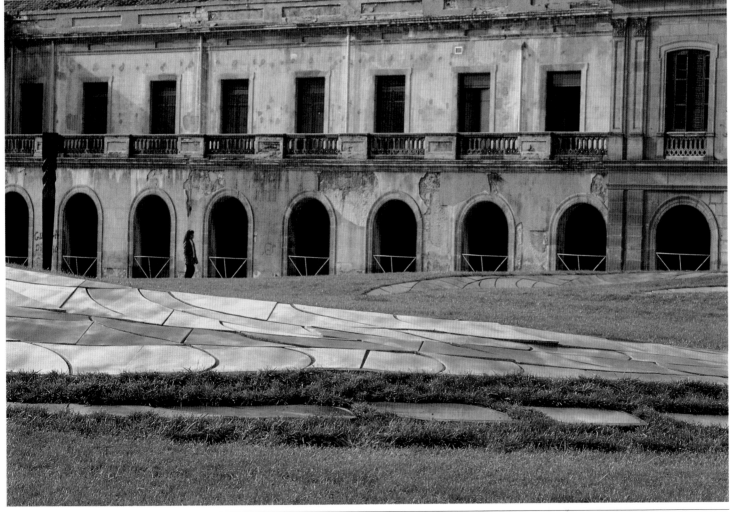

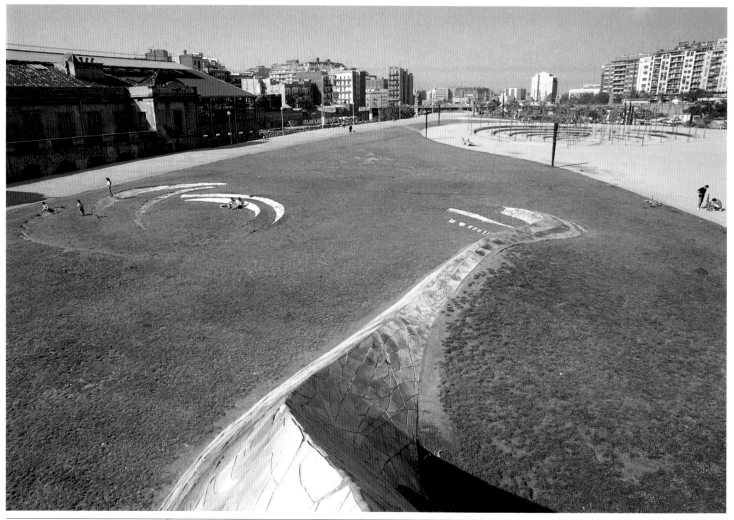

The lampposts also designed by Pepper are truly sculptural pieces.

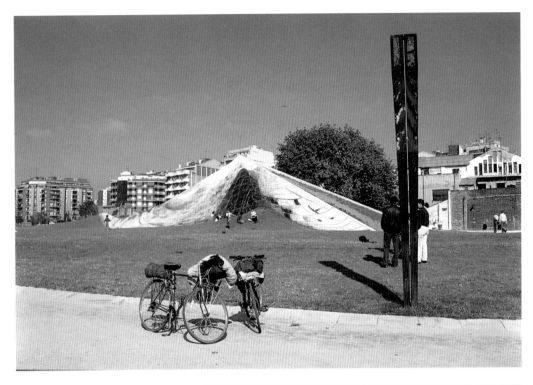

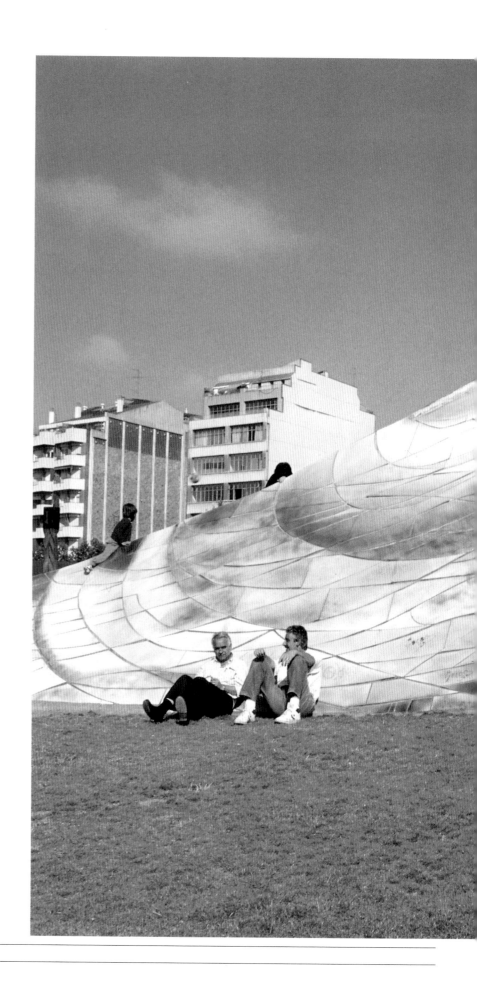

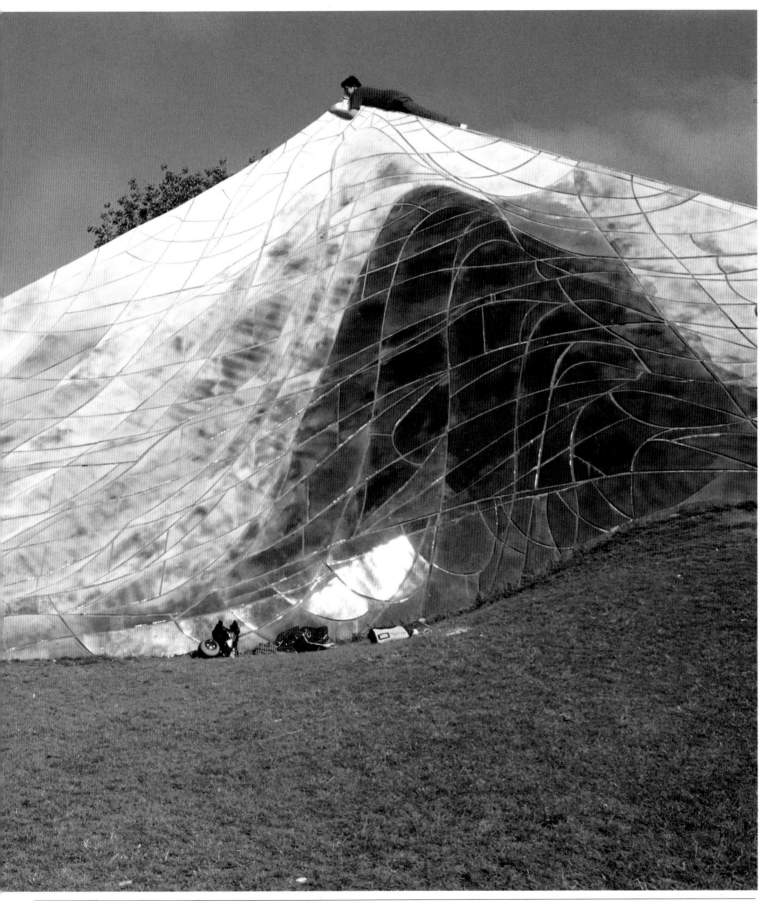

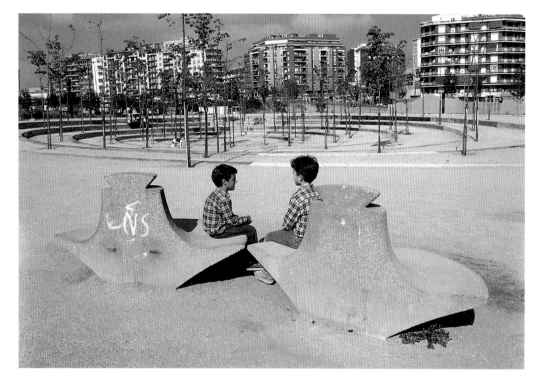

Spiral of Trees is another startling work by the American sculptress.

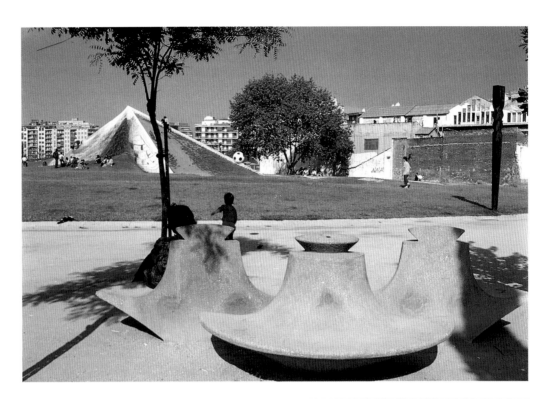

The Moll de la Fusta linking the city to the sea

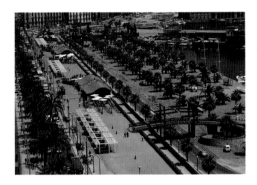

Architect:
Manuel de Solà-Morales

Sculptor:
Robert Llimós

A Barcelona that had had close links with the sea, that had even been the power that dominated the Mediterranean in the Middle Ages, that used it as the main form of travel and communication with all the peoples of that cradle of civilization — strangely enough that very same Barcelona soon erected a barrier in front of the sea and grew up with its back to it.

This occurred at the end of the last century, when industrialization and shipping reached their peak, to the point of converting the port into an exclusively working area. Hence the fact that there was not the slightest scruple about transforming its seafront into a place destined entirely to facilitate such work.

This being so, it is not surprising that the remodeling of what was the Moll de Bosch i Alsina, the first public space to give back to Barcelona that immediate, close-up vision of the sea, should require three very substantial operations.

The first of these was the demolition of the warehouses and other large constructions of no architectural merit whatsoever, which had been built for storing the cargo unloaded from ships to prevent it getting wet or being robbed.

The second was to get the independent port authority to agree not to use the wharf for any shipping or related activities. This was the year 1982.

And the third was to remove the railway track running through the port, which in its day had done so much to facilitate trade.

This was how that space, of a length roughly equal to three blocks in the Eixample and situated at such a nerve center, was handed over for the use and enjoyment of the people of Barcelona.

The most important goal for that whole area had now been attained: to recover the space for public use — in this case a space enhanced by the added value of giving on to the sea.

This was an aspect that affected the past, but there was another dimension that decisively affected its future. For that particular sector was to be converted into a stretch of one of the principal ring-roads around Barcelona, which when completed will prevent a vast amount of traffic having to pass through the city center.

The problem faced by Manuel de Solà-Morales, the architect of the project, was an extremely complex one, for he had to harmonize the flow of traffic along the Passeig de Colom and the ring-road with the creation of a large public space.

One of the principal achievements of the project was to find a means of crossing the ring-road. The flow of traffic along it when it comes into service, which could have an adverse effect on the area, has been cushioned by designing it on a series of different levels that hide it from view and reduce the noise. At the same time, the difference of levels means that pedestrians on the seafront are able to view the buildings along the Passeig de Colom as if they were standing on a terrace. It is a pity that, because the ring-road cannot be sunk any lower, the view of these front-line buildings is cut off at first-floor level.

Despite the fact that the official name of this wharf was the Moll de Bosch i Alsina, it has always been popularly known as the Moll de la Fusta (Timber Wharf), for the warehouses were mainly used for storing wood. This name also strikes a strong poetic note, for the avant-garde poet Salvat Papasseit, forced to earn a few pennies on which to survive by working as a watch-

man, admitted that he knew only too well what it meant to guard timber on a wharf.

Each morning, at the same time, a huge crane has to travel along one of the thoroughfares, between the Moll itself and the elevated walkway. This was why the architect had to resort to drawbridges, which thus gave him the opportunity to design two bridges that are real sculptures in both form and concept. In addition, they were painted red, not to draw attention to them but to give a Post-Modernist touch by way of the coloring. Close observation shows that the design of the bridges pays somewhat more attention to form than to function, for given the current progress of technology and making the maximum use of available materials, problems that previously existed are being resolved with increasingly greater simplicity. Hence the fact that in not a few cases the purpose of

a bridge is considered to be mainly an aesthetic one, with the strictly functional aspect being taken for granted and considered of minimal interest.

One can see that it was an architect who designed these bridges, when observing how the base and the ramp have been planned from a purely architectural viewpoint. I am sure that an engineer would have produced a more uniform design, more integrated in the characteristic anatomy of constructions intended to span a space. The overall result here is certainly interesting, for perhaps the details are more subjective and in particular more creative.

The painter Robert Llimós has here produced sculptures for the first time: two curving blue and green lines, so typical of his style of painting, which are firmly planted in space.

Along the elevated walkway are a series of edifices operating as bars or restaurants. To my way of thinking, some of them are badly sited, for they block the view of the more interesting buildings along the Passeig de Colom, such as the one just in front of the Capitania General.

The plan is to place along the walkway at least four sculptures by the controversial young Austrian artist Rob Krier, whose brother Leon is already well known in professional circles around the world. He has been commissioned to produce a tribute to a number of local personalities connected with the sea. Of the two pieces in an expressionist style of realism that have already been cast in bronze, one is a bust of the poet mentioned above, Joan Salvat Papasseit, and the other is in memory of the military engineers who laid out the Barceloneta district.

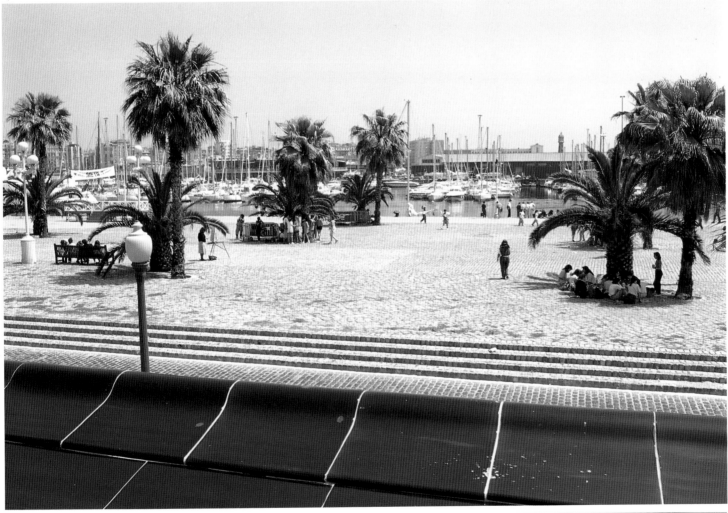

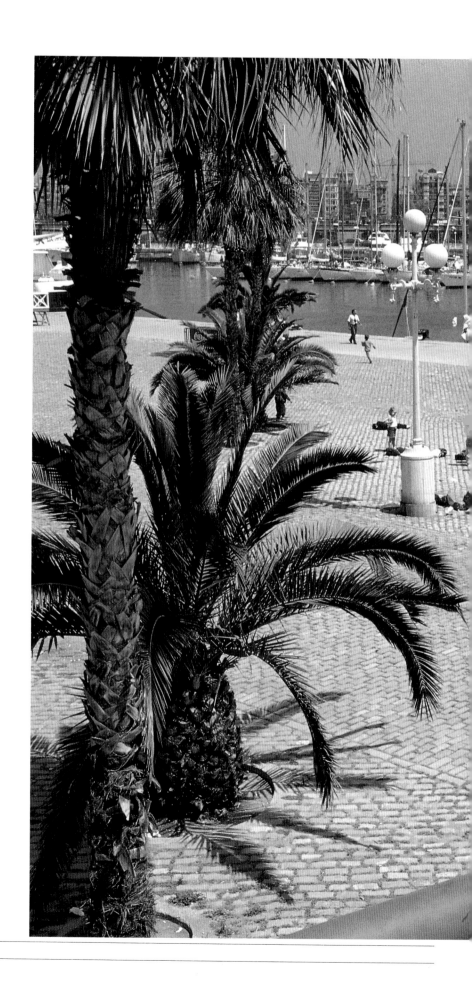

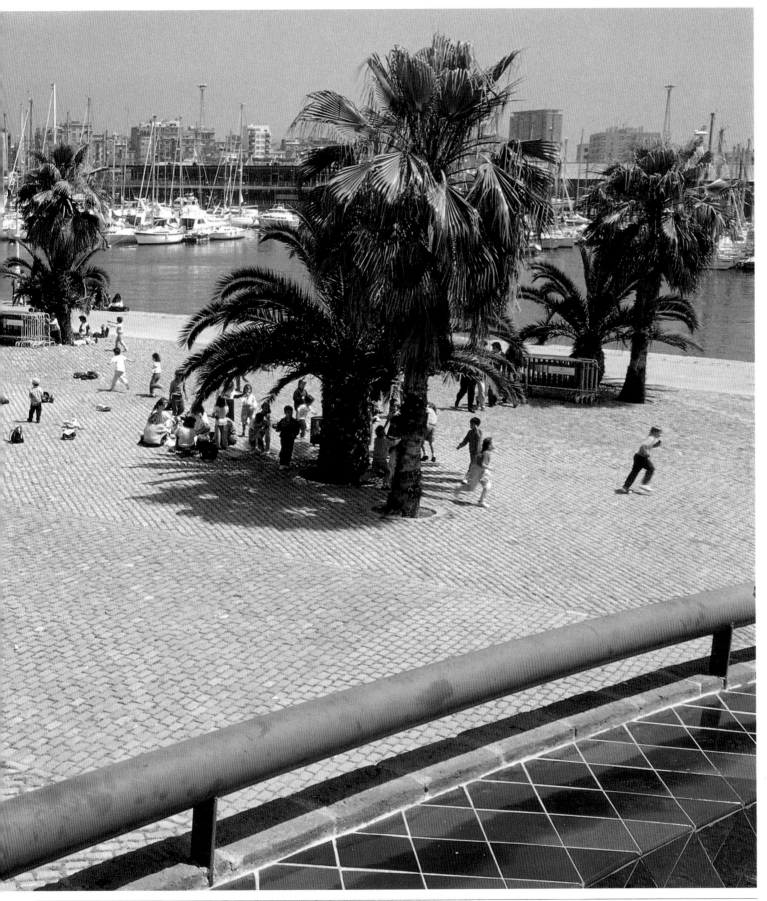

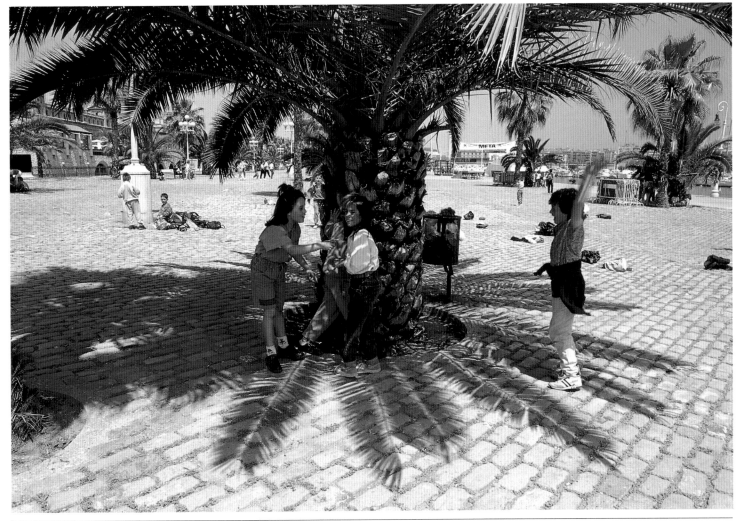

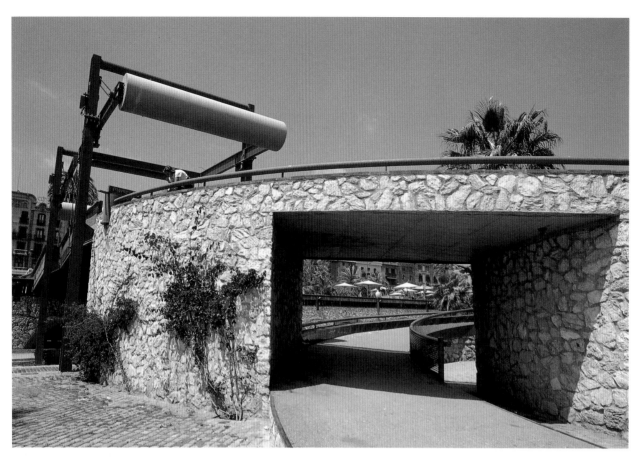

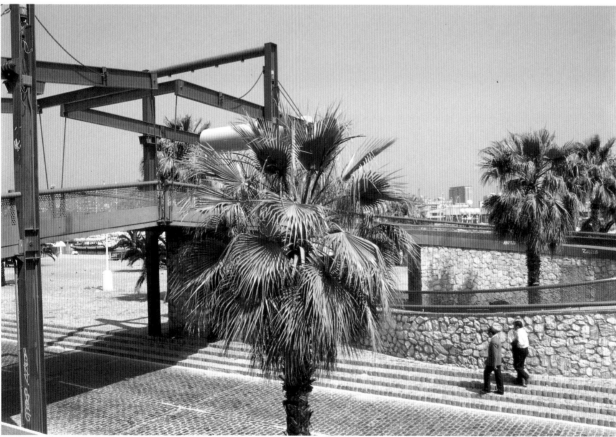

The bridges designed by the architect Manuel de Solà-Morales must surely be considered as sculptures. On the right, the sculpture drawn by the painter Robert Llimós.

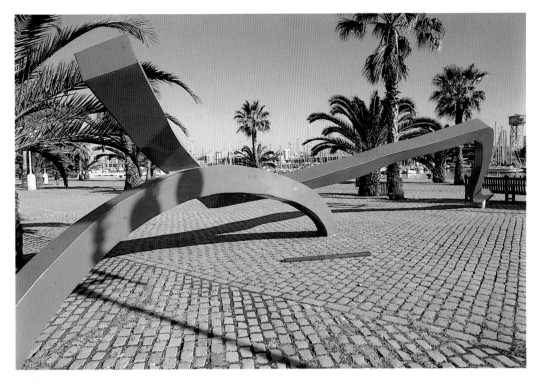

Two Kellys in the Plaça del General Moragues

Architect:
Olga Tarrassó

Sculptor:
Ellsworth Kelly

This small square is bounded by Carrers Felip II, Palència and Sagrera. Despite its size, from a planning point of view it must be seen as the integrating point of a large area covering over 50,000 square meters, for it will link up with the zone surrounding the future RENFE Sagrera railway station, in which the show piece will be the Parc de Sant Martí. And it is in this whole area that the bridge designed by the architect-engineer Santiago Calatrava will play an undisputed leading role.

The square pays tribute to the memory of a historic Catalan general. His name was Josep Moragues i Mas, and he distinguished himself by his heroic actions during the War of the Spanish Succession and the siege of Barcelona. After the surrender, he tried to escape and reorganize the resistance movement, but he was captured in 1717 and his head was displayed for twelve long years on one of the city gates.

The remodeling of this half-block was the work of the young municipal architect Olga Tarrassó. It is a very simple square, in which she has tried to intervene as little as possible. I think she understood perfectly what was needed, for sometimes an excessive protagonism can have negative repercussions, according to the characteristics of the surrounding area. Here, in addition, the design toned well with the essential nature of the work of the American sculptor Ellsworth Kelly and also with the historical events associated with the figure of General Moragues. Tarrassó merely stretched along one of the sides of the triangle a gentle, angular rampart built of red brick. It breaks up the visual effect, creating a dual area, but it is also a bare, minimal element in which she has used a material that in my view recalls fortified constructions.

Tarrassó's work helps to create an atmosphere in which the two pieces by the American sculptor and painter are easily integrated. Kelly was born in 1923 in Newburgh (New York). His artistic career has always been distinguished by works in wood or metal with pure, simple lines. Some of his pieces have been installed in Lincoln Park, Chicago and in the Metropolitan Museum of Art, New York.

One of the sculptures is a monolith of extreme nakedness, a quality that is emphasized by the material employed. A single piece of white concrete 20 meters high, its clean lines and color immediately attract the attention of the passer-by.

Near this stands an impressive dihedron. It is 13.5 meters tall and is made of corten steel, and exposure to the air has served to give it a rich patina. Its color is warm, and despite the fact that it consists of an elementary aperture of a disarming simplicity, it is important to observe carefully the dialogue and the tensions that spring from its now close, now distant relationship to the white stele.

The Plaça del General
Moragues is enhanced by
the proximity of
Calatrava's bridge.

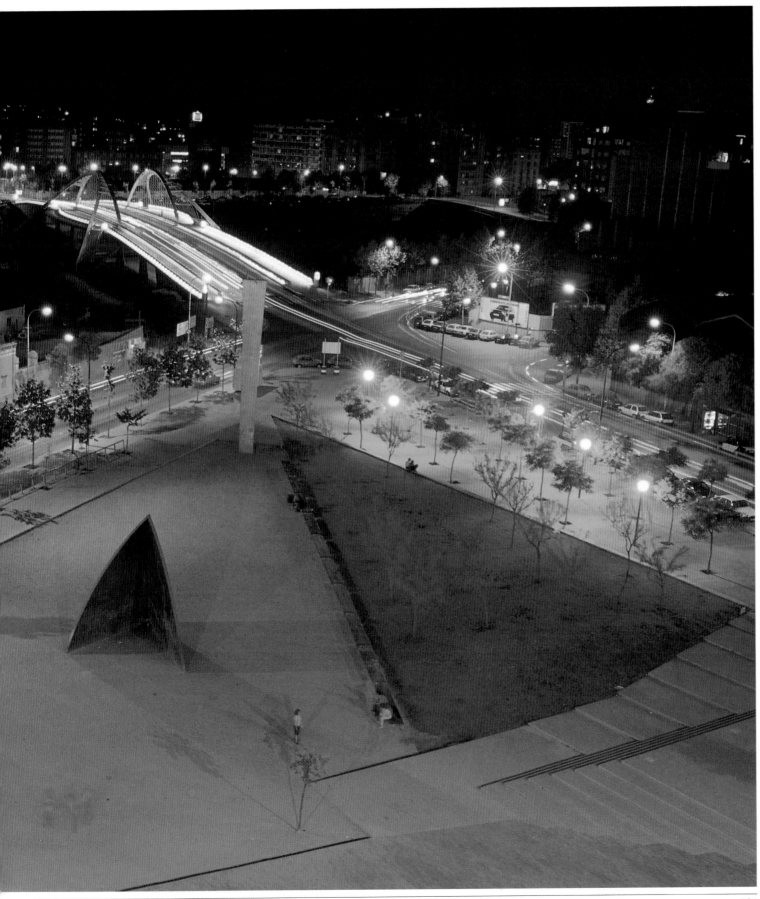

Kelly's simple, essential
monolith.

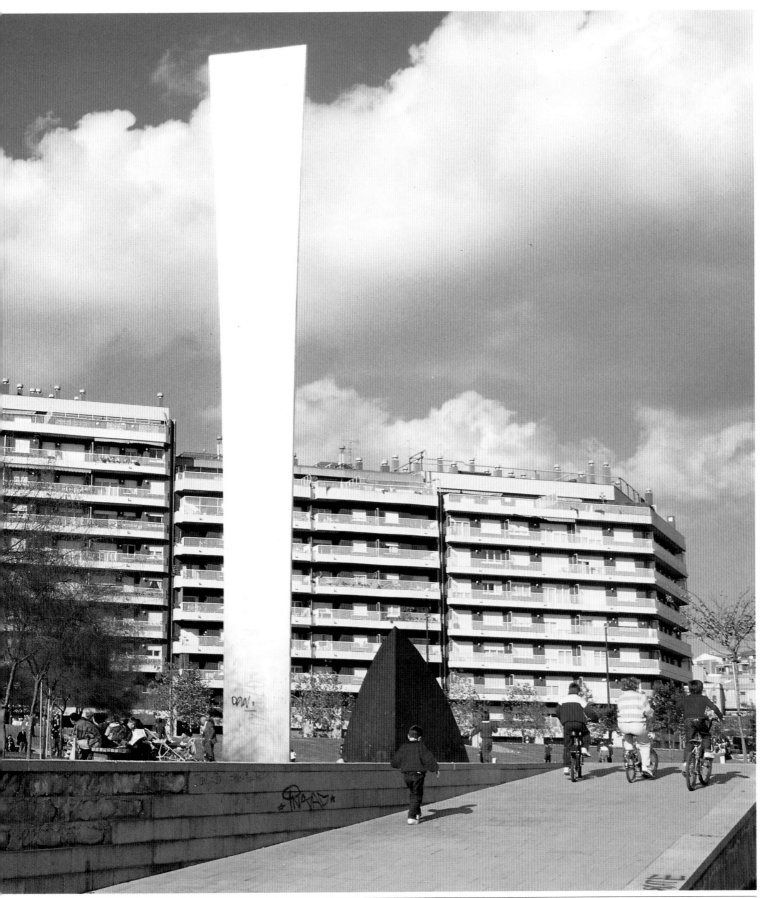

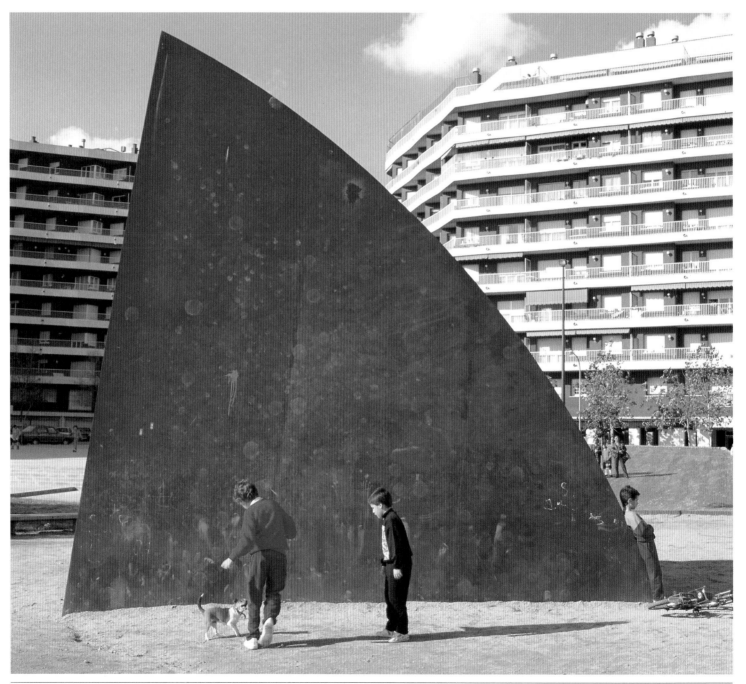

The corten steel dihedron embellishes the square and forms an attractive counterpoint to the brick surround designed by the architect Olga Tarrassó.

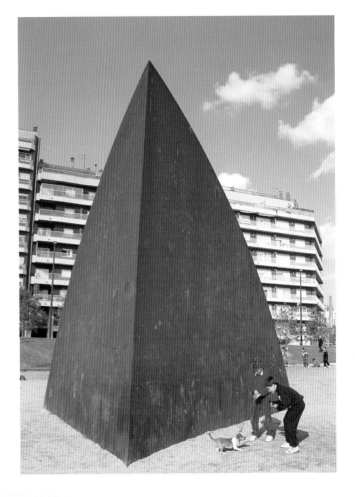

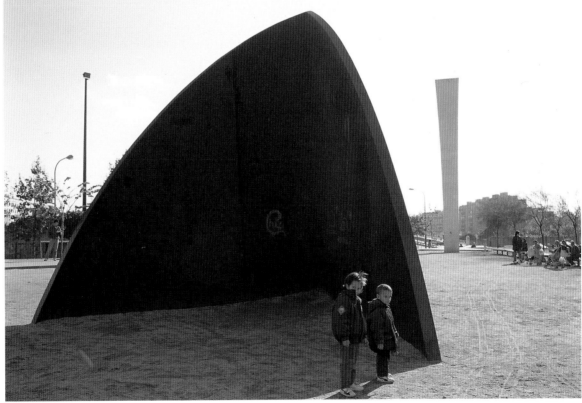

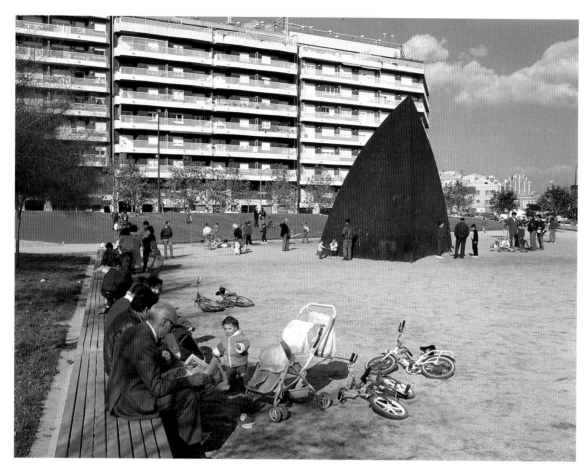

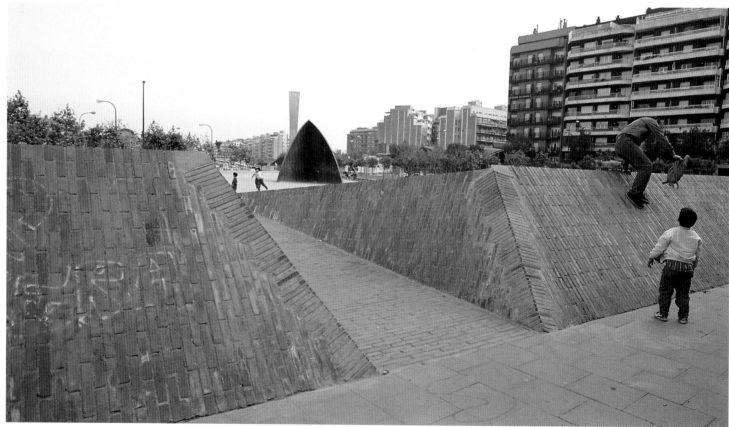

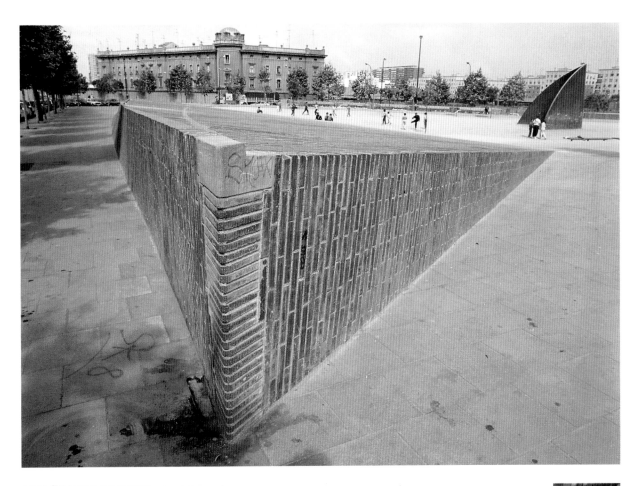

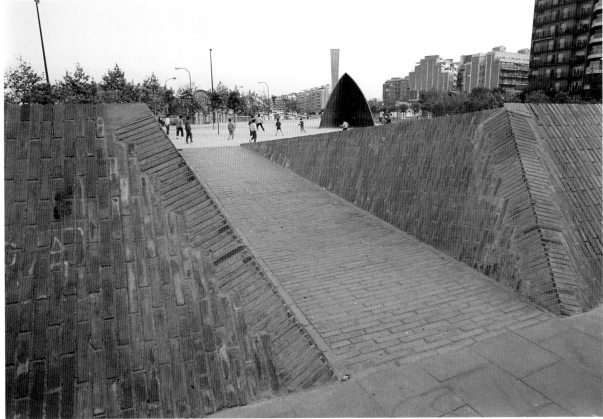

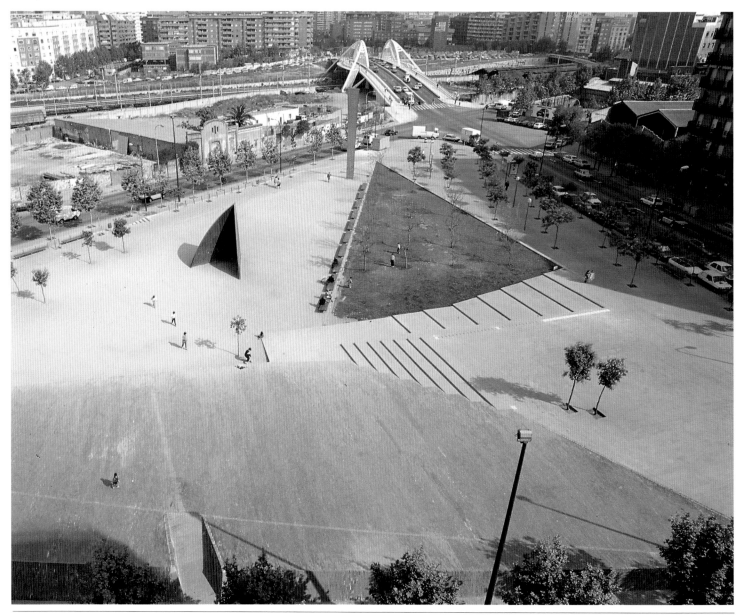

The creative gardens of the Vil·la Cecília

Architects:
José Antonio Martínez Lapeña
Elies Torres

Sculptor:
Francisco López Hernández

The Quinta Amèlia is an old park that failed to escape the property boom when it was acquired by the City Council some time ago. On the adjacent site that formed part of it stood the Vil·la Cecília, surrounded by a spacious garden. The construction of the Carrer de Santa Amèlia cut through the Quinta Amèlia park and the gardens of the Vil·la Cecília, but the remodeling of the area was so successfully done that instead of separating them irreversibly the street has helped to relate and even link them conceptually.

Whilst the park is designed in the French style, the Mediterranean gardens have been embellished with a series of bold, avant-garde touches.

The project was the work of the architects José Antonio Martínez Lapeña and Elies Torres. It was a daring one, respectful yet imaginative, unusual yet communicative, artistic yet functional.

The first thing one notices is the pains they took not to disturb either the layout of the garden or the vegetation. And, however unobservant one may be, one cannot fail to notice too the touches of irony with which the architects adorned their work, albeit with exquisite restraint.

No sooner has one entered the park than one's attention is drawn to the gate. It is an invention based on an optical illusion, which although it does not totally deceive the eye, as the traditionalists would wish, plays a game with the visitor, for it creates an unorthodox visual sensation that is sufficiently measured to enable one to realize from the outset what it is all about.

Very close to the gate are a number of unusual trees. They are made of metal, with their trunks and their large, flat, fan-like leaves suggesting a tropical origin. The indirect lighting, deflected by the metal plates, adds to the ambiguity. At no time did the architects attempt to deceive the astonished visitor, who immediately realizes that they are lampposts of a very avant-garde design.

On entering through the main gate, there is a large pool on the left. A narrow strip of water surrounds the disturbing sculpture by Francisco López Hernández — *Drowned Woman* — in its magnificent setting. The life-size figure cast in bronze is modeled with the minute attention to detail that was to be expected from a conspicuous member of the Madrid group of realists. Alongside it is the wall surrounding the garden, which has been given a pictorial treatment: painted in blue wash, it is adorned with bunches of straggling roots and strategically placed flaking patches, giving it an air that is somewhere between decadent and rural, between abandoned and solitary.

By merely painting some emphatically white lines, the architects have succeeded in emphasizing vistas that both mark the way to go and give a certain illusion of perspective. Sometimes the lines are straight, at other times angular; quite often they are broken or winding. It is important to reflect on how such a subtle, minimal feature can manage to make such an overall impact, for it seems that although the device tries to pass unnoticed, it is sufficiently eye-catching for one to be aware of its constant presence in every single part of the gardens.

The recreational aspect of the gardens — which must not be overlooked, for they contain a sports ground — is accentuated by the appearance more suited to a

children's playground that was given to the benches, with their simple forms and crude, garish colors.

It is the first time I have seen any gardens designed in an avant-garde spirit that are also characterized by their exquisite discretion, for the architects considered there was no justification for detracting from nature or for interfering with the traditional style of the garden. The result is highly satisfactory and gratifying.

A garden filled with amusing asides by the architects José Antonio Martínez Lapeña and Elies Torres.

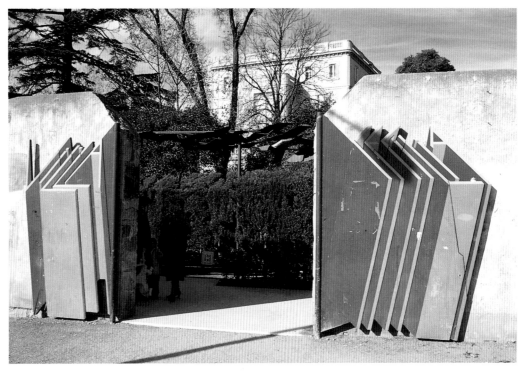

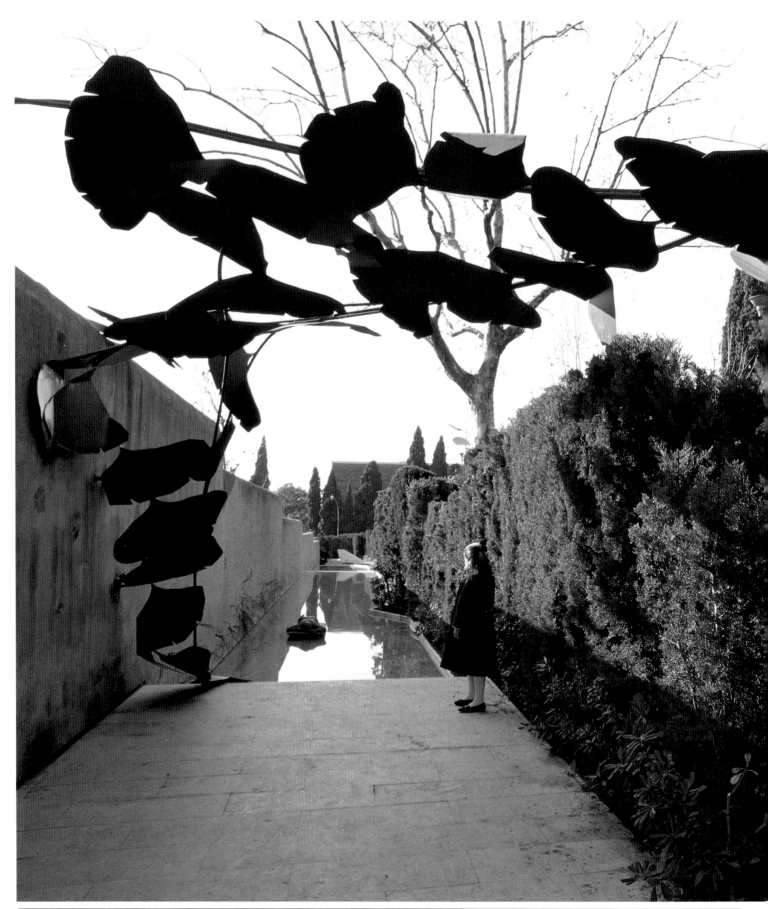

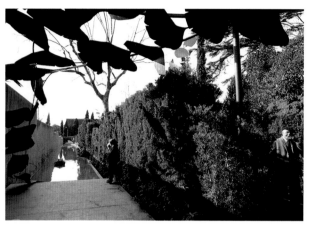

Sculptural metal trees
created by the hand of
man.

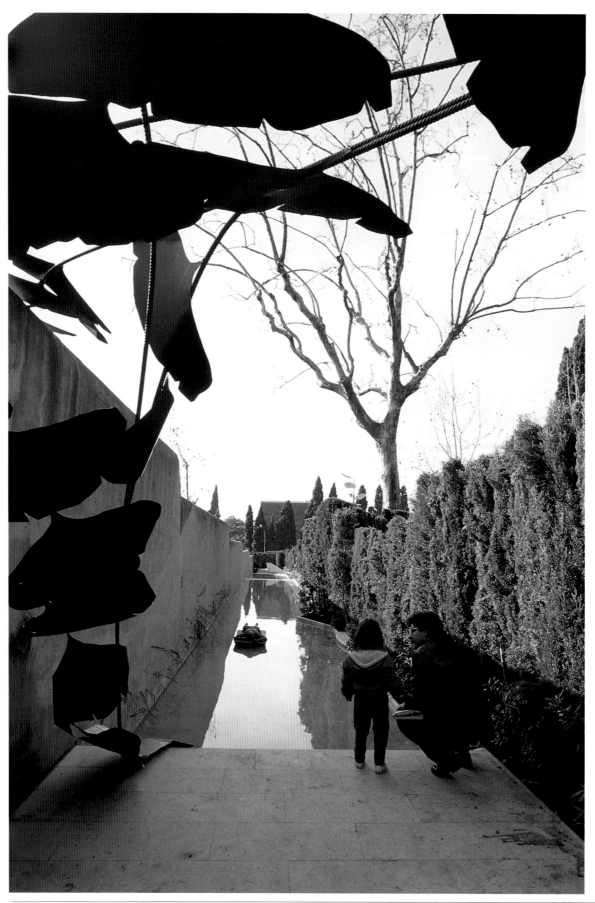

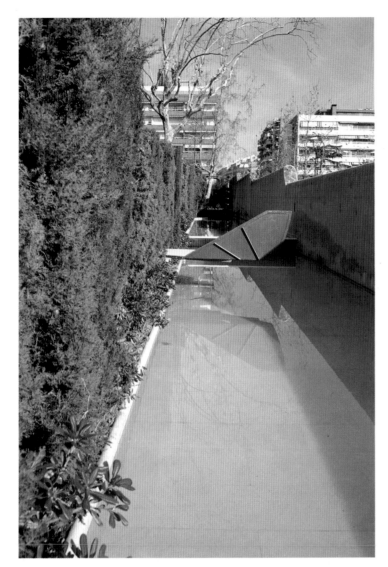

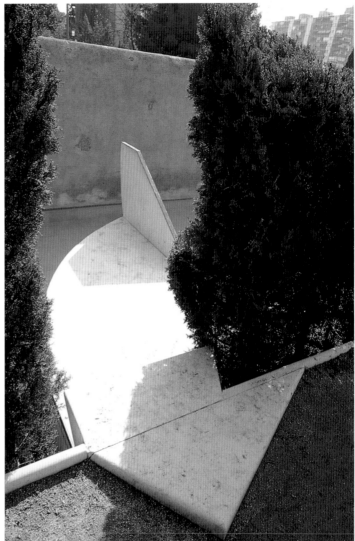

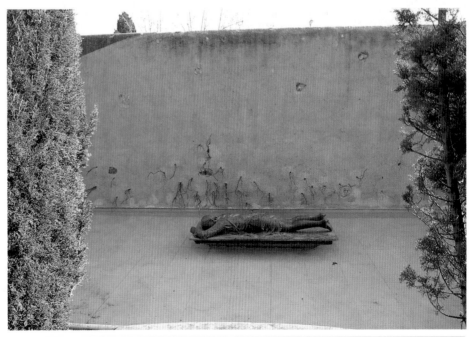

Drowned Woman, a provocative and disturbing work by the sculptor Francisco López Hernández.

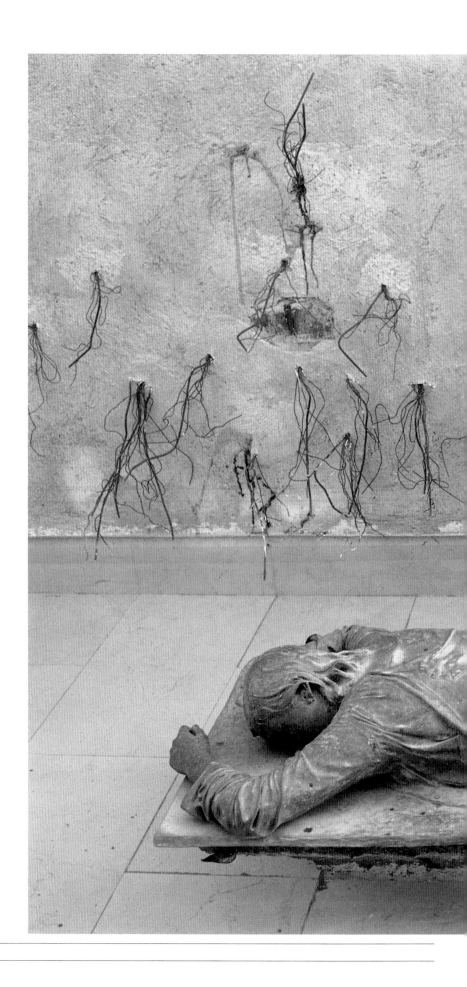

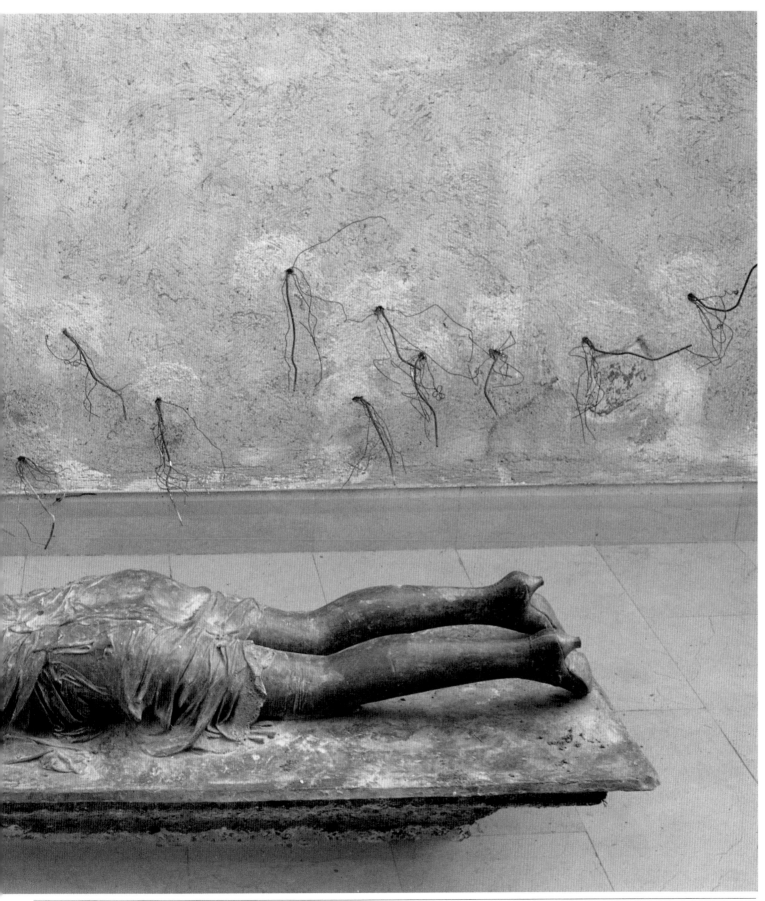

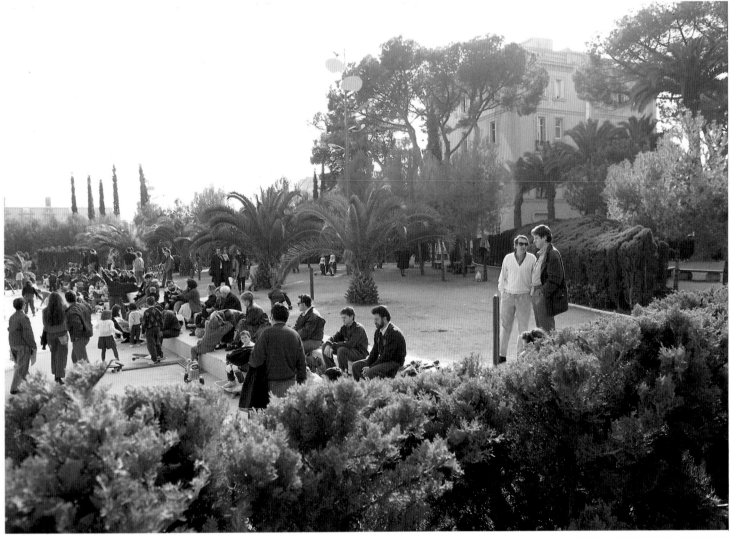

The Via Júlia, between Sergi Aguilar and Antoni Rosselló

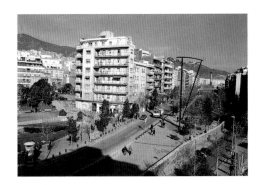

Architects:
Bernardo de Sola
Josep Maria Julià

Sculptors:
Sergi Aguilar
Antoni Rosselló

"Not even Le Corbusier could do anything with this," exclaimed Bohigas in a mixture of indignation and desperation. But those who know Oriol Bohigas are well aware that indignation suits him, though not desperation, for he is a courageous and tenacious man. He had, in fact, just taken up his post as the City Council's head of town planning. And he made this remark as soon as he saw the Via Júlia. Until then it had been a strange, wide avenue with the pavements bordering two narrow traffic lanes in the middle of which was an enormous long hump running along the entire length of the street. This aberration was the result of the planning horrors perpetrated during the last years of Mayor Porcioles, who gave the laissez faire capitalists a free rein; just one of so many rotten legacies of the town councils of the Franco regime. The reason for this hump down the center of the Via Júlia was the decision to build the Metro tunnel almost on the surface in order to save as much money as possible.

The municipal architects Bernardo de Sola and Josep Maria Julià were given the job of putting to rights that chunk of mountain lying almost forgotten in the middle of a city street.

Their work deserves to be contemplated in detail, and it is reassuring to get out of the Metro at Llucmajor and walk the whole length of the Via Júlia. They have solved the problem of the difference of level with elegance and imagination but without force. The flower beds, the row of palm trees, the benches, steps and ramp, the large parasol — everything has been carefully studied, including the use of color.

Sergi Aguilar, one of the foremost young sculptors, dared to erect his most am-

bitious work here. And I say this because he had never done such a large piece: the formats he generally produces are for showing in a gallery.

Aguilar admitted to me that he let himself be inspired by the environment. This is certainly true, for usually in his sculptures it is the horizontal that predominates, whereas in this case it is the vertical. He also realized that although it was to be a very tall sculpture he should not succumb to the temptation of installing a useless hulk bowed under its own weight. Austerity and synthesis suit him to perfection. Hence *Júlia,* made of corten steel, 18 meters high and weighing 18 tons, is an unmistakable Aguilar, definite, elegant, graceful and strong, based on a well-studied geometry. *Júlia,* which owes its title to the name of the avenue, is a tribute to immigrants, who have settled in the Nou Barris district. At the top of the ramp leading up to the sculpture is a large metal plaque, also designed by Aguilar, on which is inscribed the following extract from *La pell de brau* (The hide of the bull) by the poet Salvador Espriu:

Fes que siguin segurs els ponts del
[diàleg
i mira de comprendre y estimar
les raons i les parles diverses dels
[teus fills.

(Make the bridges of dialogue secure
and try to understand and love
the reasons and the many languages
[of your children.)

Marking the other end of the Via Júlia is the Torre Favència, 24 meters high, designed by the architect Antoni Rosselló. It varies greatly in appearance from day

to night, for its function is to act as a column of light, more like a lighthouse that warns than a lamppost that illuminates part of the ground. The texture of the typical rust that appears on corten steel contrasts with the smooth, silvery surface of the polished steel.

Although very different from each other, the sculptures by Aguilar and Rosselló maintain a fruitful dialogue and mark a public space that has been embellished by art.

The elegant *Júlia* that
Sergi Aguilar has erected
as a tribute to
immigrants.

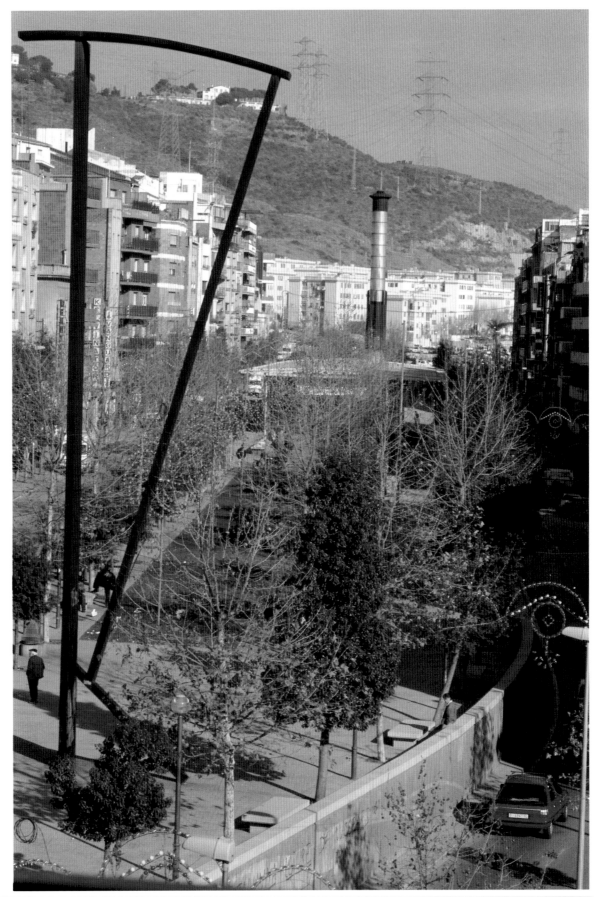

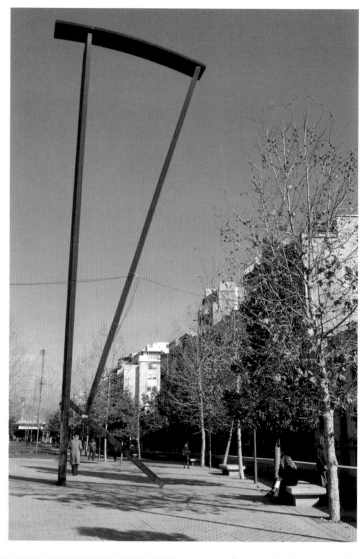

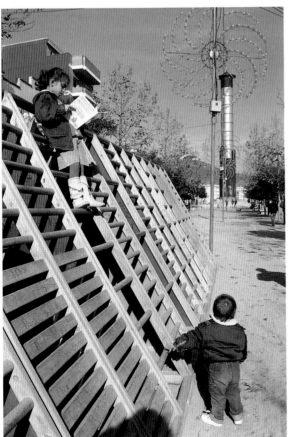

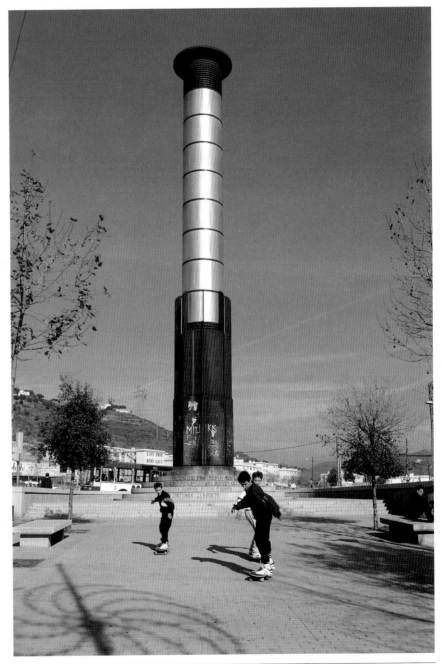

THE VIA JÚLIA, BETWEEN SERGI AGUILAR AND ANTONI ROSSELLÓ

THE VIA JÚLIA, BETWEEN SERGI AGUILAR AND ANTONI ROSSELLÓ

Plensa's cast iron in the Plaça de Francesc Layret

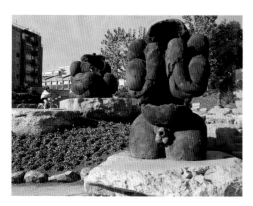

Architect:
Enric Pericas

Sculptor:
Jaume Plensa

The Plaça de Francesc Layret — named after the Catalan republican politician assassinated in 1924 — lies along one side of the Via Júlia, precisely on a level with the sculpture by Sergi Aguilar, which led Jaume Plensa to place his three pieces in the square according to how they would be seen from the foot of Aguilar's *Júlia*.

The Plaça de Francesc Layret is therefore a focus of attraction for the pedestrian strolling aimlessly along the Via Júlia.

The municipal architect Enric Pericas was responsible for the design of the square, which so far covers an area of 5,000 square meters. There are still a number of properties to be expropriated and this will increase its size. The site was not an easy one, for part of the small area was unusable because of the steep banks. The architect has overcome the problem with stepped terraces, and by combining the path with a gently sloping space and winding steps, which border the formidable pieces by the young but already renowned sculptor Jaume Plensa.

The material he has used is a typical one in Barcelona: cast iron. It was first employed in the 1860's, and gained rapidly in popularity, especially as a consequence of the fact that the City Council used it for monuments and all manner of street furnishings. So much was this so that Manuel Angelón, the author of a satirical guide to the city, dedicated a whole chapter to mocking what was considered a cheap substitute for wrought iron.

Plensa has used this material to produce three pieces, baptized with the name *Breakwater*. He models rather than outlines, since he is forced to do this as a result of gradually increasing the volume as he applies the cast iron. He admits that he finds such work exciting. It is not that he is using this material for the first time simply for this one municipal commission, but on the contrary it marks a new phase in his production, for a substance of such force, quality and especially texture gives character to a sculpture.

The three pieces are of a similar size, although the largest is about 4 meters high and weighs about 3 tons. The forms he has created are something entirely new. They give the work a dimension and a profile of a highly provocative nature and of an imposing, intractable rotundity. They remind me of the unforgettable presence of the Willendorf *Venus* with its bulging forms. Similar curves inevitably put us on the track of the human body, despite the absence of any allusion to sex. I think it was a brilliant idea not to close the pieces altogether but to leave a number of apertures, for they are immediately enhanced by the disturbing interior space.

The cast iron confers on them the quality of urban sculpture rather than gallery or museum sculpture, which obviously facilitates their integration with the surroundings.

The color and texture bestow tremendous force, which also draws one towards them, and even makes one want to caress such an attractive surface. From a distance, however, the potent shapes cause an immediate impact that compells us to continue gazing at them for a long time.

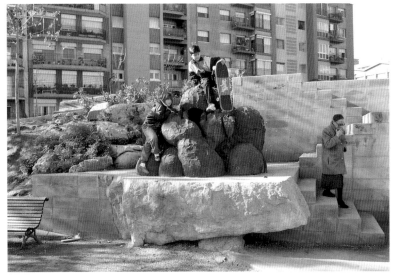

Breakwater is the title of the powerful sculptures modeled in cast iron by the sculptor Jaume Plensa.

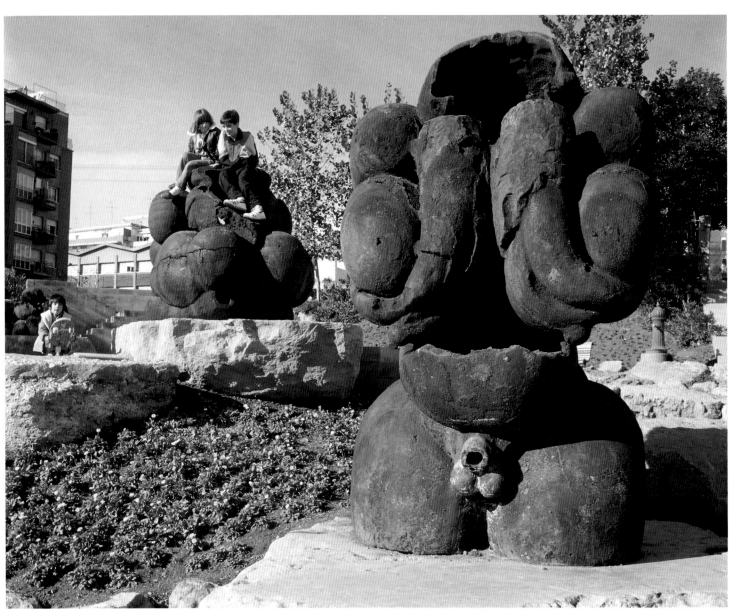

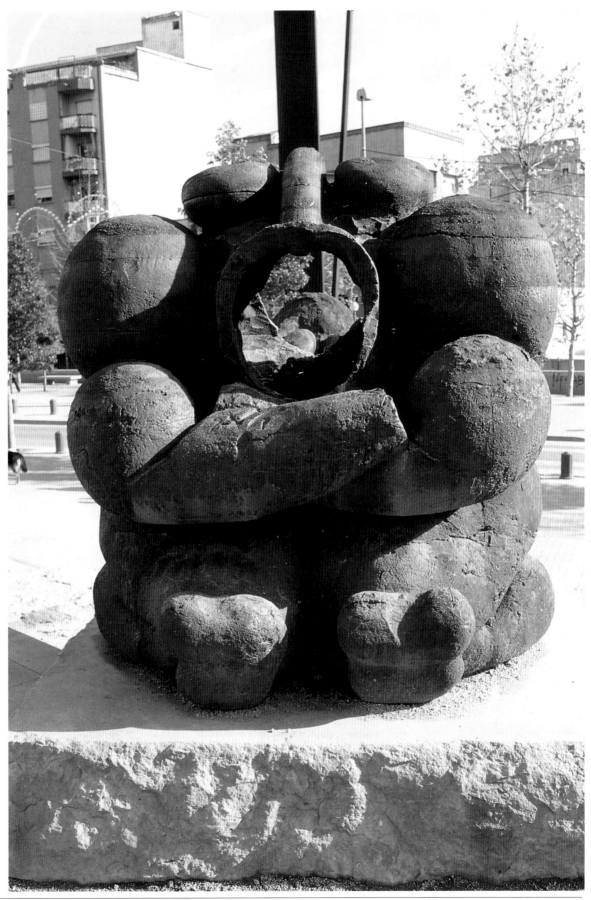

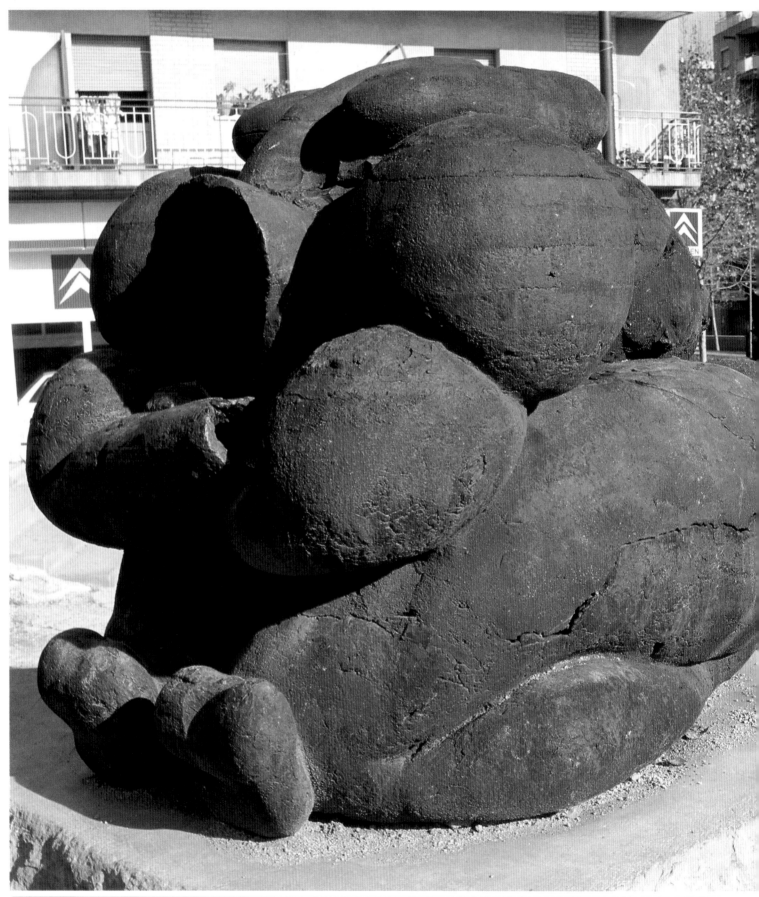

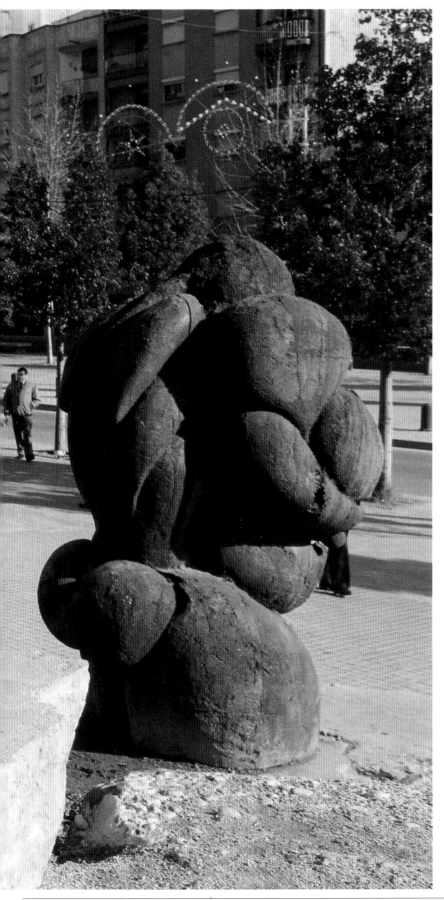

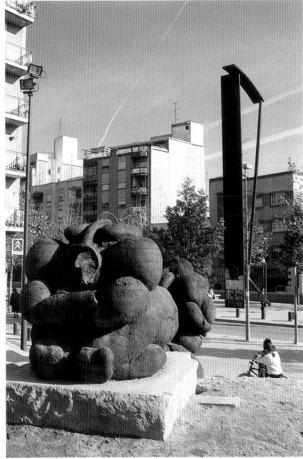

The Plaça Ángel Pestaña: Pladevall's volcanic fountain

Architect:
Enric Pericas

Sculptor:
Enric Pladevall

This square, named after the well-known trade union leader who founded the Partido Sindicalista, is situated just south of the Via Júlia and is bounded by Carrers Santa Engràcia, Enric Casanovas, Sant Francesc Xavier and Argullós. Eight thousand square meters of public green area have been laid out for the inhabitants of the congested city of Barcelona. The area is rectangular in shape and steeply sloping, but the municipal architect Enric Pericas has precisely made use of this gradient to avoid any sense of monotony. On one side he placed the local civic center, which is roofed with a large terrace; this is the purely architectural section and has been well thought out, with a series of platforms at different levels linked by flights of steps and an inclined plane.

In one corner of this elevated sector is a graceful representation of a balcony, designed with an appropriate austerity of line. The architect wanted it to suggest the idea of looking out over the square.

A series of gentle ramps connects the two levels, and this part, which is also purely constructional, is balanced by the wide sandy area containing games for the young and not so young.

Special attention has been paid to the vegetation. Plane trees, holm oaks and false acacias, as well as cypresses, bougainvillea and oleanders form a delicate arrangement that I would not like to see destroyed by hooligans. The typically Mediterranean light blue unifies the design of the railings and lampposts, and

metal benches in green and white have been sensibly scattered around.

The young sculptor Enric Pladevall wanted to plant here his own personal and non-transferable contribution to the vegetation in the square. He placed it alongside the pool with its chequerboard paving, over which it waves the capricious forms its takes on in strong sunlight. The "mutating fountain" as it is known is a Vesuvian tree, disturbing in its morphology and in the fruit it produces. What is particularly noteworthy is the attractive patina on its trunk. Suddenly, against all the laws of nature, something makes it change its shape: while one branch goes dead, the other extends itself in a triple curve, more in the form of a gesture than in the usual manner of branches. Vesuvian was the word I used, and it is an apt one, for both the color and the complete absence of leaves belong to a landscape extinguished under a scorching mantle of lava. And if this were not enough, the fruit produced by the tree is a jet of water that spurts over the pool in yet another ornate and ample curve.

Yes, a tree-fountain, but a tree-fountain from a world in which nature is closer to surrealism, to dreams. No one yet knows whether it is a sign that indicates the sort of nature we bequeath to our successors.

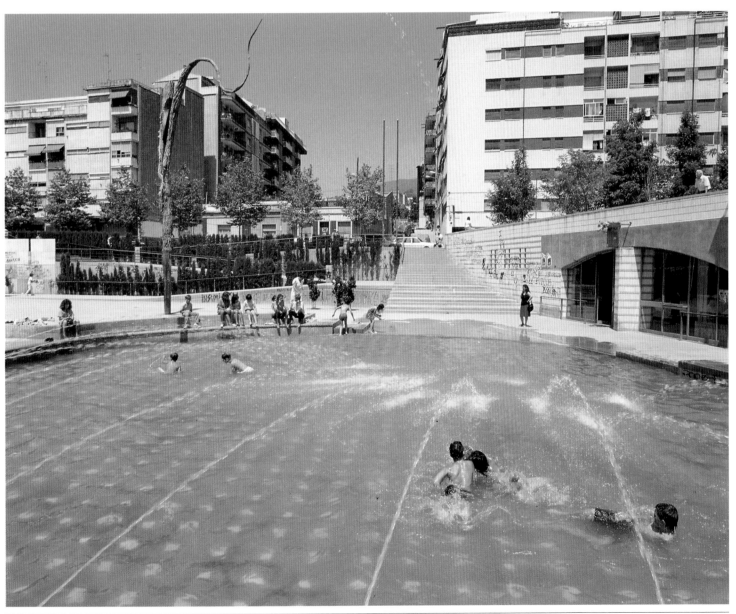

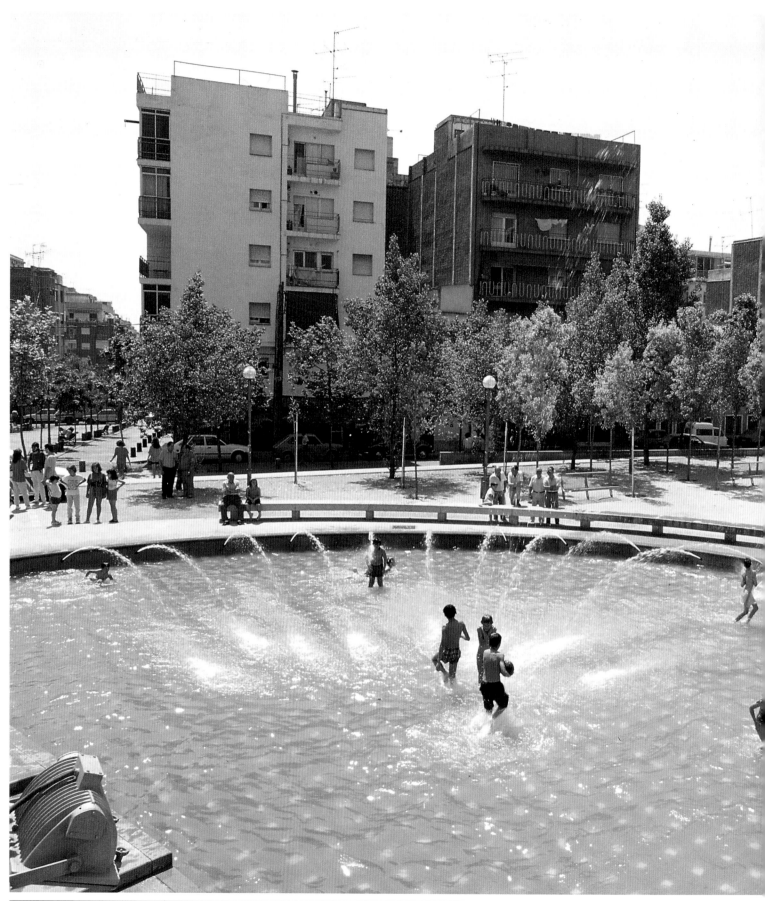

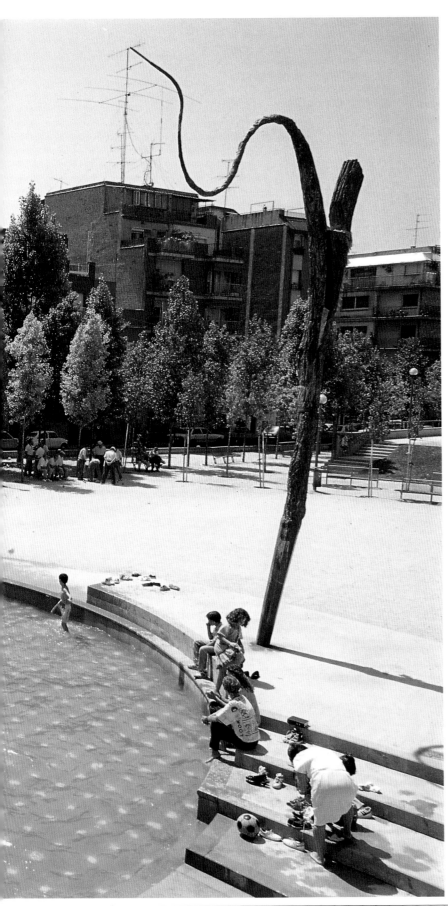

The highly unusual
sculptural fountain
designed by Enric
Pladevall.

THE PLAÇA ÁNGEL PESTAÑA: PLADEVALL'S VOLCANIC FOUNTAIN

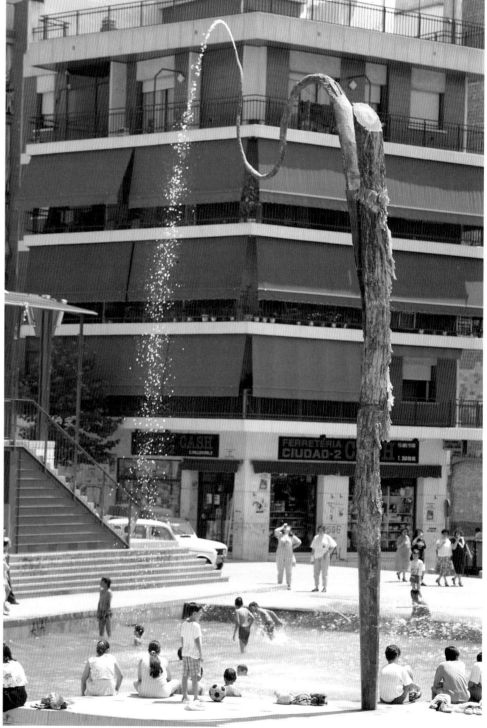

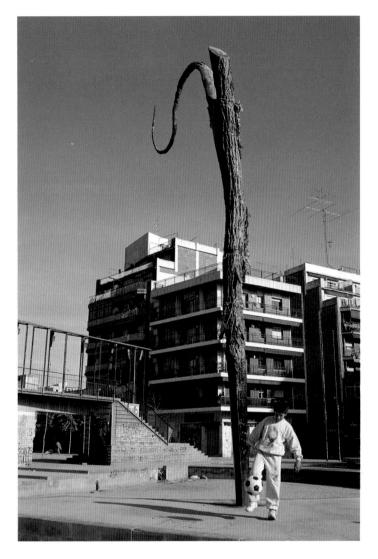

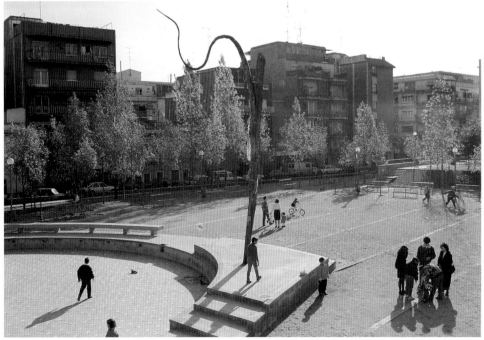

A dual homage to Pau Casals

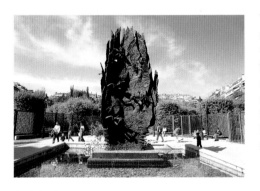

Architect:
Nicolau Maria Rubió i Tudurí

Sculptors:
Apel·les Fenosa
Josep Viladomat

The avenue now known as the Avinguda de Pau Casals is a short but highly relevant one, for it links two important places: the Plaça de Francesc Macià, one of the nerve centers of the city (in that it acts as a hinge between Cerdà's Barcelona and the more modern sector); and the gardens known as Turó Park, which despite their small size are of an enviable intensity. Moreover, it is not often that one finds in Barcelona a space adorned with such an abundance of foliage as this one, although in London it would not even merit the name "square" in the English sense, as its designer, the architect Nicolau Maria Rubió i Tudurí, observed. However, I consider it to be a real park, for all things are relative and depend not so much on size as on the mentality with which they were designed. In this respect the gardeners of the Far East have so clearly shown how in a very small space they can create a landscaped garden that in the Western world would seem to call for a good number of acres.

This district of Barcelona has for long been inhabited by the upper-middle classes. This will enable us to understand the reactions to the two sculptures that have been placed there. Since the end of the Spanish Civil War, the (round) square at the start of the Avinguda de Pau Casals was named after Calvo Sotelo, and the avenue itself after General Goded, both closely connected with the military uprising led by General Franco against the Republican Government.

In the early seventies, the Galerie Maeght in Paris opened a gallery in Barcelona. The famous art dealer, who had long included Miró, Tàpies and Llorens Artigas among his principal artists, and closely collaborated with the architect Sert (designer of the Maeght Foundation in St.-Paul-de-Vence), thought it would be a nice gesture to donate a sculpture to be erected in a public place. And so a splendid "stabile" by Calder was installed in the center of the avenue. But the residents disliked this example of avant-garde art and made their views known. The problem was easily solved: Maeght donated that formidable bright-red piece to the Miró Foundation, since when it has adorned the façade of the building.

The first democratically-elected City Council changed the name of the avenue — and those of other streets — to Pau Casals, which led to the idea of a sculptural tribute. The piece chosen was a classical sculpture by the renowned artist Josep Viladomat, who had also preferred exile to remaining in Spain under the dictatorship and fled over the border to Prades, where he lived for several years with Casals. It was there that he modeled the present sculpture. In order to do the back, he asked another distinguished refugee, the poet Josep Maria de Sagarra, to sit for him on a number of occasions.

When the authorities set the sculpture in place they were prepared for the angry reactions of the residents, or at least the people who frequented the area, and asked the foundry to make several extra bows for the cello. Unfortunately, the bow has already had to be replaced no less than three times.

Another sculptor, Apel·les Fenosa, of the same political persuasion as his companions in exile and also an ardent admirer of the maestro, produced a second splendid tribute in bronze, which shows an exquisite feeling for music.

Apel·les Fenosa, a great music lover, modelled this homage to Pau Casals.

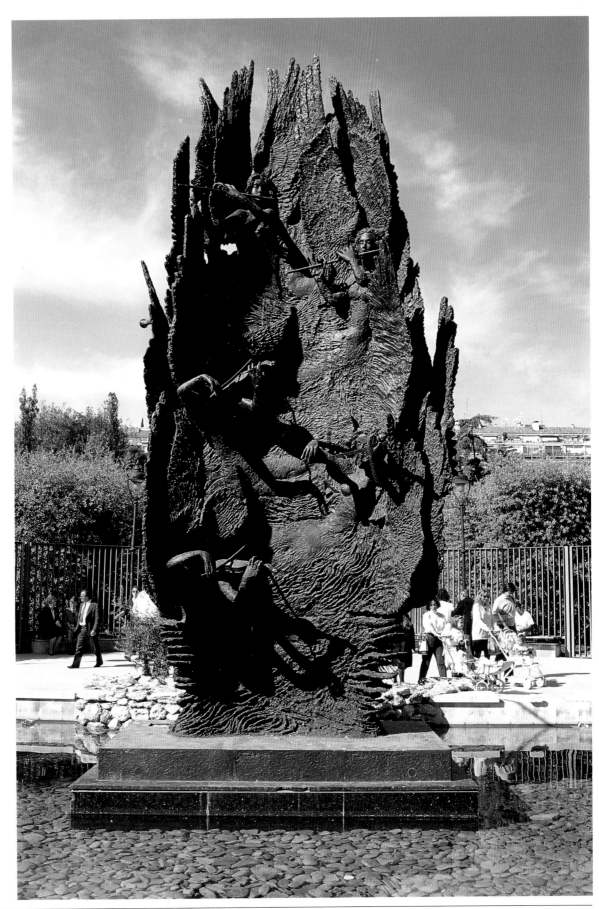

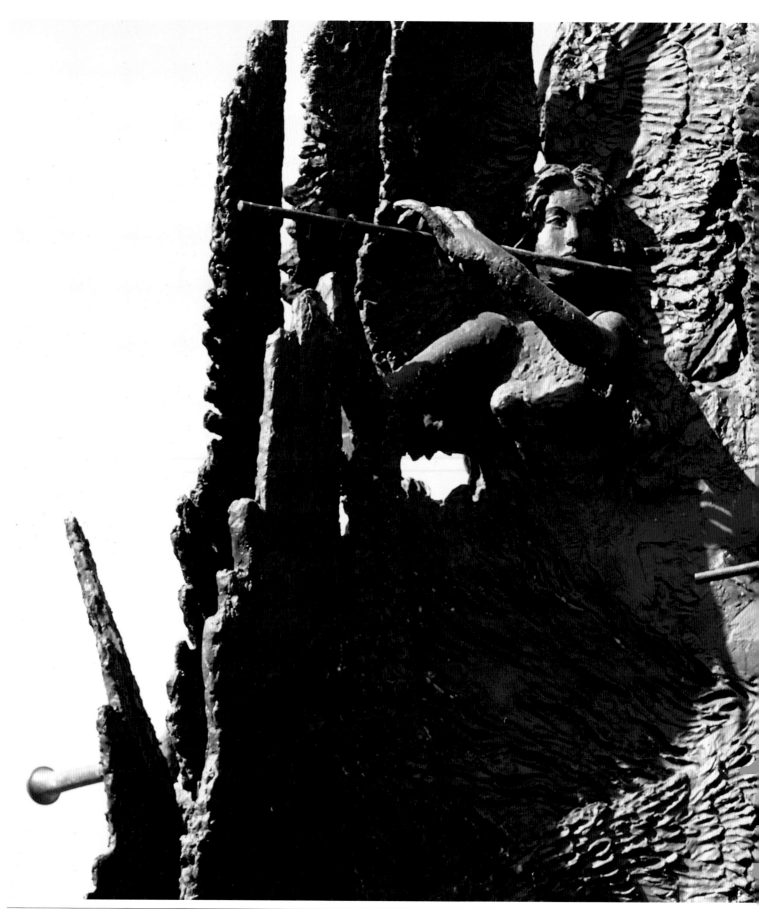

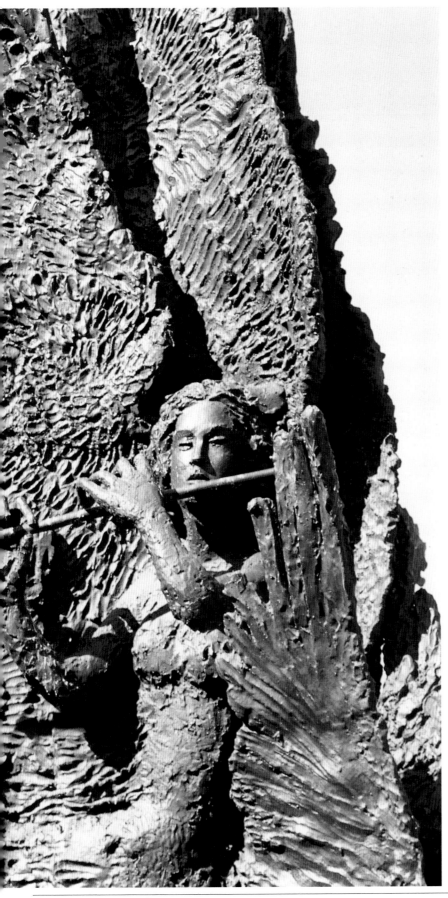

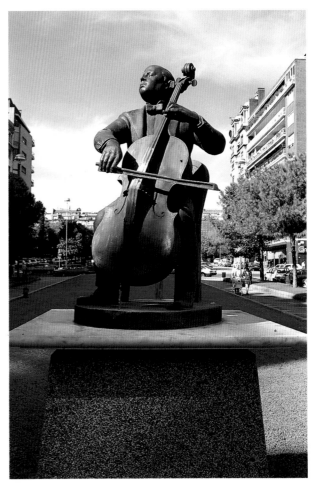

The maestro as seen by
Josep Viladomat, who
lived in exile with Casals
in Prades.

A Fenosa and six sculptural lampposts by Falqués in the Avinguda de Gaudí

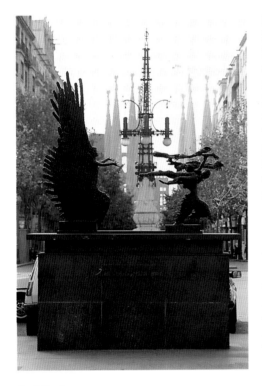

Architect:
Màrius Quintana

Sculptor:
Apel·les Fenosa
Lampposts by Pere Falqués

By 1992, Barcelona will have transformed the maximum number of available spaces into squares, parks and gardens, and consequently the planning authorities are now contemplating the possiblity of remodeling some of the broader streets and avenues. But the Avinguda de Gaudí, which fulfills this idea to perfection, was designed at a time when its result should be interpreted more as a premonition than as an example of municipal planning policy.

This was due to the fact that the architect responsible for the work, Màrius Quintana, knew just how to interpret in all their purity the ideas of Léon Jaussély, who in 1905 produced a wide-ranging plan to reform the already historic Cerdà Plan. He attempted to put into practice the popular desire to establish a hierarchy in a grid system considered too uniform and egalitarian. The line he traced with the Avinguda de Gaudí broke up the reticular pattern in the same way as, in their day, Van Doesburg's diagonals broke up the squares of the puritan Mondrian; but it also gained a vista in a city that precisely lacked any large architectural features as the focal point of a perspective. In this case he offered the opportunity of viewing at the same time no less than two great examples of *Modernisme*: the Hospital de Sant Pau designed by Domènech i Montaner, with sculptures by Gargallo and Eusebi Arnau, and Gaudí's Sagrada Familia.

After the avenue had been remodeled and converted into a pedestrian precinct, bravely rescued from the despotic clutches of the city traffic, Quintana successfully embellished it not only with some carefully-designed street furnishings — air vents for the underground carpark transformed into lollipops, benches, pergolas, awnings — but also with a sculpture by Fenosa and some truly sculptural lampposts by Falqués.

Apel·les Fenosa, a Barcelona artist held in high esteem in France, modeled a sensitive and poetical piece with the delightful title of *The Fine Weather after the Storm*. It is a bronze of considerable size, in which the figures have a particularly poetical movement.

At the turn of the century, Pere Falqués i Urpí, municipal architect and the author of the beautiful lampposts-cum-benches in the Passeig de Gràcia and the double-armed lampposts in the Passeig de Lluís Companys, designed six lampposts on large stone plinths with the aim of "monumentalizing" the strategic crossroads at Diagonal and Passeig de Gràcia. They involved ironwork of considerable complexity, carried out by the noted iron craftsman Manuel Ballarín. The arrival of the motorcar ousted them from their original site and they were condemned to the muncipal warehouse, from where they were rescued and duly restored for their present attractive setting. Sensibly, they were given a reddish tone that benefits from a certain restraint, which in my view suits them much better than the black they had previously been clothed in, although this was not original either, for Falqués always had a strong feel for colors.

233

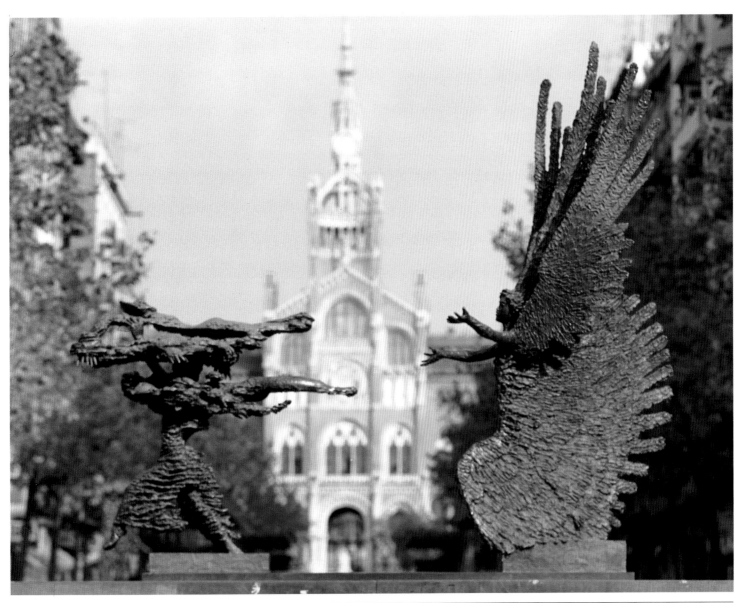

A FENOSA AND SIX SCULPTURAL LAMPPOSTS BY FALQUÉS IN THE AVINGUDA DE GAUDÍ

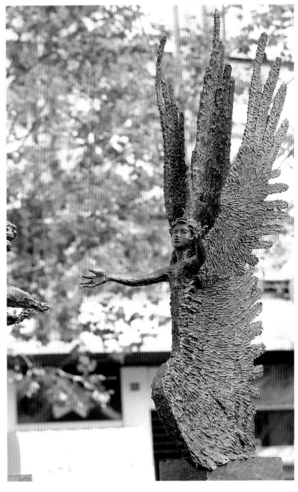

The Plaça de Llucmajor and Viladomat's historical sculpture *The Republic*

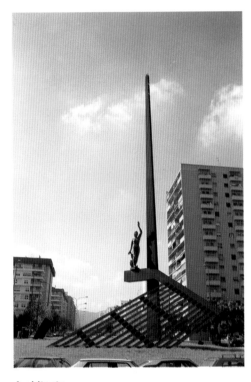

Architects:
Albert Viaplana
Helio Piñón

Sculptors:
Josep Viladomat
Joan Pié

The monument to the Republic that now presides over the recently reformed Plaça de Llucmajor has a troubled history that is worth recounting.

The Barcelona politician Francesc Pi i Margall was one of the four presidents of the First Spanish Republic. Hence the decision to dedicate a monument to him. Although Alfonso XIII was on the throne at the time, one of the key points of the new Barcelona was chosen as the site: the crossing of Passeig de Gràcia and Avinguda Diagonal. The foundation stone was laid in 1915. But municipal indolence delayed commencement of the work for so long that the dictator General Primo de Rivera came to power before anything had been done and his iron regime made it impossible to carry on with the project.

The proclamation of the Second Republic in 1932 paved the way for finally carrying out the plan. The following year, the renowned sculptor Josep Viladomat was commissioned to model the female figure that was to embody the image of the Republic. He completed it in record time. Almost four meters high, it represents a naked girl walking, wearing the Phrygian cap of liberty and carrying in her raised left hand a small piece of the large laurel branch she holds in her right hand.

This sculpture crowned the tall obelisk which still stands in the center of the crossing, while a stone medalion with the head of Pi i Margall in relief, by Joan Pié, was placed on the front of the plinth.

Everthing was ready for the solemn unveiling, but the separatist *coup d'état* on October 6th, 1934 prevented it taking place. So the event did not occur until 1935, and it was more prosaic than ceremonial, for the mayor simply gave orders by telephone to remove the sheets covering the monument.

With the Civil War, the fall of the Republic and the establishment of the Franco regime, another troubled period began, although of a very different sort.

The first fascist City Council quickly ordered the sculpture to be taken down. Until this order was actually carried out, *The Republic* remained on top of the obelisk, though covered in a Spanish flag. On removal, the sculpture and the medalion of Pi i Margall were taken to a municipal warehouse, where they remained lying on the floor along with other items that had also been condemned, such as statues of historical Catalan nationalists. The rest of the monument, with a new sculpture on it, was transformed to commemorate the military victory in the Civil War.

The first mayor to be democratically elected, the Socialist Narcís Serra, ordered a suitable site to be found in which to install *The Republic,* while the monument at the crossing of Diagonal and Passeig de Gràcia continued intact and the square was renamed after King Juan Carlos I.

The attempt to erect the sculpture at the top of Carrer de Balmes caused protests from the largely right-wing residents in the area. Finally, the newly-designed Plaça de Llucmajor was chosen, for together with the Via Júlia, Plaça Ángel Pestaña and Plaça de Francesc Layret this square was intended to transform that part of the new but run-down district of Nou Barris.

The Plaça de Llucmajor is, in addition, an important junction formed by Passeig del Verdum, Passeig de Valldaura, Via Júlia and lesser streets. This was the reason why the architects Albert Viaplana and Helio Piñón, the designers of the avant-garde Plaça dels Països Catalans,

who took on the delicate job of remodeling this square, decided to orientate the republican figure in relation to the visual force of the Passeig de Valldaura.

The two architects opted for a radically avant-garde sculpture to serve as the base and support for the two figurative pieces, but one that would at the same time have an epic strength.

They took traditional elements such as the obelisk, the flight of steps and the ledge, but treated them in their inimitable and uncompromisingly innovative way. The solid steps of the unorthodox flight direct the eye towards the austere needle, but the final piece crowning the inclined, stepped plane leads to *The Republic,* which appears suspended in the air. The menhir-obelisk of corten steel with its stabilized oxidation has enabled a height of 30 meters to be reached with a hollow form reduced to a minimal presence. It provided the architects, however, with the possibility of inserting up its entire height a channel of natural light filtered through a succession of discreet louvres; the filtered daylight gives a warm, subtle touch to the work. While *The Republic* looks down the Passeig de Valldaura, the Pi i Margall medalion carved in stone by the sculptor Joan Pié faces up the avenue.

It is worth contemplating this monument — which combines in an exemplary way an avant-garde design with a historical figure — when the thick curtain of night has fallen, for the subtly diffused lighting gives this work of such finely tuned creativity the solemn patina and sense of ritual it demands.

Viaplana/Piñón were bold enough to create a sculpture, and have achieved a form placed fluidly and forcefully in space that is a sculpture worthy of an artist rather than a timid imitation produced by an architect's pencil.

Viladomat's historical sculpture *The Republic* contrasts with the avant-garde structure recently designed by the architects Viaplana/Piñón.

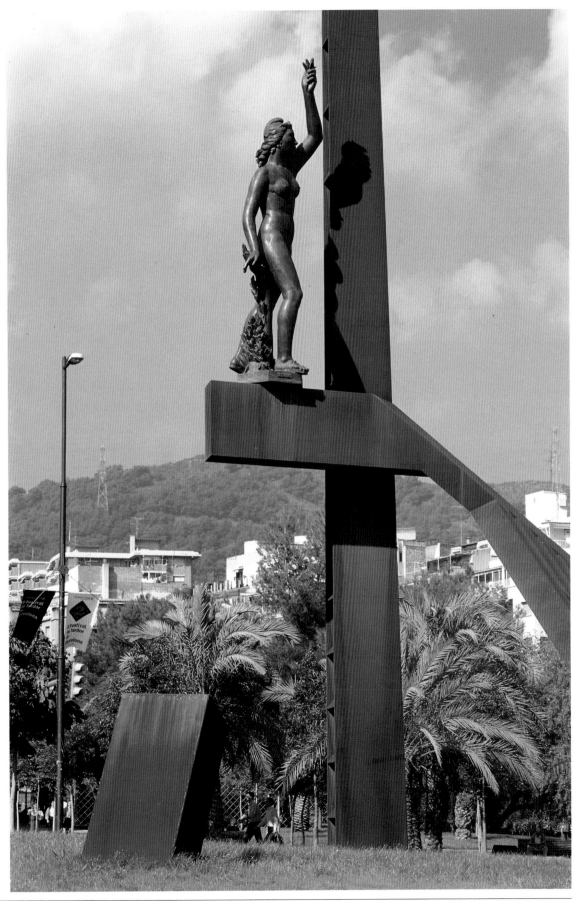

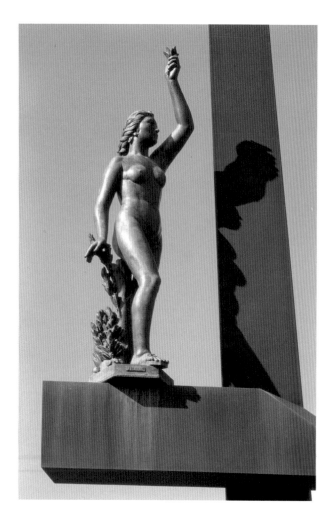

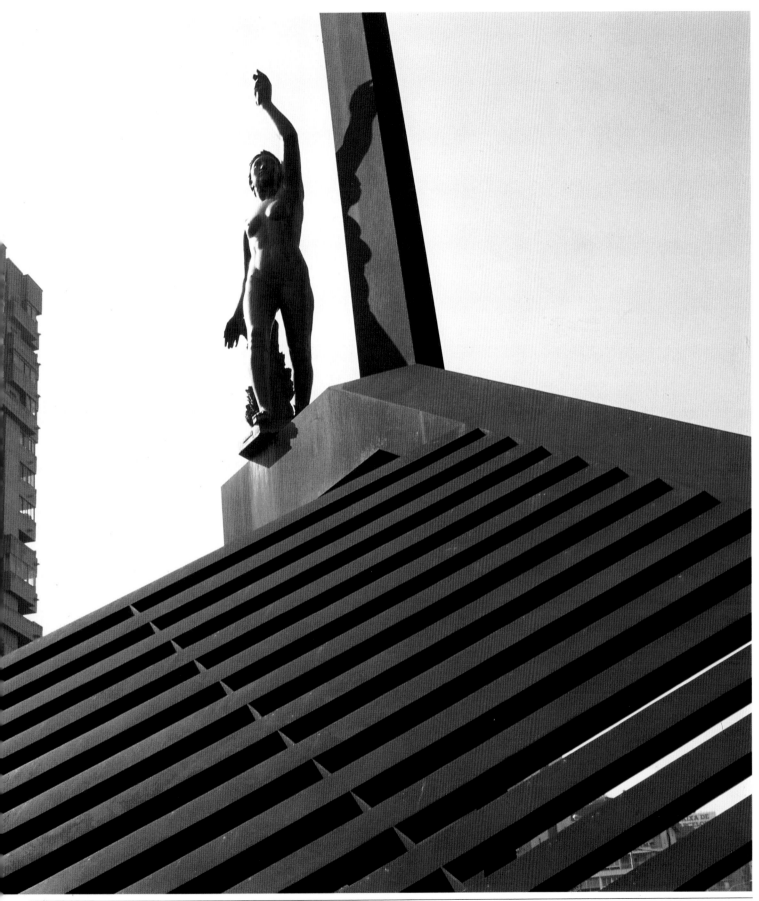

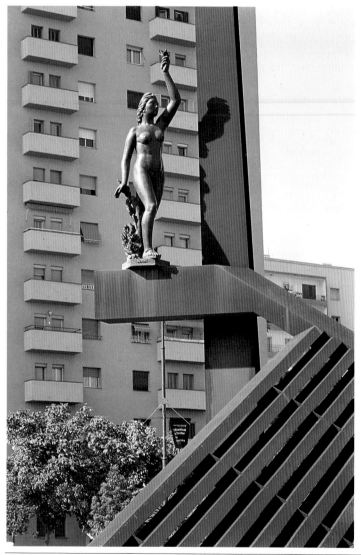
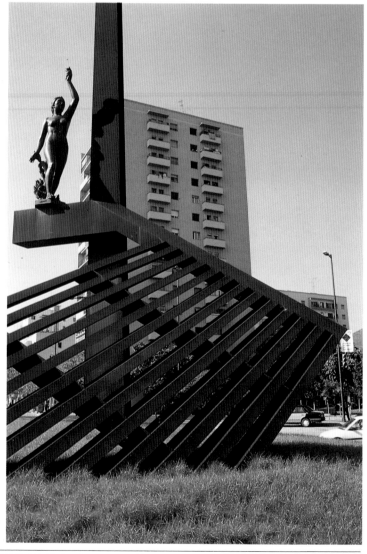

The Mies van der Rohe Pavilion

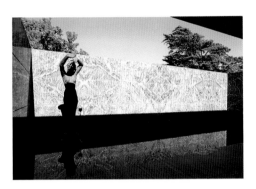

Architect:
Mies van der Rohe

Sculptor:
Georg Kolbe

This is a special case, for it is neither a square nor a sculpture in the strict sense. But for me the whole building is not only a work of art but also a sculptural piece of the first order. This, after all, was why it was reconstructed.

The great Mies van der Rohe designed the pavilion in 1929, not to contain or display anything, despite the fact that it was intended for the International Exhibition that year. It was to be the reception area of the German Pavilion and it was to be used for the visit of Alfonso XIII and Queen Victoria Eugenia, who were coming to sign the visitors' book. This is why Mies van der Rohe did not design anything inside it, but only created two chairs — historic and world famous pieces known as the Barcelona Chair. They were, and are, the thrones of Modernism, since they were made for the sole purpose of providing Their Majesties with a certain degree of comfort when signing their names.

The Pavilion is a masterpiece that already in its day confirmed its designer as one of the best architects of Modernism. It is such an avant-garde building that even now its essentiality is overwhelming: everything is substance and austerity, nothing is ancillary. Emptiness is the great achievement, and the circulation he manages to establish enhances the immediate close relationship between the visitor and the work of Mies.

The materials are extremely well chosen and the harmony between them is mutually enriching. The water, by its very immobility, is transformed into a sheet and thus becomes one more material, though it possesses the qualities of real living matter.

The special quality of the Pavilion can be even better understood if we look careful-ly at the plan of the ground floor. It makes me feel as if I am looking at a composition by one of those avant-garde Russian Suprematists, who placed their colored or colorless pieces in a sea of whiteness — a whiteness that Mies van der Rohe interprets as the space through which the visitor is to circulate. Hence the force of the emptiness that is so exciting.

The Pavilion was considered from the outset as one of the most important works of architecture and a milestone of Modernism. There were few people who, in 1929, realized the value of something that was so tiny, delicate, sensitive, functional, severe and authentic. Although it is true that it was designed and constructed with a view to being dismantled at the end of the Exhibition, it is no less true that the voice of the art critic Rafael Benet was the only one to call for it to remain permanently in place.

So, as originally planned, the Pavilion was taken down.

After half a century, and thanks to a City Council that showed an unusual sensibility towards architecture and planning, the miracle occurred and the Pavilion was reconstructed with exemplary accuracy, and with the collaboration of the architects Cristiano Cirici, Fernando Ramos and Ignasi de Solà-Morales.

The high quality of the sculpture by Georg Kolbe gives a markedly human touch to the whole construction, which is "inhabited" every day by silent visitors, who with a ceremonious and reverential air immerse themselves in a different way of allowing historical architecture to influence them: by feeling it as something truly alive and up-to-date.

**The magical space
created in 1929 by Mies
van der Rohe, with the
sculpture by Georg
Kolbe.**

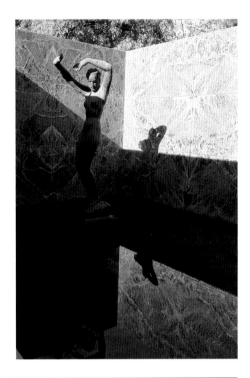

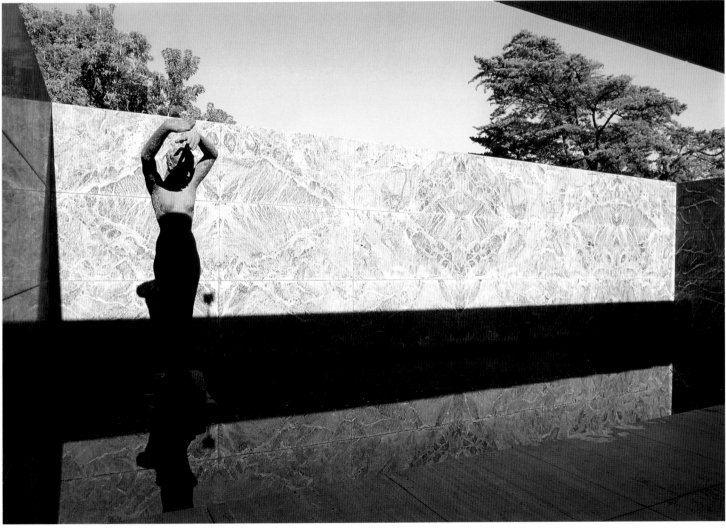

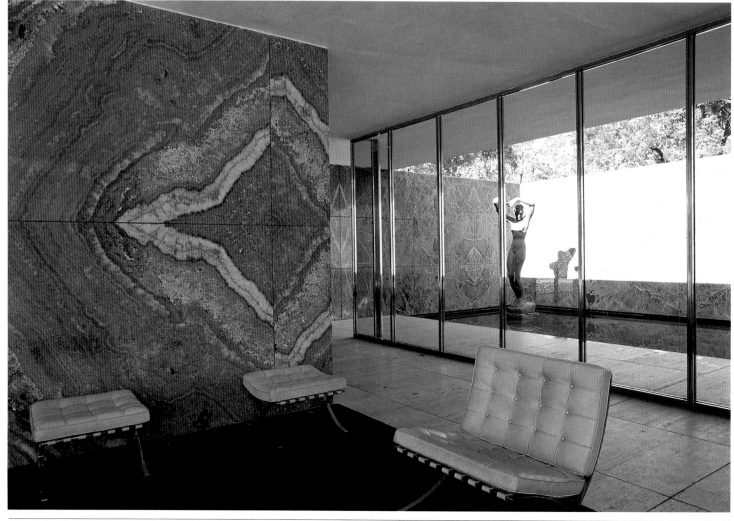

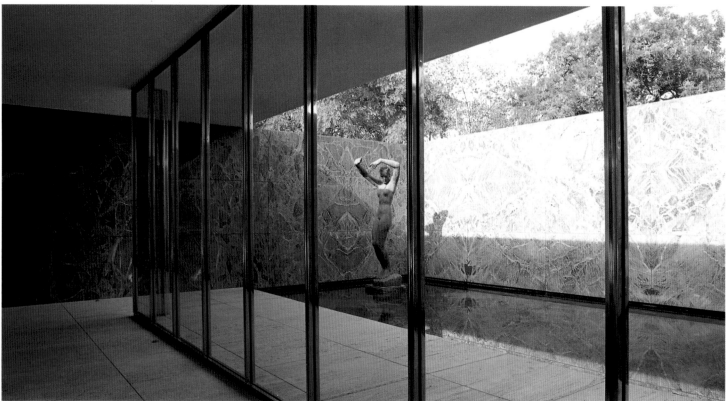

Castillo pays homage to the bicycle in the Plaça de Sants

**Sculptor:
Jorge Castillo**

Sants was one of the municipalities annexed to Barcelona in 1897. When the grid layout designed by Cerdà half a century earlier began to spread out to the villages that surrounded the city like a fan, the Barcelona City Council decided to absorb them. However, some of these, such as Sants, had a very strong personality of their own, which they were determined not to give up. And I think it splendid that this should be so, for in large cities it is essential to fight at all costs against uniformity and anonymity. And one of the most healthy ways of successfully conducting such a civic fight is for each district to emphasize and vitalize its particular marks of identity.

One of the marks that define the personality of Sants has been the *Vapors,* that is to say the textile industries operated by what was then a revolutionary form of power: steam. Another mark concerned recreation, particularly cycling; in fact its cycling clubs have long had a special reputation. The Unió Esportiva de Sants is the name of the sports club founded half a century ago that first set up a football section, and then a cycling section to channel the immense popularity of the two-wheeled sport, to the point that at the end of the twenties it decided to sponsor the Volta Ciclista a Catalunya, a tour of considerable prestige that is still held every year.

All this is à propos the fact that when the district of Sants decided to ask the artist Jorge Castillo to produce a large sculpture for its most important square, which had recently been refurbished, it was suggested to him that he might dedicate it to the cyclist.

The name of Jorge Castillo is known all over the world, mainly for his paintings and drawings. Born in Galicia, he has been a rootless person, although he has maintained close connections with Buenos Aires, Barcelona and lately New York. But I consider his true homeland to be art and also his family.

Castillo has done sculpture too, an art form that seems intimately linked to his particular world.

His first sculptures are dated 1962, though they were a somewhat uninteresting experiment with earth, and he eventually destroyed the works he had created with his own hands. He then changed his methods and started to use paper cut-outs, and later metal cut-outs, as in the large piece that gives character to the Plaça de Sants.

A sculpture by Castillo starts with penciled lines on a scrap of paper. A prodigious draughtsman, at that particular moment he has to create something more than a setting for his dream figures, trying to give a space to the form. From this will emerge figures with clearly-defined silhouettes and flat surfaces, translated into paper or metal cut-outs.

The cyclist struggles to escape from the two dimensions that in my view are embodied in the large plane, but in this case the paradox is that this very same plane also represents space, the three-dimensional air that the cyclist passes through.

Sants pays tribute to its tradition of cycling with this creative sculpture by the painter Jorge Castillo.

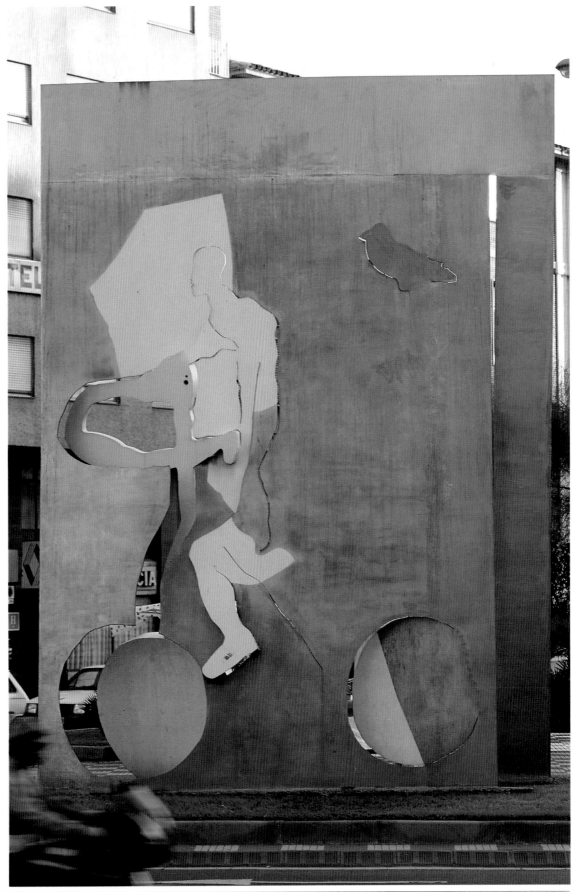

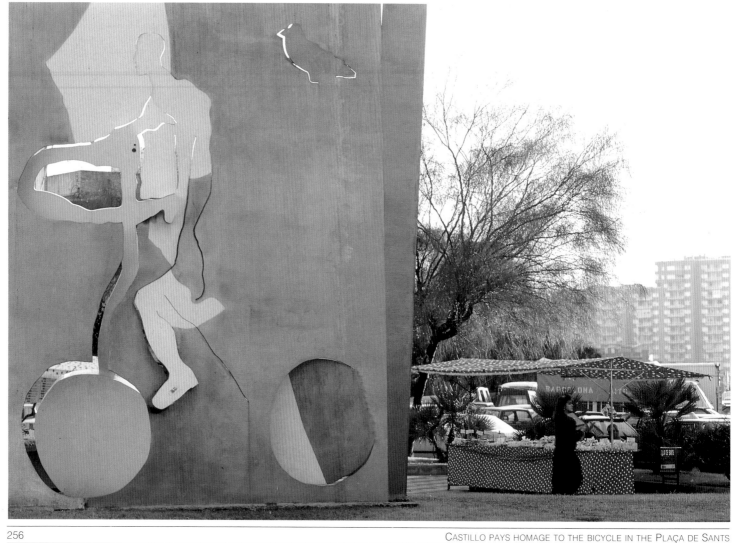

Shifrin evokes the International Brigades at the northern end of the Rovira tunnel

**Sculptor:
Roy Shifrin**

David and Goliath is the monument commemorating the fiftieth anniversary of the departure from Barcelona of the International Brigades.

People from all over the world came to Spain to fight on the side of the Republican Government against a fascism that was threatening to destroy the whole of Europe: the Spanish Civil War was a rehearsal of the fight for democracy and freedom against the totalitarianism that in Europe was essentially represented by Hitler's Nazi Germany and Mussolini's Fascist Italy. The International Brigades marched along the Ronda de Sant Pere, the Ronda Universitat and through the Plaça de Catalunya. They fought on the most dangerous fronts, and spilled their blood for the ideals in which they believed, until one day those that were still alive had to return, cheered and bemedaled, to their own countries and their own homes. They did not do so of their own volition, but under an agreement signed by a number of states forming what was known as the Non-Intervention Committee.

One of the corps that left a trail of glory and heroism behind it was the Lincoln Brigade. The mere fact of enlisting under that historic name, which will forever be linked with the fight for freedom and against slavery, was eloquent enough. Such was the flag under which the American volunteers fought. Three thousand young Americans came. They earned much admiration for their dedication and their readiness to fight, for they had many opportunities to demonstrate this in the hard tests to which they were subjected. Suffice it to say that almost half of them were killed in combat and that most of the rest were wounded to a greater or lesser degree.

Half a century after the emotional farewell they received from the people of Barcelona, this impressive monument was unveiled on October 28th, 1988. The ceremony was conducted by Mayor Maragall and was attended by over three hundred survivors from the International Brigades. There were representatives of the Spanish Veterans of the Civil War, and also of the Abraham Lincoln Brigade. Many veterans and sympathetic individuals had collected funds for the monument. Among the contributors were names of such international fame as, for example, Bernard Malamud and Leonard Bernstein. When it came to selecting the site, they obviously chose Barcelona, the key point of the Brigades' arrival and departure from a Spain torn by civil war.

To my mind they were right to choose this particular space, so much part of a Barcelona that has nothing to do with the one they knew and yet so united to the city that is today developing with irrepressible dynamism and that seems at last set to face the future on the threshold of the twenty-first century.

The monument is the work of the New York sculptor Roy Shifrin, who has maintained a close relationship with Barcelona and Catalonia. In fact he lived there for thirteen years, and had all his works cast at the small Vilà foundry in Valls. Ten American cities have works of his in public places, and the largest is located at the entrance of Manhattan Community College in New York City.

The title of the monument is *David and Goliath,* and it evokes the fight to the death between the two biblical figures. The giant is represented here by his enormous helmet, which has fallen significantly to the ground, while David, the embodiment

of the young men sacrificed in the name of freedom and democracy, is represented by an athletic torso halted in mid-action, rent wide open, a shield in its raised left hand. It is a composition of a markedly epic style, with the David atop a stone column — the sculpture is 8 meters high overall — that gives it a grandeur that is in keeping with the subject it commemorates.

The New York sculptor Roy Shifrin commemorates the heroism of the International Brigades with this representation of the torso of David and the fallen helmet of Goliath.

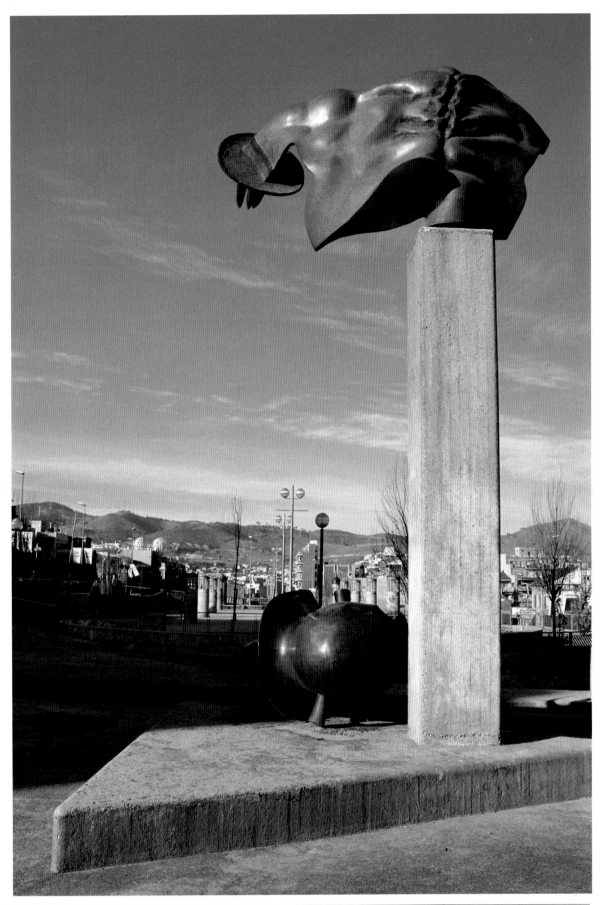

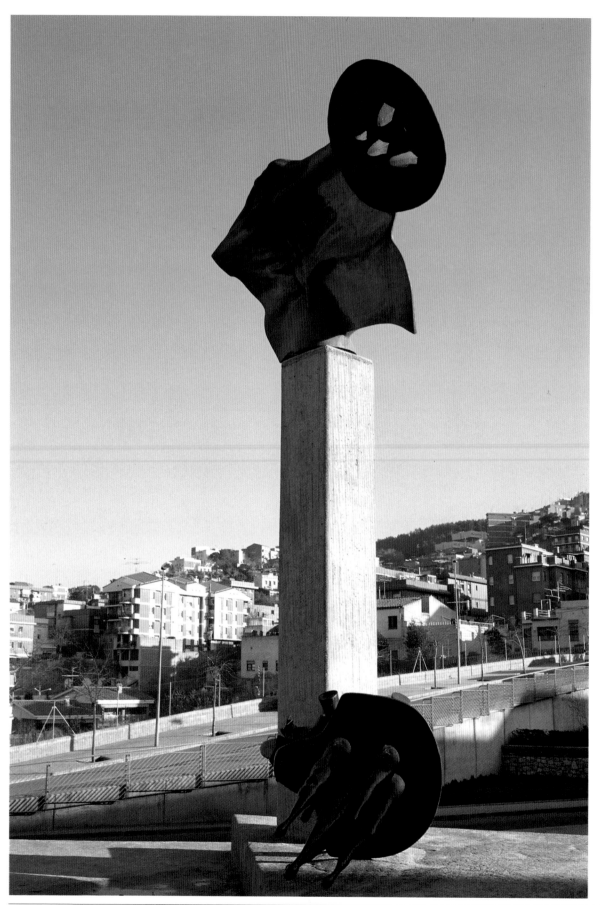

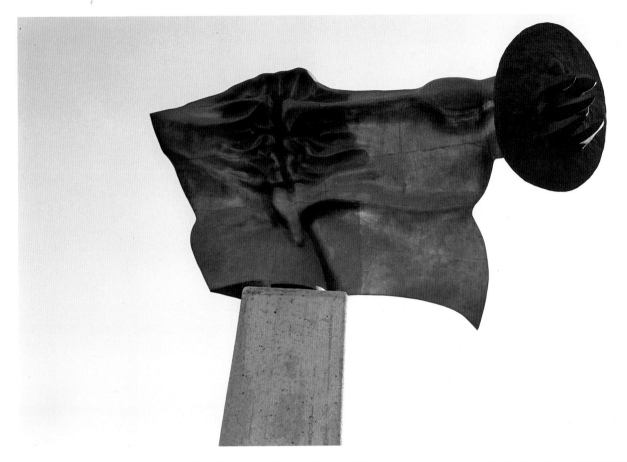

The Sculpture Garden at the Joan Miró Foundation

Architects:
Jaume Freixa
Jordi Farrando

Sculptors:
Tom Carr
Pep Duran
Gabriel
Perejaume
Enric Pladevall
Jaume Plensa
Riera i Aragó
Erna Verlinden

Joan Miró once showed me a spiral-bound notebook in order to explain what he considered the Foundation that would bear his name should eventually be like, and said, "I shall never fill in the first page." Exactly, for he never wanted the Foundation to be a pantheon for the practice of "archaeology," but a living place in which young artists in particular could exhibit their work. The first page was filled with the generosity that was always so characteristic of Miró; he donated a more than sufficient number of works to make it a place in which students and specialists would find everything they wanted.

The Foundation has remained faithful to Miró's unwritten wishes, and during its first phase the Espai 10 was devoted to exhibitions of the work of young avant-garde artists.

On January 14th, 1988, the extension to the Foundation was officially opened, providing it with a further 3,800 square meters of space. One of the sides of the building that had previously had no windows now acquired another dimension and gave onto an abandoned garden that in the time of Forestier, the architect who had landscaped a good part of the mountain of Montjuïc, had been christened the Plaça del Sol. In order to dignify that adjacent space, the Foundation suggested that the City Council should create a sculpture garden in it. The idea was well received, but on condition that the garden should be open to the public and owned by the Council, although looked after by the Foundation.

And so it came about that this delightful place from which the whole of Barcelona can be seen was officially opened on December 15th, 1990.

Rosa Maria Malet, the Director of the Foundation, chose eight sculptors, all of whom had exhibited in the Espai 10.

Tom Carr is represented by *Needle,* an unorthodox pyramid highly characteristic of his type of work.

The provocative Pep Duran has installed a couple of handcarts loaded with glass doors, titled *Transparent, the Landscape.*

Gabriel, with *Ctonos,* has erected a long piece of marble supported by an iron and brass structure.

Tiled Roof by Perejaume follows the poetic, irrational line of Magritte with a roof of the local type laid on the ground.

Enric Pladevall composed his *Large Spindle* by means of an intelligent and sensitive combination of iron, zinc and wood.

Jaume Plensa has produced *Dell'Arte,* a piece in bronze, iron and cement that is as definitive as the best of his work.

The irony and youthful romanticism that characterize Riera i Aragó are powerfully represented in his *Large Aeroplane with Blue Propeller.*

And Erna Verlinden has planted *Flight 169,* a garden in stainless steel and goose feathers that is the perfect counterpoint to the historical garden that has been restored by the architects Jaume Freixa and Jordi Farrando.

Those who visit this provocative space, which can be entered direct from the road through the gate in the large metal fence designed by Jaume Freixa, will be surprised by the sculpture standing in the center of the garden. It is a bronze piece that was erected there on May 23rd, 1909 in honor of *Manelic,* the most famous of all the characters created by the playwright Angel Guimerà. *Manelic* was his best

known and most universal work, for the tragedy was performed to great acclaim in opera houses and cinemas all over the world. The sculpture was modeled by the local artist Josep Montserrat i Portella, who distinguished himself at the time by his very popular subjects approached with a realism that was rich in detail. Guimerà was present at its unveiling, for it was by way of a homage to himself. When Rosa Maria Malet asked the eight artists selected whether they wanted *Manelic* to be removed, the reply was unanimous, for none of them wished to disturb that historical work.

Tom Carr speculates on one of his favorite forms, the pyramid.

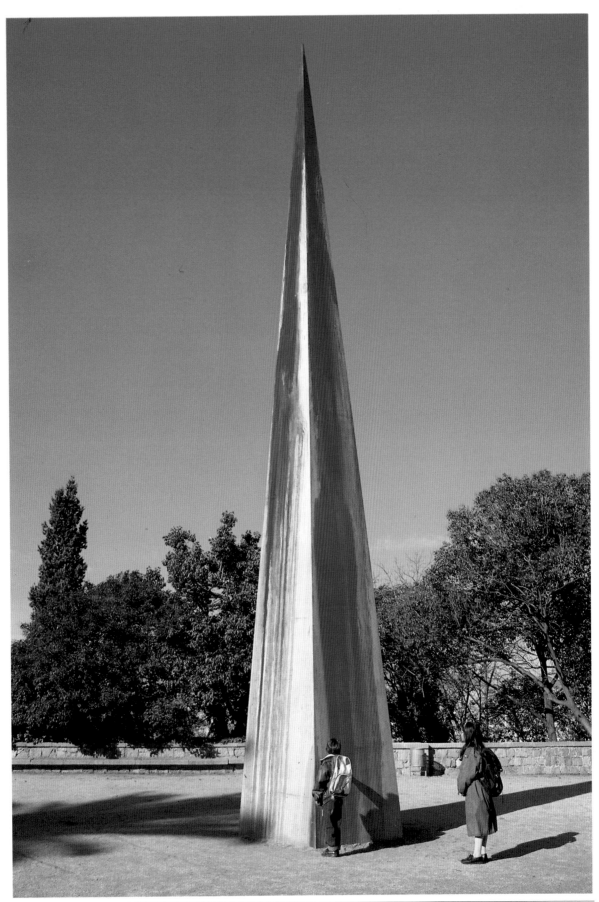

Pep Duran incorporates in his sculpture the reflection in the glass.

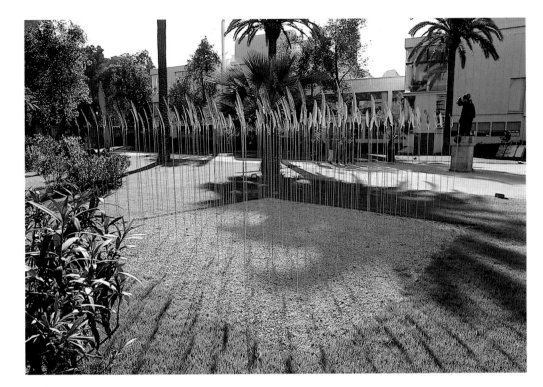

Erna Verlinden planted this sensitive, delicate bed of feathers that wave gently in the wind.

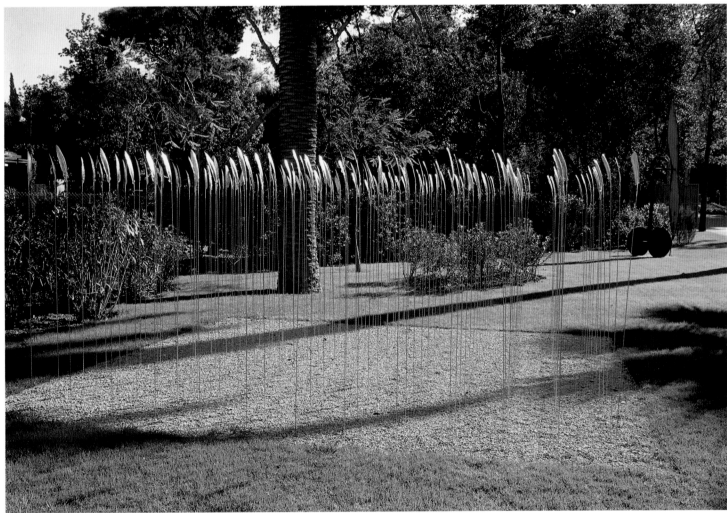

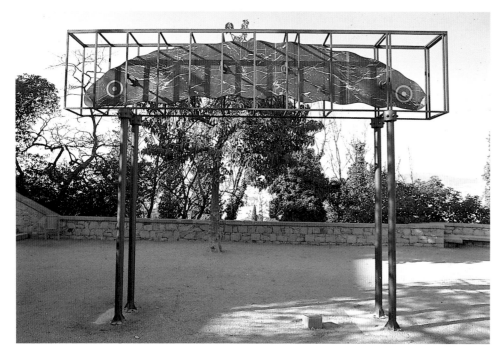

Left: The unorthodox portico erected by Gabriel. Below: One of the marvelous flying machines from the productive imagination of Riera i Aragó.

Right: An unusual but highly suggestive piece by Jaume Plensa. Below: A roof at ground level, created by the provocative Perejaume.

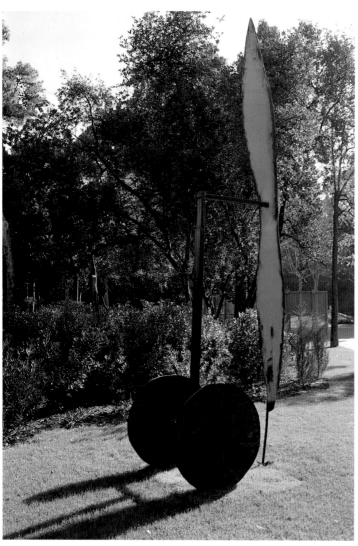

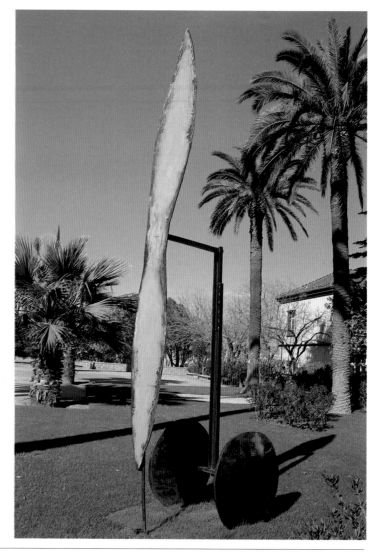

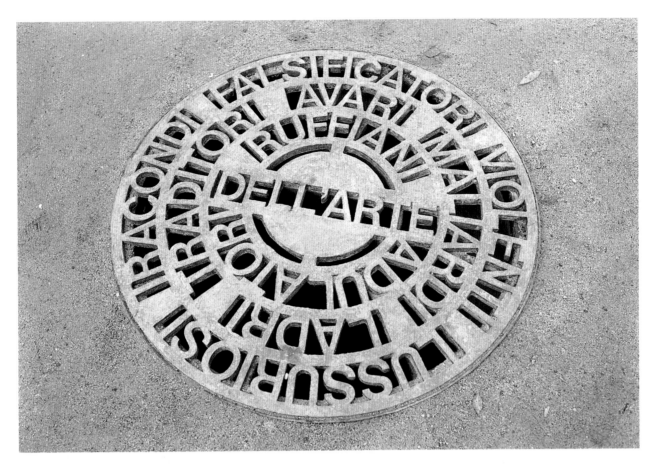

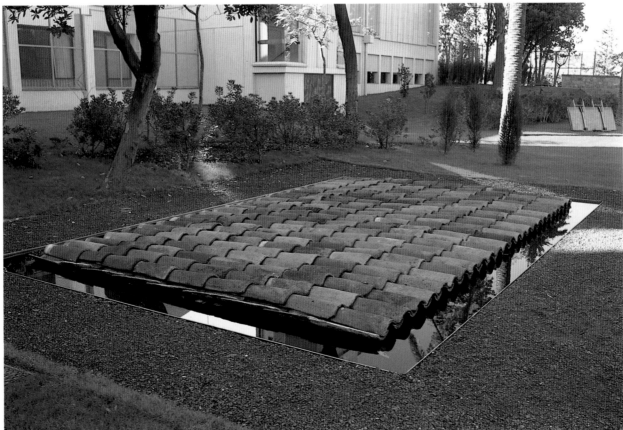

Large Spindle in iron, zinc and wood by Enric Pladevall.

The submarine by Riera i Aragó at the entrance to the Rovira tunnel

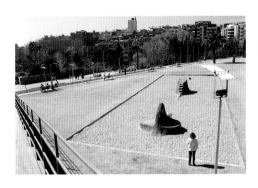

Architects:
Beth Galí
Màrius Quintana

Sculptor:
Riera i Aragó

A submarine in the sand has nothing to do with either the desert or the Gulf. It just happens that the title of the work — for it is a sculpture — is *Submerged Submarine*. Its author is that most popular of young sculptors Josep Maria Riera i Aragó. I still recall the impact of his first exhibition at the Galeria Joan Prats, which caused a fever of buying.

The City Council, with its propensity for monumentalizing the new public spaces that have sprung up throughout the city in an irresistible surge of urban development — whether or not connected with the Olympic Games — commissioned him to produce a sculpture in 1986. The location was chosen by the artist himself, for he considered that the proximity of the attractive Parc de les Aigües would enable him to bring one of his favorite themes into play. There are three subjects that permanently stimulate him in his prolific output — balloons, submarines and, in particular, airplanes — to the point that his entire recent production is dedicated to birdmen. These three subjects have to do with the world of machinery, but machinery interpreted in a romantic way, with ingenuous vision and playful imagination, recreated by an artist for whom childhood is the true homeland of his art.

A stone's throw from the Alfons X Metro station, just above the southern entrance to the Rovira tunnel, half way along Carrer de Thous — such precision is necessary because this area, which is now being laid out by the architects Beth Galí and Màrius Quintana, has been a sort of no-man's-land up until now — there is an esplanade at the foot of a impressive structure that is to become a carpark. On this wide terrace there recently appeared a large space filled with coarse sand from which the majestic profile of a mysterious submarine emerges.

It is a children's playground, of course, but also a recreational area for adults able to view such an unorthodox work with the vivid imagination of a child. Children will immediately want to see where the bronze artefact ends and will dig around in the sand to discover whether the nose, turret and tail are actually connected. The sand and the insubmergible masses also have something in common with those solemn, dry Japanese gardens, of which Rioanji is perhaps the most typical. And in the same way that those gardens induce the Zen monks to meditate, this submarine also provides food for thought.

The three bronze pieces, which measure 32 meters overall, have a disturbing effect. The image makes an abrupt, unexpected impact that is aggressive enough from the plastic point of view. And since this is an exceedingly unorthodox interpretation, the fixings where the bronze plates were joined, and even the numbering on them, have been left visible, though in fact these are all marks of an industrial process that can in no way concern the artist.

And it is not only the submarine that evokes water, the omnipresent element in this large work, but also the blue of the nearby railings, the ship's planks used in the construction of a walkway near the sculptures, the name of the park itself, and the water tower. In such a context, the submarine designed by Riera i Aragó is intended to fascinate not only youngsters but also all those who still see things with innocent eyes, which are the eyes of the imagination.

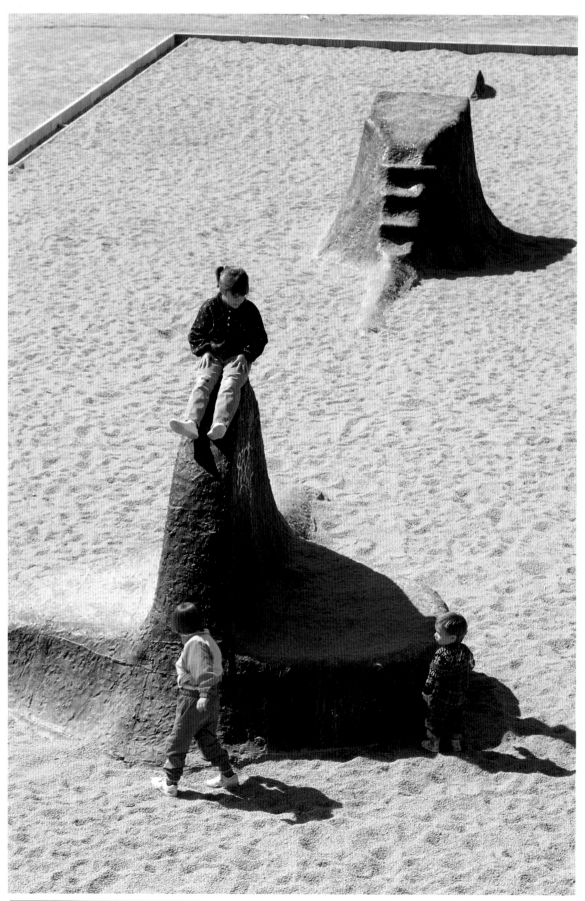

A form that
could be emerging
or sinking.

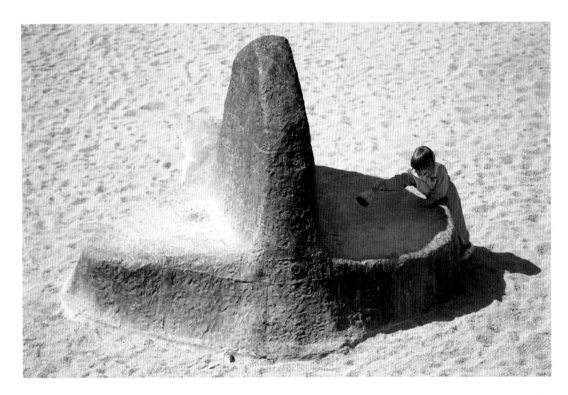

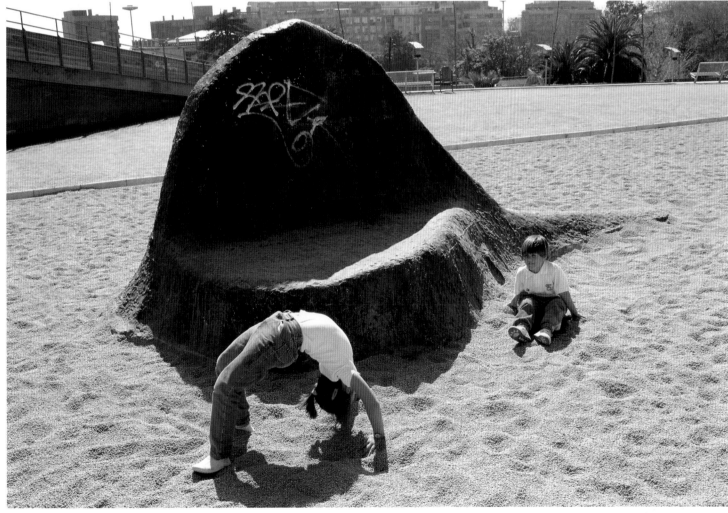

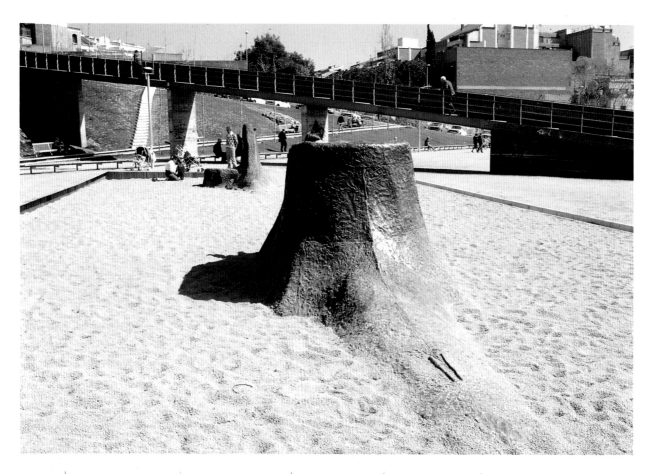

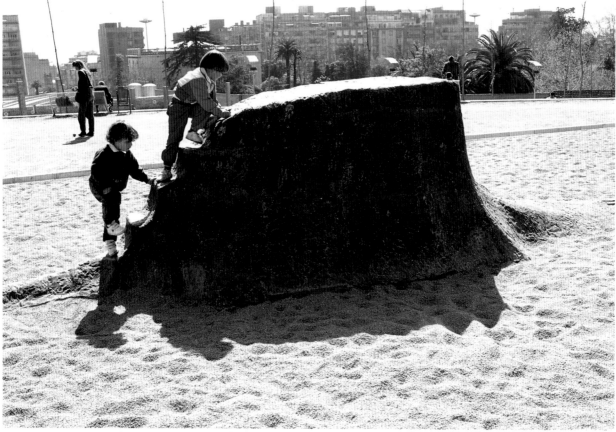

THE SUBMARINE BY RIERA I ARAGÓ AT THE ENTRANCE TO THE ROVIRA TUNNEL

A fat *Cat* by Botero to grace the surroundings of the Olympic Stadium

Sculptor:
Fernando Botero

Botero has become one of the most well-known artists in a very short time. I am not in the least surprised, for his work benefits from an air of ingenuousness and an amiable plastic treatment that everyone understands and likes. His subjects, too, are highly accessible. This being so, it is natural that his standing in the market should run parallel to his popularity. I can understand his success, which will continue to grow, but I confess I am not receptive to any of these ingredients.

Fernando Botero was born in Medellín in Colombia in 1932. As a result of family circumstances, he felt a natural inclination for bullfighting since childhood and his real vocation was to be a bullfighter, but this was not to be. The deep mark left by this is very evident, for one of his favorite themes is bullfighting and all that goes with it.

The world of Botero has been defined as "fat," and with reason. Unconsciously or not, each artist creates his own plastic anatomy, and in this respect Botero follows a "fat" course, as opposed to the stylized Byzantine line that is so easy to detect in the history of painting, which began with Giotto, was followed by Masaccio, Piero de la Francesca and Michelangelo, and continued with Rubens and Ingres.

His exaggerated shapes must be seen in relation to his discovery of a voluptuousness of form and an exaltation of volume. It should be noted too that Botero has always seen the cube as an absolute plastic form, and for this reason his shapes tend to be squat.

It was thus inevitable that one fine day Botero should decide that his very voluminous, sculptural figures should ac-quire another dimension and be placed fully in space.

It is in this context, therefore, that we must consider the *Cat* that is to be situated next to the Olympic Stadium on Montjuïc. It is not merely a fat cat but a gigantic cat, for not for nothing does it measure 7.17 meters long by 2.28 meters wide by 2.16 meters high and weigh 2,200 kilograms.

This *Cat,* like the people and figures that fill Botero's canvases, is disturbing in its forms and is of a notable simplicity. But, in addition, the overblown scale of this animal introduces a further element of surprise.

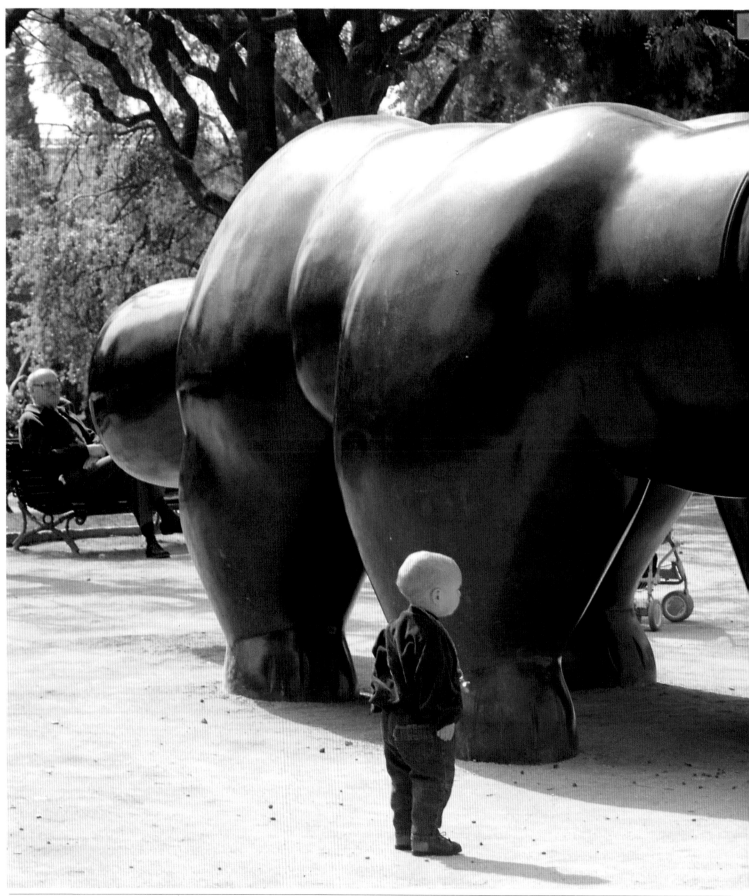

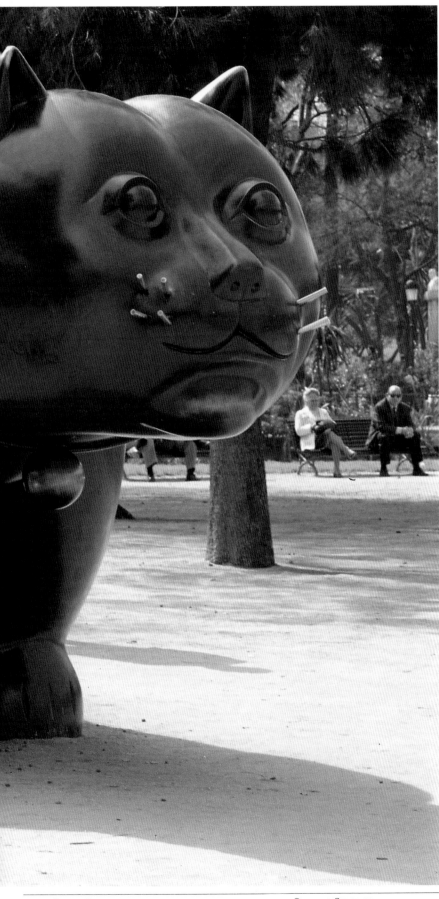

This cat that bewitches the youngsters and is now in the Parc de la Ciutadella will eventually be installed near the Olympic Stadium.

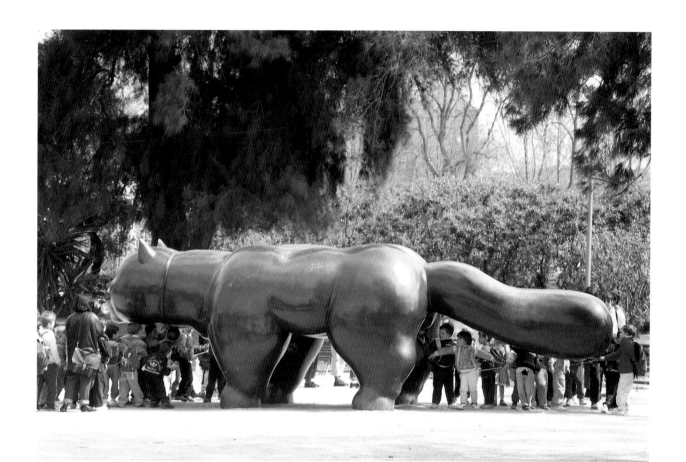

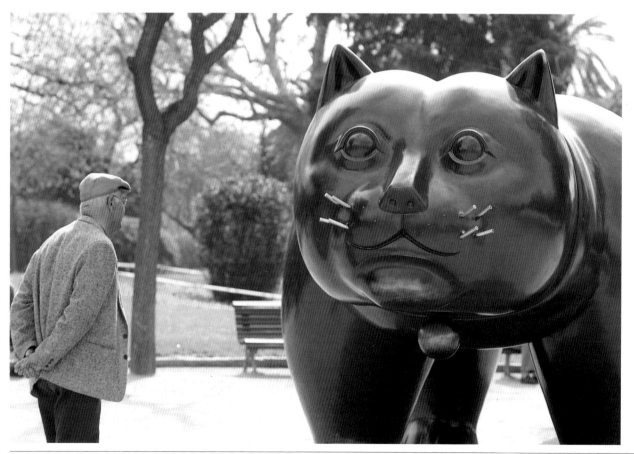

A FAT *CAT* BY BOTERO TO GRACE THE SURROUNDINGS OF THE OLYMPIC STADIUM

A large Clavé embellishes the Parc de la Ciutadella

Sculptor:
Antoni Clavé

Antoni Clavé is a painter from Barcelona who has lived in France since the Spanish Civil War; he is considered one of the great artists of the contemporary avant-garde and is acknowledged the world over. It may surprise people that a huge sculpture by him should now appear in a Barcelona park. But despite having produced a good hundred or so sculptures, he himself is to blame for the fact that this parallel activity has received little recognition.

He produced his first three sculptures as far back as 1939: *Shell-Beach, Telephone* and *Man with Monocle*. They were surprisingly ahead of their time, but it was not until the sixties that he returned to this facet of his work. In addition, he has persistently refused to show it on its own, to the point that a good many of his exhibitions of paintings include a few pieces of sculpture only as an aside.

The great work erected in the Parc de la Ciutadella — the site of that great exhibition over a century ago — is clearly a response to the sculptor in him, for when situating a work in space his innate sense of the proportions and the plasticity of this art form can clearly be observed.

When the City Council suggested he produce a work to commemorate the first centenary of the Universal Exhibition of 1888, he accepted with enthusiasm. One can understand why. In the first place Clavé is a sentimental person and the ties he has always wanted to maintain with Barcelona are very dear to him. Despite the fact that he decided to flee to France at the time of the Spanish Republican diaspora — "As the author of a poster denouncing Franco and his bombing of the population, I had no choice" — he never wanted to cut his links, as others did, with the city of his birth. And despite

having stayed on and settled permanently in Paris and later in Saint-Tropez, despite having formed a French family, as soon as the political situation changed he started visiting Barcelona so as not to lose contact with his friends and relatives and also to show his work.

Secondly, he was flattered that a Council that commissioned large works from local, Spanish and foreign sculptors had not ignored him and above all had recognized a side of his work that, for the reasons outlined above, had always taken second place.

Last but not least, Clavé immediately accepted the commission because he still has a very emotional relationship with the Parc de la Ciutadella. He was only a child when he was first taken for walks in the gardens, and such memories are of immense importance not so much because of the passing of time as because of the nostalgia he has felt since 1939 for everything to do with Barcelona.

The sculpture is composed of two clearly differentiated parts: a Clavé and a collage.

The large central piece which is fixed to a steel framework *is* the Clavé — and I say *is* because he made it with his own hands at the same scale (8.8 × 4 m), for he does not see how it is possible to do otherwise, although it is a well-known fact that many sculptors make a small model and then have it enlarged to the size they have been asked to produce; they take no part in the actual process, just as they never produced their own engravings or lithographs. The only thing in this case that was done by the firm of Caldererías Delgado was to copy the sculpture that Clavé had made in resistant, non-perishable materials.

This large Clavé is a double-sided relief in aluminum, a material that has for a very

long time formed part of his particular plastic language. The piece is adorned with all manner of incisions and relief work from his universe of forms, and with polychrome additions in red, blue, black and grey.

The collage consists of four cogwheels, two of them four meters in diameter. Clavé the sculptor has always been distinguished by his interest in using fragments of reality, which he sometimes transforms in a provocatively unorthodox way. In this case, the pieces have not even been manipulated, but merely employed for their evocative qualities. Indeed, the wheels were taken from a large machine that had been used for dredging harbors such as the one at Cadiz.

Only a great artist such as he is able to imbue such a difficult marriage — a Clavé with a large pure collage — with such exceptional force and create a single, inseparable whole in which the two parts mutually enrich each other.

Homage to the Universal Exhibition of 1888 also benefits from a fascinating element: movement. The wheels of the collage revolve and the large panel with the Clavé also turns horizontally on a vertical hinge. The movement evokes the actual working of industrial machinery, but it also contributes a personal memory: the merry-go-round that stood nearby when he was a child and on which he loved to ride.

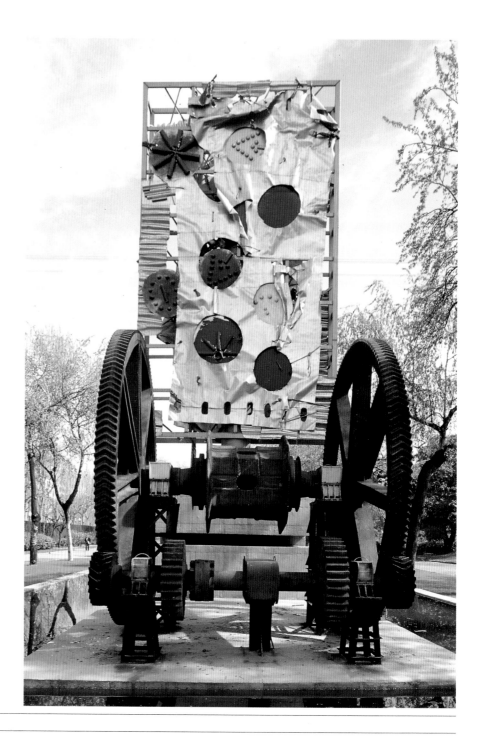

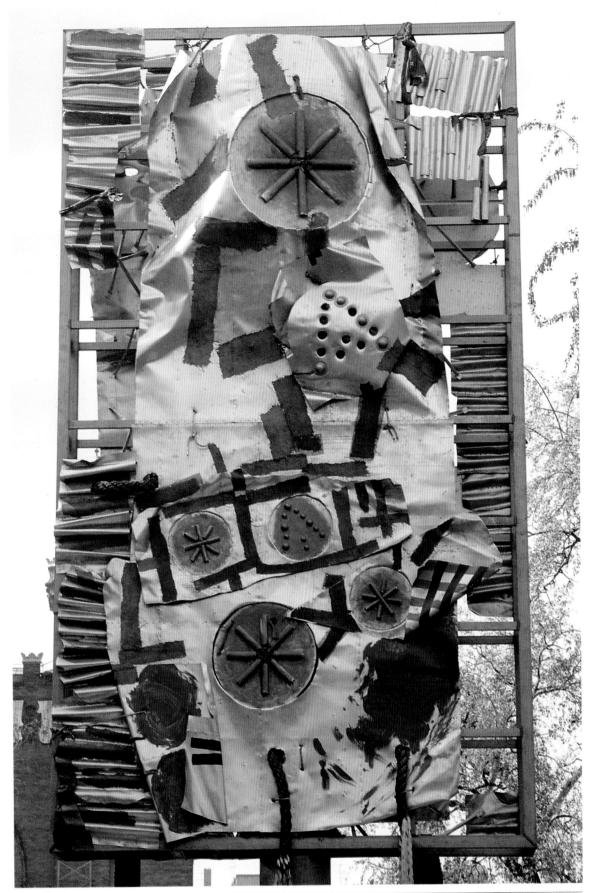

Miyawaki's aerial drawing beside the Palau Sant Jordi

Architects:
Federico Correa
Alfonso Milá
Carles Buxadé
Joan Margarit

Sculptor:
Aiko Miyawaki

The most important space created in Barcelona as a result of the challenge of staging the 1992 Olympic Games is the esplanade between the Olympic Stadium and the Palau Sant Jordi. It is important for two reasons: its size — unusual in a city built on the basis of making the maximum use of available space — and the high standard of design, both from an architectural and planning point of view.

The authors of this brilliant work are the team of architects Federico Correa–Alfonso Milà–Carles Buxadé–Joan Margarit. Its principal virtues are space, scale, rhythm and harmony.

The space is the largest and most grandiose in the entire city. In addition; it is a fascinating, created space in which value is precisely attached to the force of emptiness, albeit an emptiness that helps to emphasize the architecture.

It is built on a human scale, using the same unit of measurement the rest of Barcelona possesses, one which distinguishes it from other large cities such as Paris — particularly La Défense — or London. And this human scale can be seen as soon as it fills with people. The human body is not only reduced in size but serves as a notable reference point; it is integrated into and maintains a fruitful dialogue with the surroundings.

The harmony and rhythm have been successfully accomplished by the team of architects, for having first achieved the overall magic, they then completed the difficult mission of designing with a strength and purity the many parts that make up such an intense space.

The esplanade I am describing is the one framed by the Estadi Olímpic and the Palau Sant Jordi, which occupies the first third of the six hundred meters of open

space: three articulated, stepped levels on three horizontal planes with a central avenue.

There are some parts that will remind the perceptive observer of the style that Puig i Cadafalch imprinted on the general plan of the 1929 International Exhibition, such as the Olympic Stadium itself — which has been preserved almost intact — and the lighting reminiscent of Forestier along the central avenue. The water, the asymmetrical layout, the light and the soft coloring are some of the items that perform a basic function when it comes to planning the whole complex.

The cascading water is of particular importance, since it divides and gives life. It is a splash of pale color that stretches in a brilliant ribbon between the Stadium and the first terrace. The water, bubbly and alive, contrasts with the still pool that marks the central avenue.

The asymmetrical layout is most appropriate. The courage shown by the architects when it came to cultivating the emptiness is confirmed by this daring asymmetry, which was already insinuated in the solitary tower designed by Domènech i Roura on the left-hand side. Asians say that symmetry is repetition, and they are right.

The lighting gives depth, underlines the essential features and magically enhances the theatrical effect. The thirteen cylindrical towers, 16 meters high and composed of eleven segments, have been assigned a relevant role. They demarcate the overall space, but they also confer solemnity and have a marked individual presence. Strongly emphasizing the cascade, extremely subtle on Miyawaki's sculpture, glowing inside the delightful parterres with their ancient orange trees — the lighting

is used in different ways depending on whether it is general or very localized.

A certain amount of color has been employed, although so subtly that it might almost pass unnoticed. The soft tones of the artificial stone, the almost white concrete, the balanced patches of green grass, the shining metalwork, the pinkish paving, the measured ochers — they are all so very appropriately combined.

The perfect relationship between the austere combination of vertical and horizontal lines, and the flight of steps with its hedonistic curve, are achievements that constitute an unforgettable visual pleasure.

Needless to say, the place brings a decisive added value to that large complex. Von Weizsacker, the German President, was so right when he said that such a beautiful setting might be taken as the real Olympus of sport.

In this ambitious, exciting and evocative place, just in front of the main entrance to the Palau Sant Jordi, our attention is likely to be drawn to a forest of concrete pillars of medium height, linked together in the air.

This is Miyawaki's sculpture.

She is not simply the wife of Arata Isozaki, the architect who designed the Palau Sant Jordi; she is Aiko Miyawaki, who lives and works in Tokyo, was originally a painter, and since 1966 has devoted herself exclusively to relief and sculpture.

It was in 1980 that she discovered what she has called "Utsurohi"; the Japanese concept *utsu* expresses the idea of emptiness. With this name, she tries to communicate the idea of an instant in movement, subject to continuous change, whether because of the time, the day or the season; in addition, it denotes something that exists but disappears, something that is visible but also invisible, that is concealed but can be seen. Although it implies a certain dynamism and instability, at the same time it is an attempt to demonstrate the ambiguity and the relativeness of a specific reality that we perceive. Hence a good time to appreciate the sensibility and delicacy and subtlety and nuances of her work is the evening, in order to capture at their best the changes wrought by daylight and then by the delicate lighting that shines from inside each trunk and spreads along the branches.

When Miyawaki is offered a place for her *Utsurohi,* the first thing she does it to make a detailed study of the surroundings and then produce numerous drawings and several models, until she finally installs the work, and once *in situ* she then personally makes any necessary changes to the lines in space after they have been put to the acid test of their actual setting. Miyawaki has installed seven works in Japan, two in France, three in the United States, and the next will be in Australia. The one in Barcelona is her thirteenth.

There are 36 concrete columns, crowned with metal bands and linked in the air by steel wires that sway in the wind. Each constellation — a group of three or four columns — seems to me like those flourishes that our Art Nouveau designers were so fond of, except that they needed façades, stained glass windows, walls and furniture as supports, whereas Miyawaki places them purely and simply in the air. For she actually draws in space.

This reminds me of something Miró told me à propos of the defeat of the Republicans in the Spanish Civil War and the irrepressible rise of a Hitler who condemned "degenerate art" to the flames. Miró was convinced that the Nazis would establish a dictatorship of a brutality never experienced before, but at the same time he admitted to me that he was resolved to continue drawing, even if it had to be with a twig in the sand or with cigarette smoke in the air.

The essential yet constantly changing nature of the sculpture by the Japanese artist Aiko Miyawaki.

MIYAWAKI'S AERIAL DRAWING BESIDE THE PALAU SANT JORDI

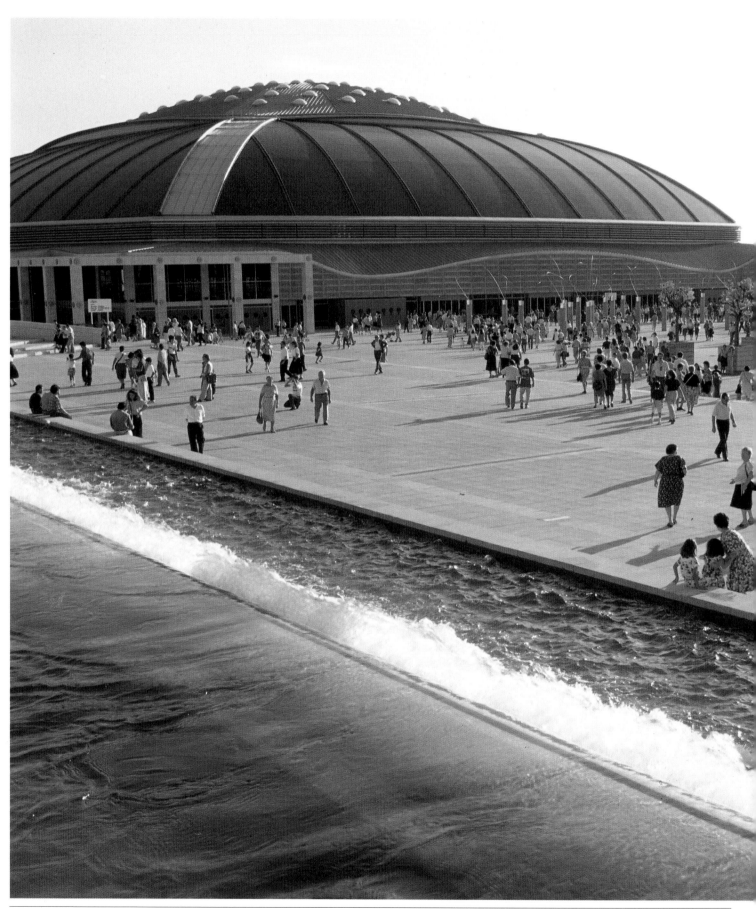

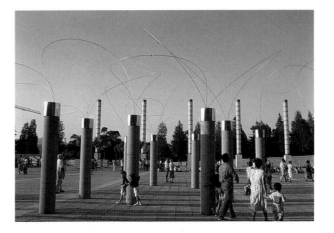

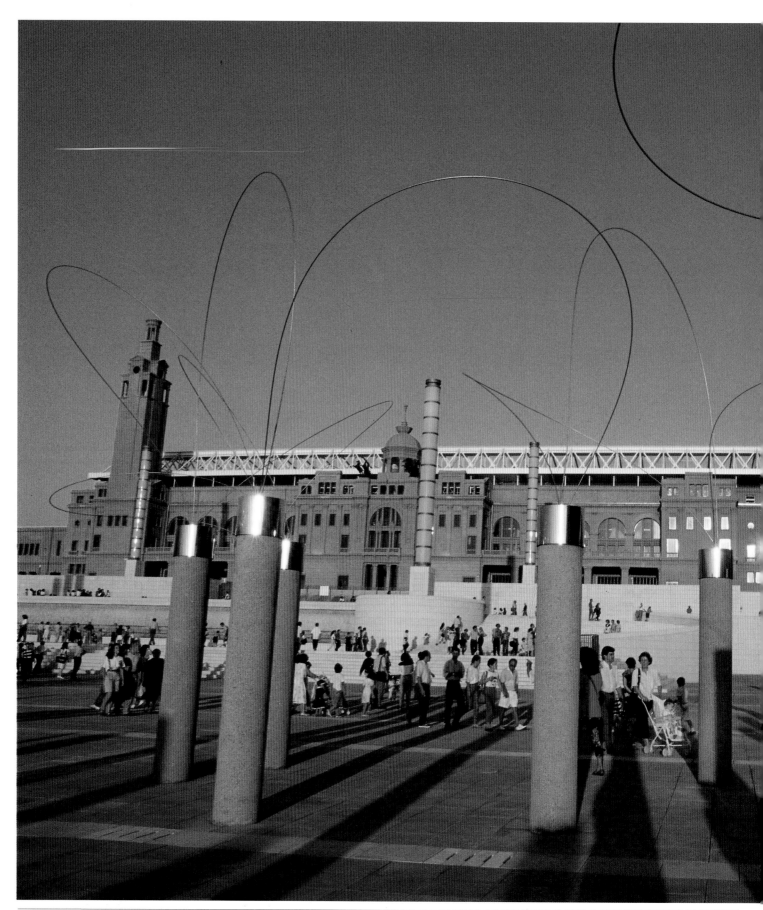

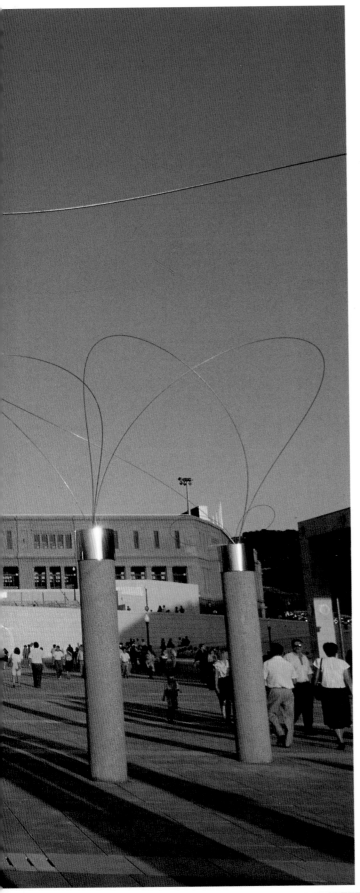

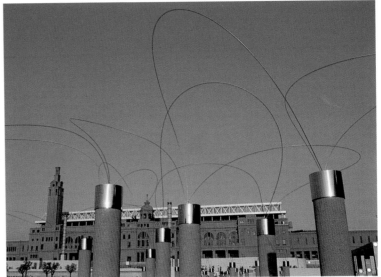

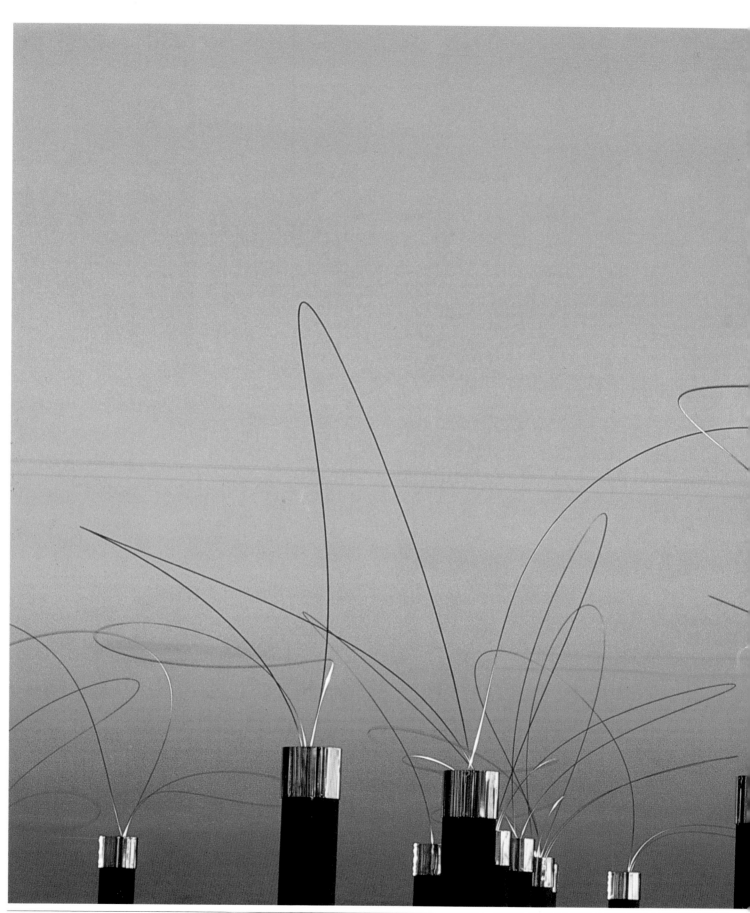

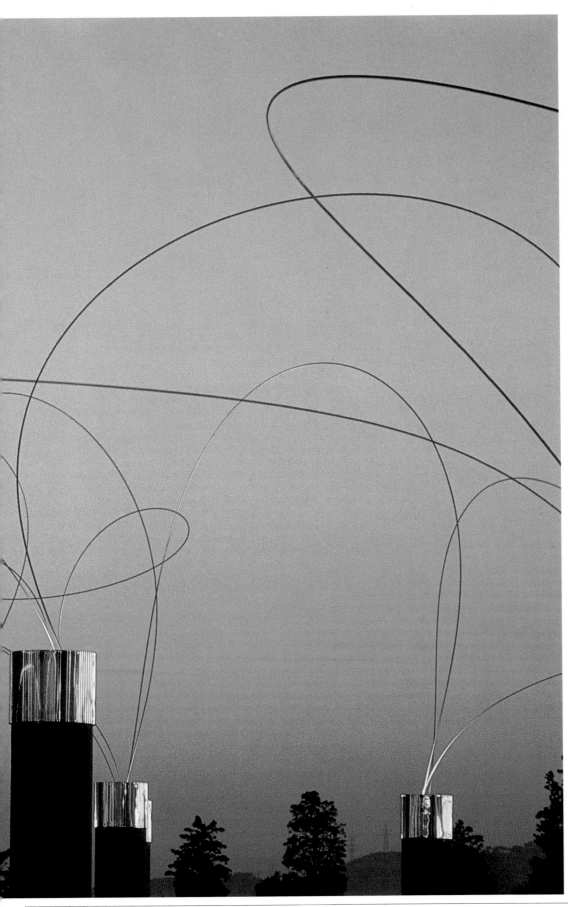

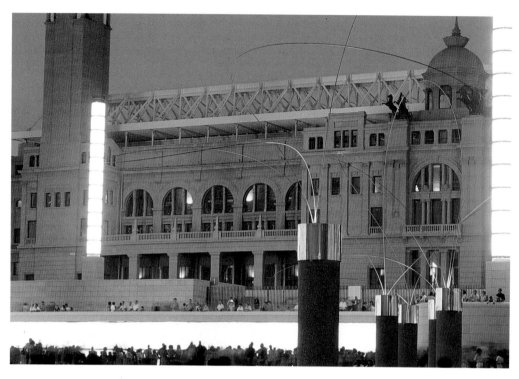

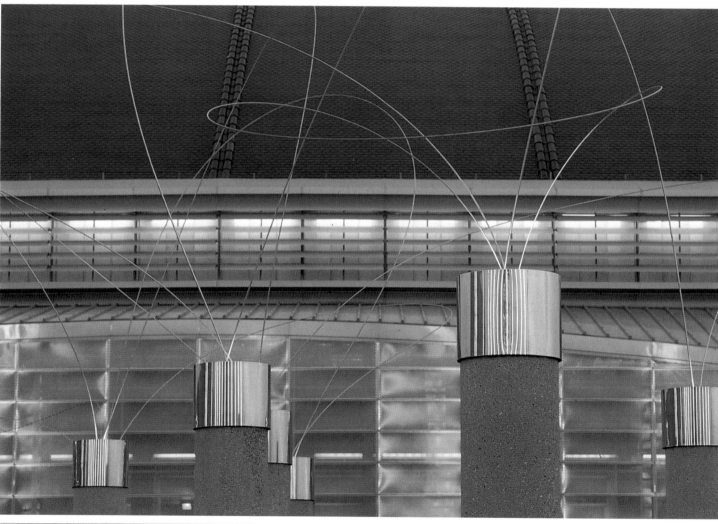

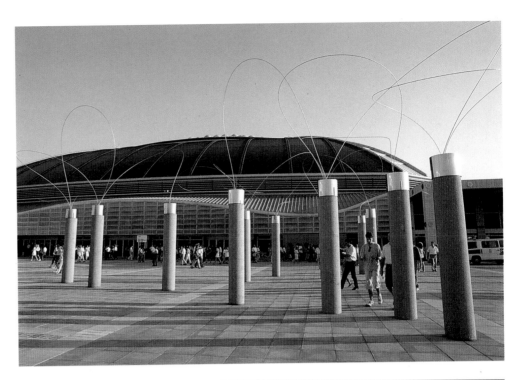

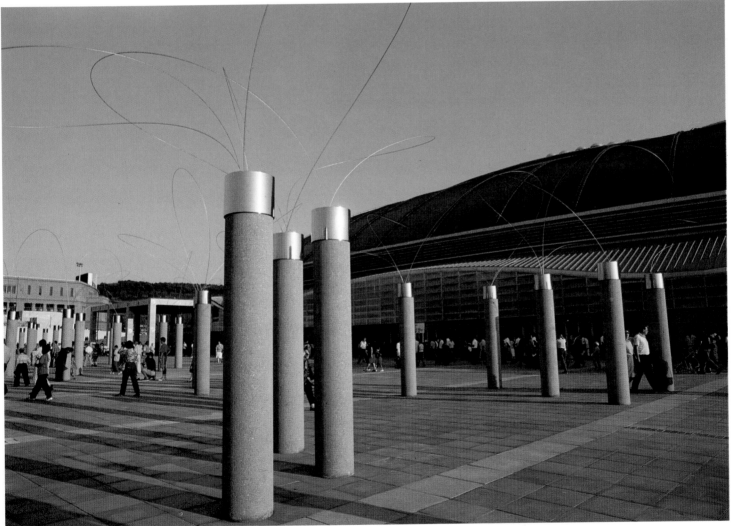

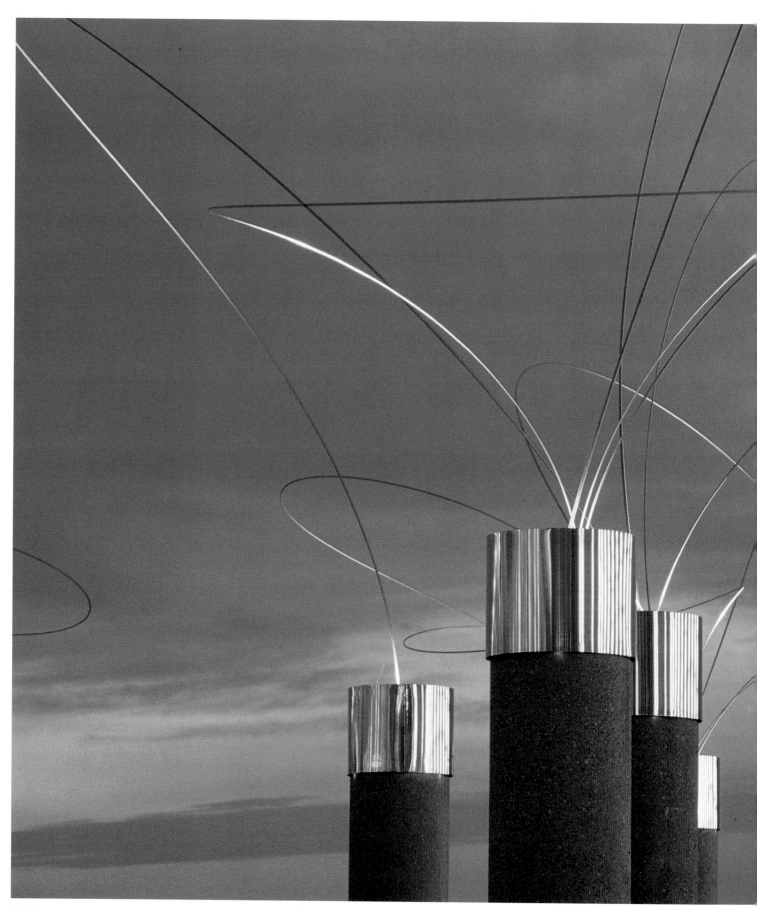

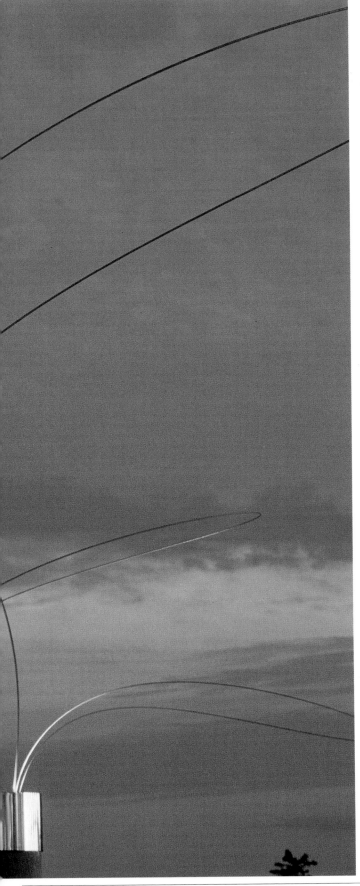
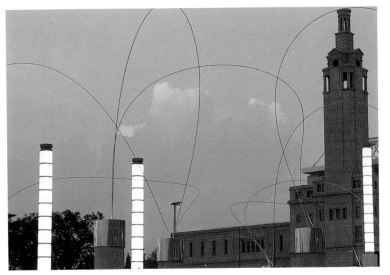

1. Velòdrom
2. Via Júlia
3. Rio de Janeiro
4. Francesc Layret and Ángel Pestaña
5. Llucmajor
6. Sóller
7. Creueta del Coll
8. Plaça de la Palmera
9. Rovira tunnel
10. General Moragues
11. Bridge between Felip II and Bac de Roda
12. Avinguda Gaudí
13. Parc del Clot
14. Vil·la Cecília
15. Avinguda Pau Casals
16. Estació del Nord
17. Parc de la Ciutadella
18. Passeig de Picasso
19. Plaça del Rei
20. Països Catalans
21. Espanya Industrial
22. Escorxador
23. El Moll de la Fusta
24. Plaça de Sants
25. Fundació Miró
26. Mies van der Rohe pavilion
27. Olympic Stadium

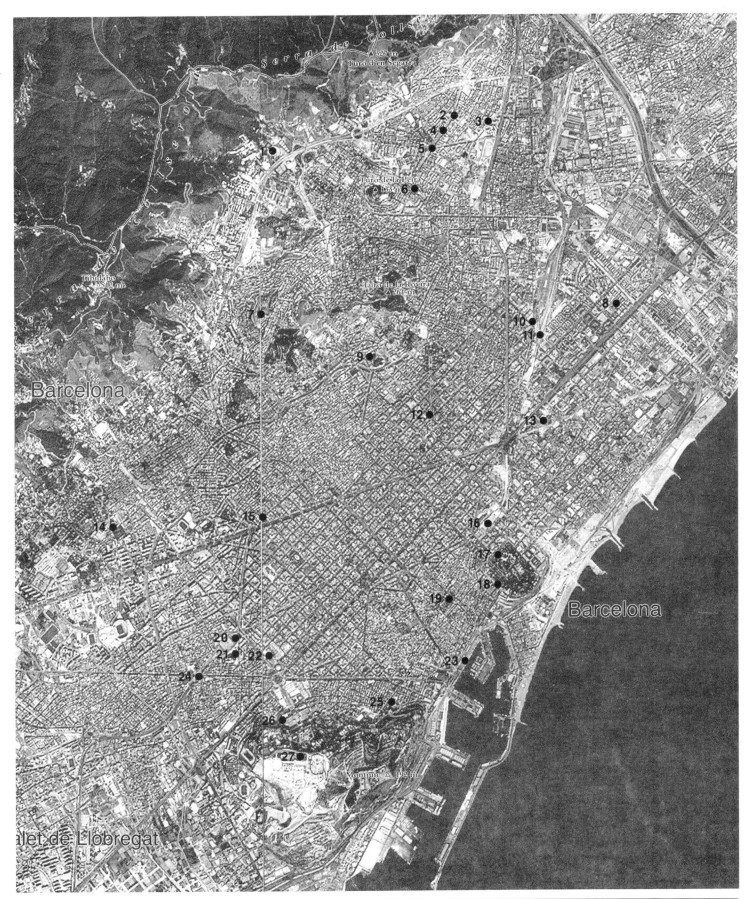

Index